Photograp

Children

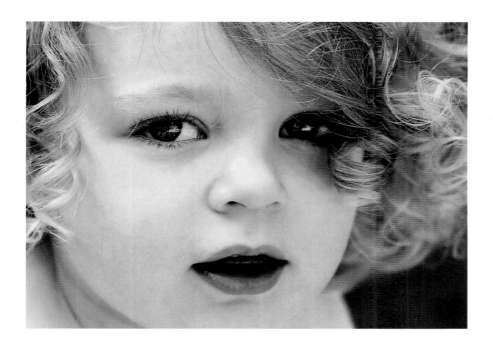

THE BetterPhoto Guide to
Photographing
Children

JIM MIOTKE

AMPHOTO BOOKS

AN IMPRINT OF WATSON-GUPTILL PUBLICATIONS
NEW YORK

FOR DENISE
and
camera-toting moms everywhere

Editorial Director: Victoria Craven
Senior Editor: Abigail Wilentz
Project Editor: Carrie Cantor
Art Director: Timothy Hsu
Designers: Areta Buk and Jay Anning, Thumb-Print
Production Manager: Salvatore Destro

First published in 2008 by Amphoto Books
an imprint of Watson-Guptill Publications
Nielsen Business Media
a division of The Nielsen Company
770 Broadway
New York, NY 10003
www.watsonguptill.com
www.amphotobooks.com

Library of Congress Control Number: 2008929138
ISBN-13: 978-0-8174-2448-0
ISBN-10: 0-8174-2448-2

Watson-Guptill Publications books are available at special discounts when purchased in bulk for premiums and sales promotions, as well as for fund-raising or educational use. Special editions or book excerpts can be created to specification. For details, please contact the Special Sales Director at the address above.

Typeset in ITC Berkeley Book

Printed in Malaysia

1 2 3 4 5 6 7 8 9 / 16 15 14 13 12 11 10 09 08

Acknowledgments

I am deeply grateful to many people who have helped me write this book. First and foremost, I would like to thank my family—my wife and best friend, Denise, and our children/models, Julian, Alex, and Alina. I am grateful to Brian and Marti Hauf for their loving support. I would not be anywhere without Team BetterPhoto—including Karen Orr, Kerry Drager, Jay and Amy Wadley, Celia Burkhart, Keri Malinowski, Tori Ashe, Ricardo Chavez, Pete Whitmore, Maureen Whitmore, and Jeff Moore. I am also indebted to the fantastic team at Amphoto—Victoria Craven, Amy Rhodes, Abigail Wilentz, Carrie Cantor, Lori Horak, Areta Buk, Jay Anning, and Melissa Berger. I feel honored to know and work with such great photographers as Vik Orenstein, Jim Zuckerman, Brenda Tharp, Lewis Kemper, George Schaub, Rob Sheppard, Tony Sweet, William Neill, and every one of the amazing instructors at BetterPhoto. And I give my thanks to the great BetterPhoto community and to the hundreds of BetterPhoto members that responded to my survey, providing me with pages and pages of topics to discuss and questions to answer in this book.

Contributing Photographers

These photographers placed as finalists or winners in our monthly photo contest at BetterPhoto.com or are members of the Photographing Children Club at BetterPhoto.

Erinn Aloi
www.afreshfocusphotography.com

Candy Avera
www.betterphoto.com?candyavera

Terri Beloit
www.terribeloitphotography.com

Sherry Boles
www.betterphoto.com?sherryb

Christina Bowker
www.betterphoto.com?christinab

Craig J. C. Photography
www.betterphoto.com?maka

Donna Cuic
www.betterphoto.com?donnac

Anna Diederich
www.betterphoto.com?annadiederich

AnnaMarie Ferguson
www.betterphoto.com?annamarie

Michelle Frick
www.michellefrick.com

Allison Gaulin
www.betterphoto.com?visionphotograph

Alison Greenwood
www.betterphoto.com?alig

Hayley Hamlin
www.betterphoto.com?hayley

Susana Heide
www.betterphoto.com?susana

Jean Hildebrant
www.betterphoto.com?hildebrant

Kerry Hogle
www.betterphoto.com?kerryh

Jessica Hughes
www.betterphoto.com?jessicah

Janet Jonas
www.betterphoto.com?janetj

Jennifer Jones
www.betterphoto.com?jenniferj

Denise Kappa
www.betterphoto.com?denisek

Karen Kessinger
www.betterphoto.com?karenr

Linda Krehbiel
www.betterphoto.com?krehbiel

Susi Lawson
www.betterphoto.com?susi

Teresa Lee
www.betterphoto.com?teresalee

Jill Lenkowski
www.betterphoto.com?tworingphotography

Jane McDonagh
www.betterphoto.com?janem

Heather McFarland
www.betterphoto.com?hkmphotos

Josh McKenney
www.betterphoto.com?josh_m

Julie Monacella
www.betterphoto.com?monacella

Amy Parish
www.betterphoto.com?bpamy

Kimberly Peck
www.betterphoto.com?kimp

Megan Peck
www.betterphoto.com?meganp

Margot Petrowski
www.betterphoto.com?moochie

Kelly Plitt
www.betterphoto.com?kelly_p

Daniella Puente
www.betterphoto.com?daniella

Jennifer Ralston
www.betterphoto.com?jralston

Jessica Sandberg
www.betterphoto.com?jessis

Monika Sapek
www.betterphoto.com?monikas

Jennifer Short
www.betterphoto.com?jennshort

Angie Sidles
www.betterphoto.com?angies

Sher Skinner
www.betterphoto.com?shers

Denise Snyder
www.betterphoto.com?dsnyder

Gianna Stadelmyer
www.betterphoto.com?gianna

Cheryl Steinhoff
www.betterphoto.com?cheryls

Darby Struchtemeyer
www.betterphoto.com?darby

Michael Swaffar
www.betterphoto.com?shutteredimage

Datha Thompson
www.betterphoto.com?datha

Erin Tyler
www.betterphoto.com?etyler

Benica Walsh
www.betterphoto.com?blw

Norma Warden
www.betterphoto.com?norma

Ilona Wellmann
www.betterphoto.com?iionaw

Kimberly Whipps
www.betterphoto.com?barefoot

Kathy Wolfe
www.betterphoto.com?kathy_w

Cindy Wong
www.betterphoto.com?cwongphotography

Contents

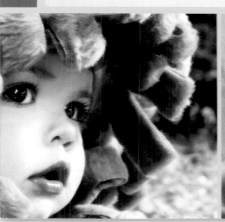
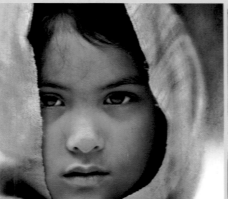
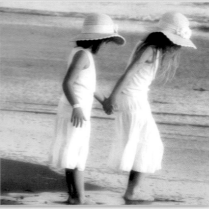

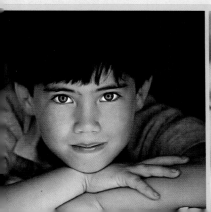
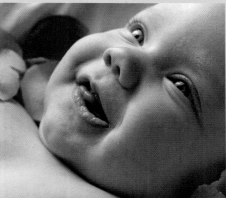
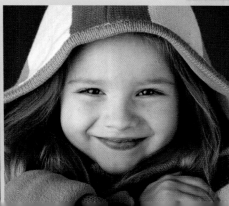

Preface

I AM A PARENT who photographs my children because I find endless joy in this activity. I try to take my camera everywhere I go—always ready to capture a meaningful moment, with my finger poised on the shutter button. I also have a studio set up in my garage so I can easily take beautifully lit photos of the kids whenever the mood strikes, regardless of the weather. I have three adorable children—Julian, Alex, and Alina—who prove to be fun and cooperative subjects time and time again. In this book, I share with you my own tried and proven tips and tricks for getting fantastic child photos—again and again.

This book is for moms, dads, grandmas, grandpas, uncles, and aunts with cameras. My hope is that it serves as both a guide and an inspiration—a jumping-off point to help you ignite your creative side when it comes to photographing your kids.

Introduction

AS WE CONTINUE into this digital world, it seems we have more and more opportunities to record and photograph our families and the world around us. We capture moments in time—snapshots of our precious children accomplishing new tasks and reaching new milestones. Getting beautiful photos of your children doing these things only makes the memory fuller and more meaningful—both for you and for your children. You end up with images that you want to put in your scrapbook, share with relatives, email to friends, and hang on your wall. And the fun doesn't stop there! Not only do these photos serve as precious mementos, but they also become an expression of your own creativity—the artist within. Can you see how you're in for a real treat?

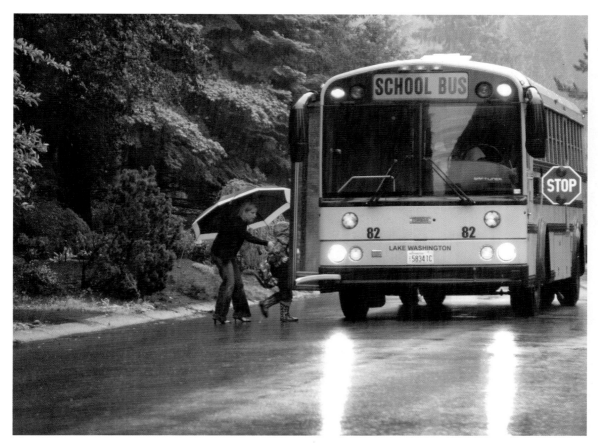

One key to success is to take the camera with you everywhere you go. Only by developing this habit can you catch the fleeting moments of childhood. Remember to mark special days like this on your calendar so you can plan ahead and be there with camera in hand when the events unfold. I will always treasure this record of my son getting on the school bus to go to his first day at kindergarten.

PHOTO © JIM MIOTKE. CANON POWERSHOT G7, 1/60 SEC AT ƒ/4.8, 35-210MM LENS AT 210MM

WHO YOU ARE

I am going to take a guess as to your motives for picking up this book:

❑ Perhaps you have a new digital camera and feel a bit overwhelmed by all the buttons, dials, functions, and menus. You want to master the functions of your new digital camera, and the operator's manual seems sorely lacking.

❑ You may have a history of taking decent pictures of children with the occasional stunner, but you wish you had a better handle on the creative challenge. You want to capture the

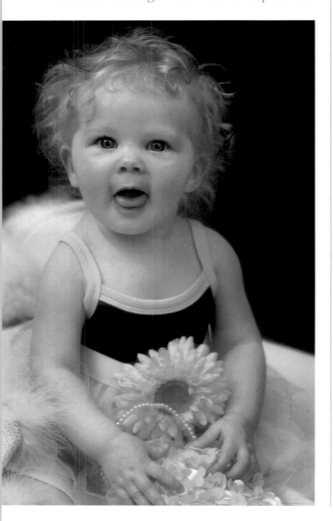

qualities that make your children so adorable every time, not just occasionally.

❑ You might find working in outdoor light easy but seek help taking the first step when it comes to working in a home studio. After all, it's a foreign, counterintuitive, and highly technical environment.

If any of the above sounds familiar, you have come to the right place. With this guide in hand, you will take your child photography up to a new level. Soon, you will feel less intimidated and better able to produce imagery of great quality, regardless of your present equipment or skill.

My goals are to do the following:

❑ Wow you with strikingly beautiful photos.

❑ Connect with you by sharing some fun anecdotes.

❑ Teach the concepts in plain English.

❑ Make the quality of your photography soar . . . through the roof!

THE CHALLENGE

Over the next several chapters, you're going to learn how to consistently capture unbelievably cute pictures of children. To me, the key principle in photography (or any creative endeavor for that matter) is to do what you love—to follow your heart and passion. And what subject do parents love more than their children?

This baby was photographed in a home studio, which greatly increases my chances of success on two levels. First, I can control the lighting and the shoot is therefore not dependent upon the weather. Second, I am much more likely to get great baby photos when I can easily start a session in the studio whenever I notice the baby's mood is right for picture-taking.

PHOTO © JIM MIOTKE. CANON 5D, 1/125 SEC AT *f*/7.1 ISO 100, 100MM LENS AT 100MM

However, as much as we love our subjects, we still often experience extreme challenges when photographing kids. Regardless of how cute they are, they can be difficult subjects to shoot. At times, the subject turns out too blurry, too dark, or too bright. At other times, your subject suffers from problems such as red-eye. Another problem is working with short attention spans, getting the subject to stay still and to cooperate long enough for you to make a great picture. The end goal—the entire reason we aim to improve our abilities with kid photography—is to get natural expressions recorded in an accurate and pleasing way. So we'll talk about how you can interact with children for best results—developing patience, fostering cooperation from your photo subjects, and working with light to produce outstanding candid photos as well as portraits. This can be a very challenging endeavor and takes a great deal of energy and patience.

As you climb the hill toward photographic mastery, a common occurrence will frustrate you: You will get a fantastic expression that turns out to be, alas, too blurry. You'll also come across the perfect background from time to time and your child will refuse to cooperate. These are the hard knocks, but the good news is that help is on the way.

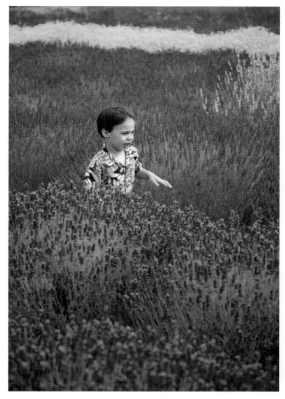

Perfect background, uncooperative kid! This happens to all of us.
PHOTO © DENISE MIOTKE. CANON 5D, 1/400 SEC AT ƒ/5.6, ISO 400, 28–135MM LENS AT 135MM

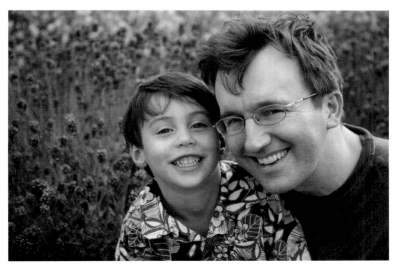

Daddy poses, too, and saves the day!
PHOTO © DENISE MIOTKE. CANON 5D, 1/250 SEC AT ƒ/5.6, ISO 200, 28–135MM LENS AT 105MM

The key to solving many of these problems is working fast. You will want to master light, composition, and exposure so you can deal with things such as aperture, shutter speed, and depth of field in a split second, in time to catch these fast-moving subjects.

In the upcoming chapters, we're going to learn exactly how to counteract and correct all problems. Soon, you'll be producing excellent photos of children every time you pick up your camera.

Beware! You will experience the following from time to time, and you just have to develop a thick skin: You will feel elated during the shoot, confident that everything is going so well. You're on fire. Every third shot is an award winner. Then, when you offload the images to your computer and open them up in Photoshop, you notice problems. You see defects that you could have sworn were not there when you were shooting: food on the face, unattractive drool, and, of course, the inevitable closed eyes.

If you love working with children, though, you are way ahead of the game. Your love—when combined with the knowledge you are about to gain from this book—will give you everything you need to stay on top of the challenge.

THE TOPICS YOU MOST WANT TO COVER

To get a better feel for most people's interests and goals, I posted a survey for the BetterPhoto community, and, in no time at all, about four hundred people responded. By far, the number-one question had to do with lighting. The second most popular question had to do with how to get kids to cooperate, stay still, and direct their gaze into the camera. Because these were the most frequently asked questions, I devote much of the book to answering them.

In chapter 1, we will explore the nuances of light as it applies to photographing children. You'll learn about the direction of light, fill flash, overcast, open shade, and late afternoon sun. You will also learn everything you need to know to set up your own first home photo studio and begin the fun journey of making images in a controlled lighting environment.

In chapter 2, we will explore the time-honored principles of composition. You will learn how not only to catch these kids while they're still in the frame but also how to compose the scene with balance and grace. We'll also explore the power of point of view, line, shape, and lens choice.

In chapter 3, you will learn how to control aperture, shutter speed, and ISO for motion blur and depth-of-field effects when photographing these fast-moving subjects. You'll find the tools and techniques you need to capture eye-catching images of kids in fast-action situations.

In Chapter 4, we will explore cameras and equipment required to make great kid photos.

In chapters 5, 6, and 7, you will learn how to get kids to cooperate and direct their attention to you, the photographer, rather than the floor, Grandpa to the right of you, or their siblings playing with toys off in the distance.

A novel feature of this book is the tips on photographing different age groups sprinkled throughout. You will gain insights about working with babies, toddlers, preteens, and older kids. Almost all of the lessons in this book are applicable regardless of the age of the child.

Note: The first three chapters of this book have been organized into three topics. With the use of the following easy-to-remember abbreviation, LCD, you should be able to remember the techniques you learn when you're attempting to take great pictures of your kids:

L Lighting
C Composition
D Digital Exposure

Lastly, just for fun, you will come across occasional "Kid Quotes" throughout the book. These are actual quotes from my oldest son, Julian, that I've written down over the years. Kids really do say the darndest things!

THE PHOTO EXAMPLES

In the examples throughout the book, I've noted a variety of important settings—shutter speed, aperture, flash, and ISO. This is to help you learn how to capture similar images yourself. Some photos have been contributed by BetterPhoto members. Most examples were captured with a single-lens reflex (SLR) camera. An SLR camera is one that allows you to interchange the lenses and that has a lot more sophisticated controls than your typical point-and-shoot camera. SLRs are pricier and usually bulkier, but I prefer to use an SLR for most of my photography because it gives me more creative control. I do, however, own a point-and-shoot camera that I carry with me as I go about my day-to-day tasks, so that I always have a camera at hand in case I happen upon a photogenic moment.

THE ASSIGNMENTS

A wise man once said that we usually forget what we hear, remember what we see, but completely understand what we do. For this reason, I have sprinkled a number of inspiring assignments throughout the book. These assignments will help you truly master each concept. They are designed to help you learn and to ignite the artist within through creative acts.

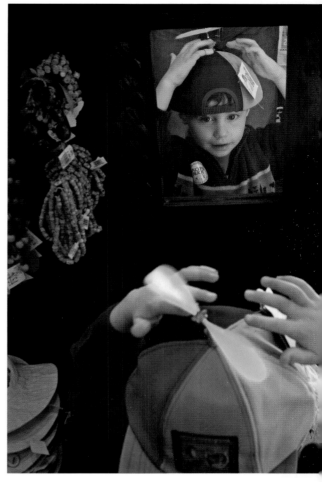

There are two ways to get great child photos. (1) Set everything up and stage the shot, and (2) follow the child around and capture moments as you see them happening. Each has its merits. Following the child around requires great energy and agility. Setting things up can create more beautiful, balanced, and clean photographs, but it sometimes backfires, as when the child goes on strike. ("No, I won't stand there!" or "I'm not going to look at the camera anymore!") I often practice a mixture of the two. This image was captured as I followed my son around at Sea World, documenting his excitement at trying on a variety of hats. There is no way I would have been able to get this shot if I had told him to stand there in that position while I tried to pose him in just the right way.
PHOTO © JIM MIOTKE. CANON 10D' 1/50 SEC AT ƒ/9, ISO 1000, 28–135MM LENS AT 44M

Safety

Remember, no photo—regardless of how many contests it wins or relatives it pleases—is worth risking the safety of a child (or yourself). Be wise. There is always a lot going on when photographing children, and it's smart to play it safe. I love working with assistants, or "kid wranglers," partly because they are invaluable to the creation of professional-quality photos but also because if I ever get carried away and forget about basic safety guidelines, it helps to have another person there to make sure everyone is kept out of harm's way.

WHAT YOU WILL NEED

My son Julian has always enjoyed being in front of the camera. For this reason, I consider myself greatly blessed as a photographer. All the same, I have to be very flexible and let him do what he enjoys in between each brief photo session. That way, I can both get the great pictures that I want and make sure he enjoys the photographic process enough to keep coming back for more. To get lifelong joy from photographing children, besides learning photographic techniques, you will need to do two things: develop communication skills and practice humility.

Communication Skills

Have you ever heard of reflective listening? This is when you repeat back what the person just said to you, to confirm that you are indeed listening and that you understand what they're saying. As a photographer, you have to be a master communicator, not only through your photos but with your words, too. You will find lots of advice in this book on communicating with your subjects and others around you.

Also, kids crave attention more than anything else. They need to feel valued, useful, and important—because the day-to-day working world so often pushes them aside or completely disregards them. We grown-ups feel we need to get "real" work done—whether that means going to the office or folding the laundry. But kids don't see things in this same light, and it pays to help them feel useful and valued whenever we can.

Humility

You will often have to face that fact that you are not the one in control. If you are having a difficult time leading the little ones to your picture-perfect spot—when they are deciding that they would much rather stay where they are, interested in a bug or a tree stump or a puddle—instead let go of your tight grasp on the reins. Go along with them as they journey though their world and endeavor to document life as it is to them, rather than their life as you'd like it to be. The best pictures will come when you are loving, easy-going, and as patient as a saint as you watch your kids enjoy their early years of life.

CANDID PICTURES: A GOOD PLACE TO START

As we'll learn in chapter 5, one of the greatest challenges when photographing kids is getting them to cooperate. Many people avoid the cooperation problem entirely. You can, too. The simple workaround is

ASSIGNMENT **Your First Assignment: Collect and Recreate Photo Ideas**

Over the years, you'll find it very helpful to keep a book or binder of photo ideas. Collect all photos that you find inspiring and put them in one place so you can refer to them later. Look through magazines and either make copies of special pages or tear them out, if you don't mind destroying the magazine. In addition to magazines, go online and look through the finalists and winning photos at the BetterPhoto contests. Print off the photos that make you take a second look. I recommend using a standard three-ring binder and clear sleeves to collect the photos you most enjoy. Refer to this binder often for reference and inspiration. When you need creative stimulation, or what I like to call a "kick in the pants," refer to these images, pick one, and see if you can recreate the photo that most inspires you.

Don't worry too much about copying another photographer's work. If you approach this with the right spirit, you'll come up with your own unique spin on the original. Think of these photos as starting points from which you can develop your own ideas.

Involve your kids in the process. Set up a weekly art project through which you look for fun photos. Your kids will love tearing up old magazines with you!

to take images of kids when they are unaware of your presence. Most of you already know how to capture candid photos: You try to be as invisible as possible, blending into the woodwork. Shoot from a distance with a long lens and watch for moments that look thoughtful and interesting enough to hold your viewer's attention, even though the subject is not looking directly into the camera.

Once you feel fairly confident that you have captured some interesting candid photos, you can gradually inch in closer to interact with the kids and work to create more traditional portraits—photos in which the subject is looking directly into the camera. Capturing a variety of both styles—candid and portrait images—is the best strategy.

Sometimes even a wide-angle lens can be used to create photos with the subject not looking directly into the camera. These can have an interesting appeal because they combine the candid feel with the sense of intimacy gained with a wide-angle lens. They look less like a mug shot and more like a captured moment of time with the child. But remember that candid photos differ from portraits in that the idea is to be invisible while you're taking the picture. Ideally, the child will not know that you are there taking pictures. Whether you use a telephoto lens or a wide-angle lens, act a bit like a spy and get in as close as you can without breaking into their awareness. For this image, I strived to remain just outside of my child's world while using a wide-angle lens to create a more intimate candid photo.
PHOTO © JIM MIOTKE. CANON 5D, 1/400 SEC AT f/10, ISO 400, 28–135MM LENS AT 28MM

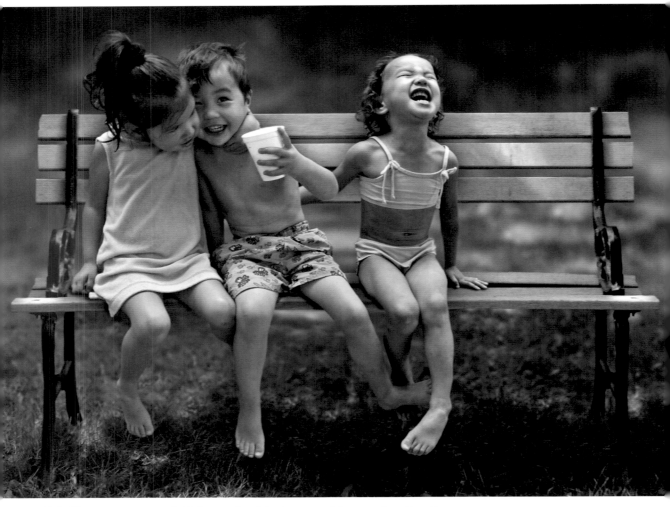

Kelly Plitt says she captured this image after "chasing around three rambunctious three-year-olds with my camera on a visit to our friends' lake cottage. Snapping like crazy, I managed to capture this candid image, which was a great reflection of the day's mood."
PHOTO © KELLY PLITT. CANON POWERSHOT G2, 1/160 SEC AT ƒ/2, ISO 100, 35–140MM LENS AT 35MM

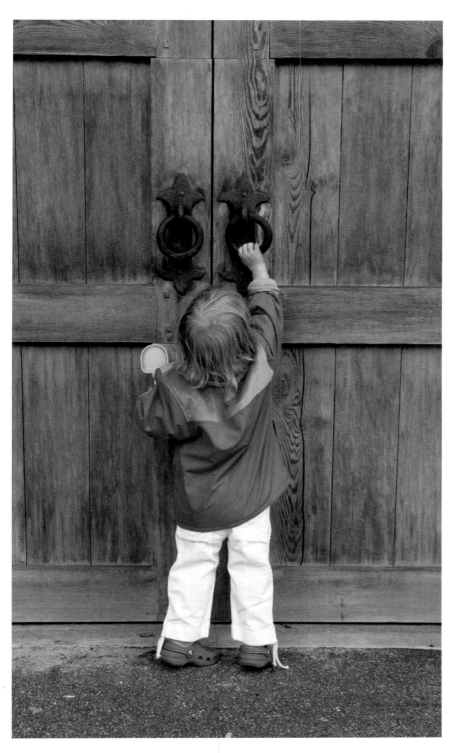

Keep a watchful eye out for clean, interesting backgrounds. When walking in Carmel, California, I noticed these beautiful doors and made a game out of examining the door knockers. Soon my children were interested, too. After quickly taking a few steps back, I clicked away until they lost interest and moved on.

PHOTO © DENISE MIOTKE. LEICA D-LUX 3, 1/100 SEC AT ƒ/3.6 ISO 100, 28–112MM LENS AT 50MM

THE ROAD AHEAD

The energy at a photo shoot involving children is both exhausting and exhilarating. If you look at it the right way, and employ the techniques you are about to learn, the experience can be delightful and satisfying. You will sleep well when it's all over, but the work will be more than worth it. Using the following photo tips, you'll begin to build a large collection of wonderful pictures of your children, pictures in which they look happy, natural, and at ease. You are about to learn how to capture fantastic candid photos as well as portraits that accurately capture your child's true beauty and wide array of natural expressions.

I am so grateful to have some basic photography training as I watch my children grow up. It's a real treat to have mementos with meaning, genuine expression, and delightful memories associated with them. You can have these kinds of photos, too.

If you've been photographing kids for some time, I wish you the joy of rising up to the next level on your photographic ability. If you are just starting out on your journey as a child photographer (or as a parent, for that matter!), I wish you many satisfying photo shoots filled with laughter and great expressions.

For these two images, I used a long lens to get in close to my subjects without entering their personal space. This allowed me to capture more candid moments when they were less aware of my presence.
ABOVE: PHOTO © JIM MIOTKE. CANON 10D, 1/90 SEC AT ƒ/5.6, ISO 400, 28–135MM LENS AT 135MM. RIGHT: PHOTO © JIM MIOTKE. NIKON 2DX, 1/125 SEC AT ƒ/5.6, ISO 100, 80–200MM LENS AT 135MM

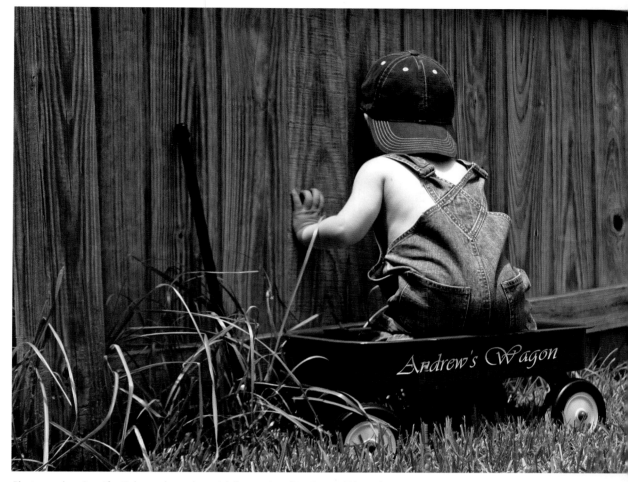

Photographer Jennifer Ralston shares her trick for getting this classic: "I love the wagon and boy in coveralls theme. I had my son sit in the wagon and asked him to see if he could see our neighbor's dog through the fence. I shot like crazy as he searched for her." One of the great joys of photographing children is that they often become so engrossed in the present moment that they forget you're taking pictures. You can work to blend into the background right from the start, or you can partially stage or set up a shot and then quickly back away to capture candid photos of the event after they forget about your presence.

PHOTO © JENNIFER RALSTON. CANON 300D , 1/400 SEC AT ƒ/4, ISO 100, 28–135MM LENS AT 41MM

"Wake up, guys! Don't go
back to sleep, Daddy . . .
it's the perfect time to wake up."

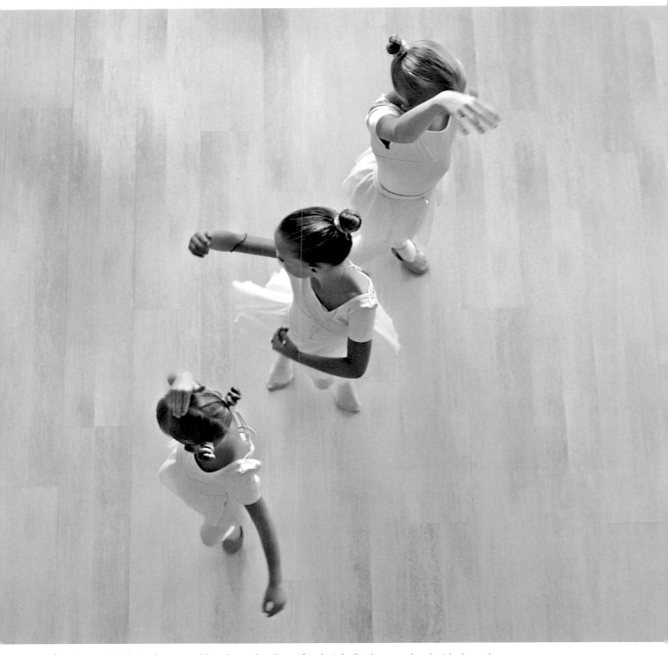

After Susana Heide had prepared her three daughters for their ballet lesson, she decided to take a few shots before sending them off. She captured this image indoors with natural light from a second-story balcony window overlooking the foyer. She writes that, "sometimes the spur of the moment candid images become treasured photos because they record real slices of life!"
PHOTO © SUSANA HEIDE. CANON 1D MARK II, 1/100 SEC AT ƒ/4, ISO 400, 28–70MM LENS AT 38MM

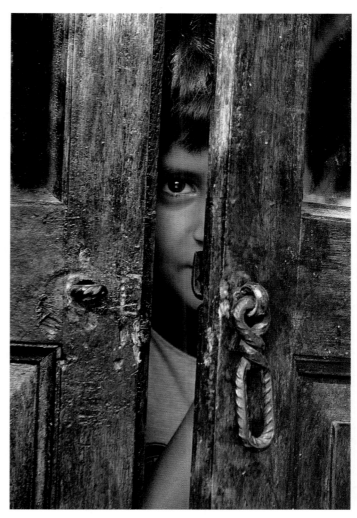

This photo was taken one afternoon with special delicate sunlight illuminating the area. Photographer Daniella Puente says, "That day, I was photographing outside and my son was playing with the door of the house. I was not so close to him, paying attention to other subjects, and he began to play hide-and-seek with me in an effort to capture my attention. I was grateful to have my long 75–300mm lens on the camera. This allowed me to capture this image without walking close and distracting him from the game." The resulting series of captures were natural and beautiful. I have found that candid photography—when the subjects are photographed by surprise—is the best way to capture small children.

PHOTO © DANIELLA PUENTE. CANON DIGITAL REBEL, 1/60 SEC AT ƒ/5 ISO 100, 75–300MM LENS AT 155MM

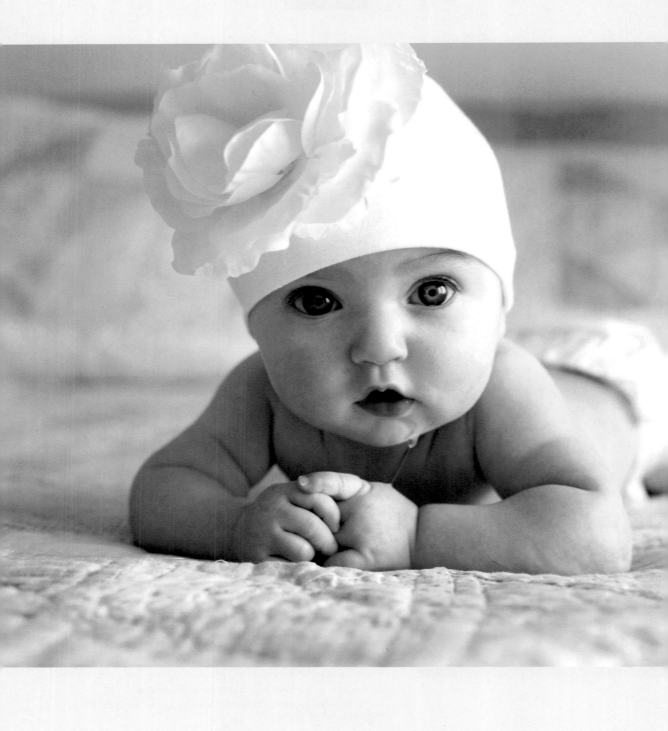

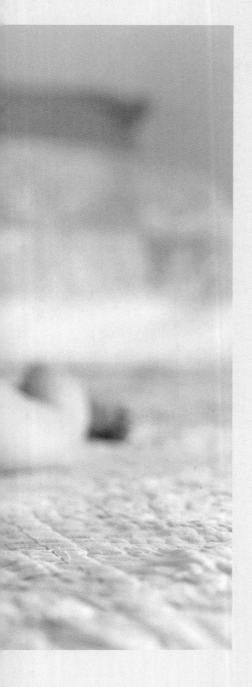

Light

HAVE YOU EVER BEEN UNHAPPY with your photos because your kids squinted and contorted their faces into quite unnatural expressions in harsh sunlight? Or perhaps half of your daughter's face got lost in dark shadows. These problems have to do with the primary ingredient in photography: light. In this chapter, we're going to start our exploration of photographing children by discussing the aspects of light that most influence the quality of your child photos: direction, quality, and color. You will learn to see light by source and ask all the right questions before shooting so you end up with delightful photos of your kids.

You may feel more confident photographing outdoor portraits but less confident when it comes to indoor lighting. Or you may feel strong using two lights in a home studio but unsure when it comes to adding a background or hair light. Wherever you are with your understanding of light, this chapter will help guide you to the next level.

This baby portrait makes excellent use of the natural light coming in from a large nearby window to the left of the camera. Setting her up in the middle of the bed allowed the photographer to get low and shoot at the baby's eye level. The bright fabric of the bed covering acted as a natural reflector, evening out the shadows and highlights.
PHOTO © MEGAN PECK. CANON 5D, 1/200 SEC AT ƒ/4, ISO 640, 50MM LENS

Three Ways to See Light As Your Camera Does

THE KEY TO MASTERING the use of light in photography is to learn to see light in the same way the camera sees it. Our human eye compensates for variances of tone and causes us to see things in a nice, even way. The camera, on the other hand, records tones in a mathematical, mechanical way. We may experience a scene that looks fairly nice to the eye, but when we see it in the LCD monitor or on the computer, the subject looks either washed out or too dark.

There are three things that you can do to see light more mathematically, more like a camera.

1 Simply squint while you look at a picture. This allows you to see a bright spot, for example, as being very bright and dark spots as very dark. When you squint, details are blurred and the tones are blended together. This gives us a visual approximation of how the camera will record the scene. If there are both bright highlights and dark shadows, you will likely get the impression that a particular scene will be too high in contrast.

2 Use the histogram. This graphic representation of all the tones in a photo is available on many cameras and gives you another way to view light mathematically. Check your camera manual to see if you have this function. If you can, set your camera so the histogram displays briefly after every exposure. Get into the habit of glancing at this chart. If you see a thin, tall spike at either end of the histogram, your photo is likely over- or under-exposed. (For an in-depth explanation of the histogram, see chapter 3.)

3 Do your "homework" after you shoot, reviewing images on your computer. When you're looking at your images in Photoshop or another image-editing program, simply question why each image looks the way it looks. We'll talk more about examining each image and its corresponding EXIF data (or metadata) in chapter 3.

KID QUOTE

Our cat was not happy about Julian being close to her as she sat on Daddy's lap. "Sorry, Kitty," said Julian. "You can't just have all the love. You have to spread it wide."

Natural Light

IT HELPS TO BREAK our study of light down according to source. You can illuminate your subject with a wide variety of light from the sun, with your flash, or with a studio lighting system. Think of these sources of light as the three main options in your toolbox. We will discuss flash and studio lighting later in the chapter; let's start learning about light by exploring natural light.

As studio lighting can be expensive and flash often produces unflattering results, many serious hobbyist photographers most want to learn how to make the best child photos they can using only natural light. The good news is that, even if you are not ready to try studio lighting or your budget doesn't allow you to try it, you can still get studio-quality results working with natural light. You just need to identify the best outdoor light and make the most of it, being flexible with the inevitable changes in the weather. Natural light can be an ideal way to begin to master the intricacies of light, especially if you're primarily interested in having fun with your kids and recording their life rather than working to deliver studio results in a timely fashion to paying clients.

When you are outdoors, you want to make the most of whatever light you have. There are several tricks of the trade that will help you do this. With these techniques in hand, you will be able to maximize your efficiency—and instances of successful results —when it comes to making awe-inspiring outdoor child portraits.

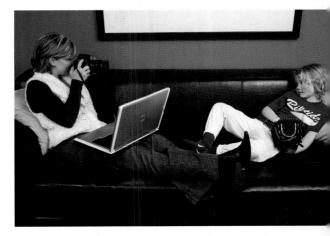

When in doubt, turn off your on-camera flash. For softer, more beautiful kid photos, strive to work with bright natural light whenever possible.

Always Be Prepared for Good Light

Why do photographers advise beginners to carry their cameras with them everywhere they go? Well, of course, you want to have your photography tools with you when your child is particularly cute or funny. More important, you carry your camera everywhere because it is light that makes or breaks a photo, and awesome outdoor light can come at any time, in any place. Photographs that make good use of light are not the result of a photographer getting lucky. The "lucky" photographer is usually one who has made a habit of bringing the camera everywhere. You can immediately increase the number of fantastic kid photos you get by simply adopting the same habit. Whether you're heading out to the grocery store, dropping off the kids at school, or taking the kids to a play date, be sure to take your camera with you in case you come into a beautiful lighting situation.

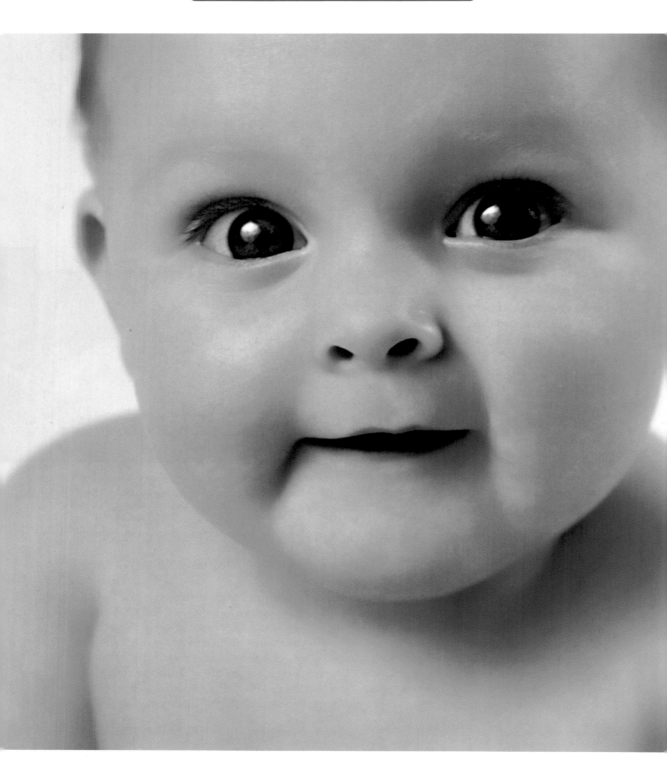

This photo makes wonderful use of soft, diffused light. The light is non-directional (appearing to wrap around the subject without any strong shadows on either side of the face). The image succeeds largely because of the soft nature of the light.

PHOTO © ALLISON GAULIN. CANON DIGITAL REBEL XTi/450D, 1/160 SEC AT *f*/5.6, ISO 400, 28–135MM LENS AT 95MM

Turn Off Your Flash

If you are using a compact digital camera, set the flash so you are the one who decides when to use it, not the camera. If using a digital SLR camera with a pop-up flash, make sure you are using a semiautomatic exposure mode such as aperture priority or shutter priority. This will keep your on-camera flash from popping up every time you're shooting in low-light conditions.

The Direction of Light

NATURAL LIGHT CAN BE USED to create beautiful child photos, especially when you understand how the direction and quality of the light affects your image. If you shoot at the right time of the day and in the right situation, you're bound to capture stunning child photos. Almost unconsciously now, I ask myself before every shoot, "Where is the source of light in relation to my subject?" Noting whether the sun is in front of my subject, off to the side of my subject, or behind my subject greatly influences my strategy for capturing outstanding kid photos. When I need to change the situation, I can often move myself or my subject to make use of a different direction of light. Thus, the direction of light is intertwined with the photographer's point of view, which we'll talk more about in the chapter on composition.

FRONTLIGHTING

Photographing with the sun behind you is called frontlighting. The sun is behind you but, more important, in front of the subject so that he or she is being hit right in the face by the direct light. This produces beautiful bold colors but can also produce harsh shadows. It can also cause your subject to squint and be uncomfortable. As it's difficult to

This funny photo of a charming six-month-old baby was primarily illuminated by a large window behind the camera and secondarily by a small window to the left of the camera.
PHOTO © KIMBERLY J. WHIPPS. CANON 5D, 1/200 SEC AT ƒ/2.8, ISO 500, 50MM LENS

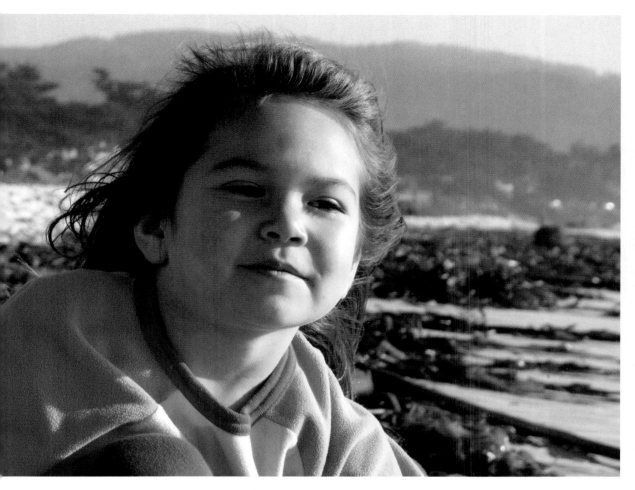

Late day can be a great time to make use of sidelighting. Photographed at the beach as the sun was quickly approaching the horizon, this image shows the girl in a beautiful, soft light. The shadows on the right side of her face bring a sense of depth and form to the viewer.
PHOTO © JIM MIOTKE. CANON POWERHOT G7, 1/1600 SEC AT f/5.6, 35–210MM LENS AT 150MM

smile when your face is doing everything it can to block out the bright light, intense frontlighting can be unpleasant for both you and your subject. Frontlight works well when it is diffused. A bright sun obscured by a lightly overcast sky can create wonderfully soft and pleasing portraits. We will explore the diffusion of light more in a bit.

SIDELIGHTING

When you see strong highlights on one side of the face and shadows on the other, your subject is being illuminated from the side. Sidelighting can give dimension to a subject, accentuating the shape and curves of the face.

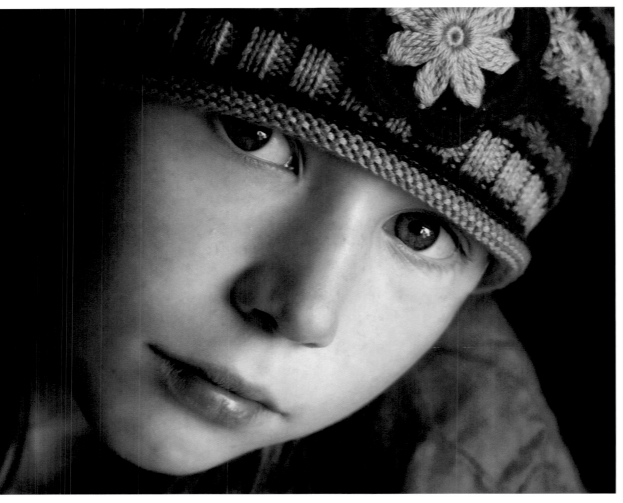

Natural indoor light from a large window lit this child. According to the photographer, this child posed like a pro—constantly providing different looks with variations on the tilt of her head. As we will learn later, the slightest head tilt can make a huge difference in a portrait. This only works for older children, but when you can combine soft sidelighting with a professional pose, you will increase your chances of ending up with a winner.

PHOTO © MARGOT PETROWSKI. KONICA-MINOLTA DIMAGE A2, 1/125 SEC AT f/3.5, ISO 200, 28–200MM LENS AT 150MM

BACKLIGHTING

The general rule that you will find in most beginning photography textbooks is to keep the sun behind you. There is good reason behind this popular rule. When the sun is not behind you, you often end up with duller colors and less contrast. Additionally, you have to watch carefully for problems such as lens flare. When your image suffers from this flare effect, bright spots of light appear all over your image. Caused by light

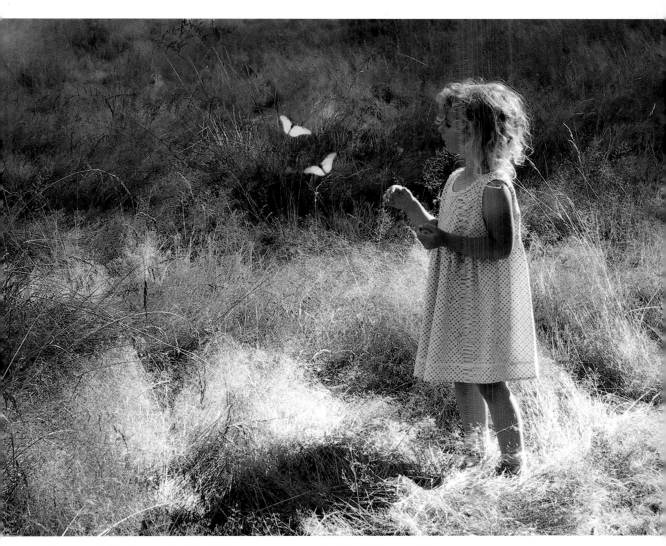

If your model has her back to the light source, you can get a bit of light around the perimeter—a rim light. In this serene image of a girl in a meadow, notice the beautiful light along the rim of the subject. As a side note, this is a composite of two different images. One is of the girl in the meadow and the other is of the butterfly. Both images were combined and toned with the use of Adobe Photoshop.

PHOTO © MONIKA SAPEK. CANON POWERSHOT G1, 1/200 SEC AT ƒ/4, ISO 100, 34–102MM LENS AT 85MM

bouncing around among the elements in your lens, flare can be reduced or eliminated by changing your angle or using a lens hood.

Contrary to popular belief, though, having the sun in front of you and behind your subject can provide excellent opportunities for creative photography. As long as you work around problems such as lens flare, backlight can add an exciting dance of light to any child photo. There are times, in fact, when a bright background is not only acceptable but actually required. If you don't care about the details of your subject and would rather get a silhouette, for example, a bright background is essential. Silhouettes are wonderful when your primary goal is to capture the shape or outline of the subject. To create a silhouette, you need to lock your exposure so that it accurately captures the bright background.

TIP

When photographing silhouettes, aim to catch moments when the subject is clear and easy to differentiate from the surroundings. If your subject gets too close or touches other objects, it will appear to merge with the other foreground elements. Your goal is to make a photo with a shape that is easy to distinguish.

Exposure for Silhouettes

When metering your exposure for a backlit portrait, where the objective is to see visible detail in your subject, you take your reading from the subject itself and use the flash or a reflector to brighten up the subject. When creating a silhouette, take an exposure reading by filling your viewfinder with the background sky just above and to the side of your subject and then pressing down the shutter button halfway. Lock exposure on this bright sky area to render it perfectly and have your subject rendered as a dark shape.

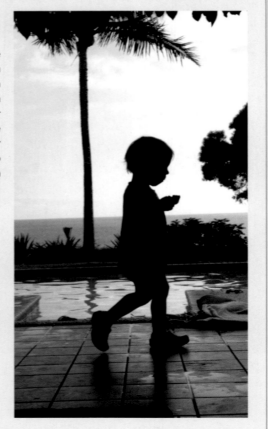

My wife captured this silhouette of our son by first exposing for the background. When he walked by, she was able to capture an image that keeps the color of the background while rendering our son as a simple, clearly defined shape.
PHOTO © DENISE MIOTKE. LEICA D-LUX 3, 1/400 SEC AT ƒ/6.3 ISO 100, 28–112MM LENS AT 65MM

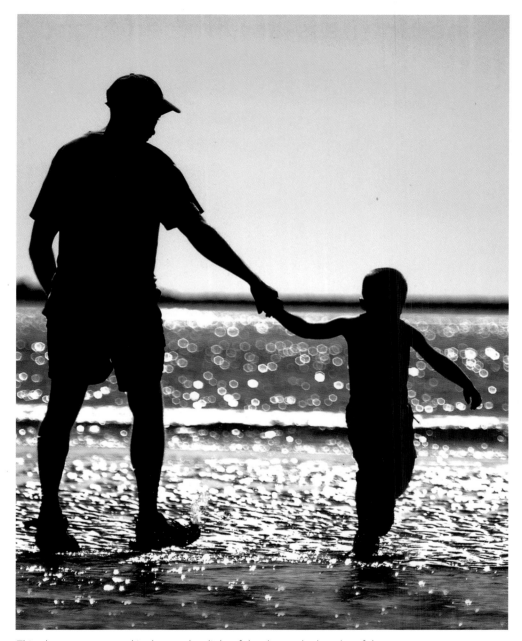

This photo was captured in the very last light of the day on the last day of the photographer's summer vacation at the beach. "Before we pile in the car for the ride home," says Cheryl, "we always say one last goodbye." It's fortunate she made use of this last light to create such a compelling silhouette. The sky in the image was warmed with a software filter in Photoshop.

PHOTO © CHERYL STEINHOFF. NIKON D70, 1/800 SEC AT ƒ/5.6, ISO 200, 70–300MM LENS AT 300MM

The Softness of Diffused Light

ONE CAN EASILY BE INCLINED to shoot in bright sunlight all the time because it's fun to be out in such nice weather conditions and because conventional wisdom says bright light is the best kind of light for photography. However, direct sunlight, especially during the middle portion of the day, can be difficult to deal with photographically. The child may squint—hiding his or her lovely eyes—and the light may be too harsh and unflattering to your subject.

Jennifer Short captured this image using natural light just under a porch overhang.
PHOTO © JENNIFER B. SHORT. CANON 5D, 1/100 SEC AT ƒ/5, ISO 100, 65MM LENS

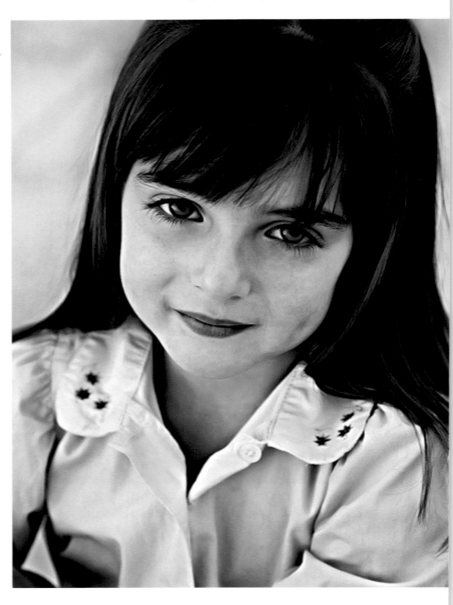

KID QUOTE

Grandpa shows an old photo of himself and Daddy to Julian and asks him who is in the picture. Julian answers, "You and Dada. I recognized your shoes."

Contrary to what we are led to believe, an overcast day is often the very best, most flattering light in which to photograph people. This kind of day, along with a few other light situations, allows you to photograph your subject in soft, diffused light. Diffused light is simply direct light that has been bent and sent off in many different directions. In diffused light, we can get soft, even colors as well as wonderful, peaceful expressions. On a sunny day, diffused light can most easily be found in open shade. On an overcast day, you can find diffused light everywhere.

OPEN SHADE

You can make use of open shade by placing your subjects anyplace where they are not being hit with direct sunlight. Here are a few such locations:

- ❑ Under trees
- ❑ Under a porch awning
- ❑ In a meadow or opening near a forest
- ❑ Close to tall buildings
- ❑ Under a beach umbrella

TIP

When photographing in open shade, be careful to avoid dappled or mottled light. Such uneven lighting may appear acceptable when viewing the scene with the naked eye, but it will render in your final photo with greater contrast. The pattern of light that appears can distract from the overall impact of the photo.

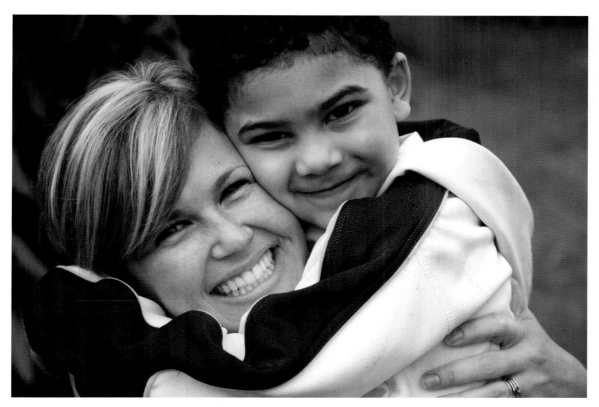

I captured this embrace under the diffused light of a bright overcast day.
PHOTO © JIM MIOTKE, CANON 5D, 1/60 SEC AT ƒ/5.6 ISO 200, 28–135MM LENS AT 135MM

BRIGHT OVERCAST DAYS

Photographing on days when there is no direct sun, you get the benefits of open shade without having to worry as much about location. You get diffused light everywhere, and this frees you up to select location according to compositional elements (which we will explore in the next chapter) or according to the activities the child finds most appealing.

One important note about photographing on an overcast day: If the overcast sky is too dark, the light will appear dull and lifeless. Before you head out into an overcast day to make child portraits, gauge the brightness of the overcast light. If it's too dull and dark, postpone your shoot or photograph your child in your home studio, if you have one.

SLOWER SHUTTER SPEEDS

One problem with photographing in diffused light is that your shutter speed can get quite slow. When photographing a fast-moving subject like a child in open shade or on an overcast day, you may need to increase the ISO setting in your digital camera to keep your shutter speed as fast as it can go. This is an easy fix, and if you're unfamiliar with changing your ISO on the fly, you'll love getting to know this important control. You will find it helps you in many situations, and the number of sharp pictures you get will dramatically increase. We'll discuss ISO and exposure more in chapter 3.

Separate the Subject from the Background

You can make your subject stand out from the background by carefully placing her in soft bright light. This works especially well when you can position either your subject or yourself (changing your point of view) to place your subject in front of a dark background. A brightly lit subject, when set against a dark background, will really pop off the page.

Notice how this child photographed against a dark background appears to pop off the page. She is in the soft light of a bright overcast sky with a dark porch behind her.
PHOTO © JIM MIOTKE. CANON 5D, 1/80 SEC AT ƒ/8.5, ISO 3200, 28–135MM LENS AT 80MM

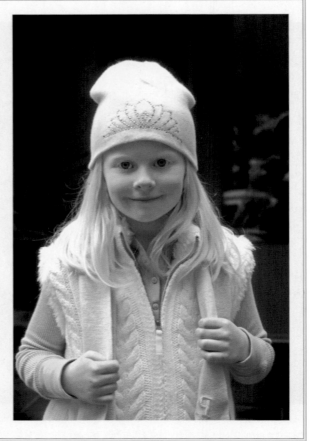

The Color of Light

LIGHT COMES IN A VARIETY of hues. Early in the morning or late in the day, sunlight is usually "warmer," in the photographic sense. Bright overcast days can be a bit "cold," or bluish. The otherwise excellent light of open shade on a clear day has a blue tint to it as well. Such cold colors often need to be corrected. To get a warm-toned light, one excellent time to shoot is in the final hours of the day.

LATE-AFTERNOON SUN

During the last hour or two of the day, sunlight can become soft and beautiful. In the last moments of the day, the light will often become gorgeous, adding a warm glow to your pictures. The late-afternoon light can be golden. As long as the sky is clear, everything becomes bathed in a lovely, golden light. It's a perfect time to take pictures of your kids.

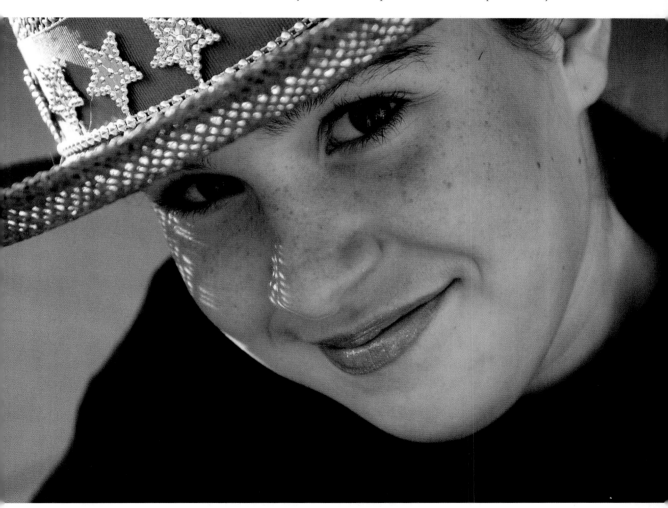

The photographer captured this close-up portrait using outdoor light at sunset.
PHOTO © ANNAMARIE FERGUSON, NIKON D 100, 1/180 SEC AT ƒ/7, ISO 800, 85MM LENS

These two images were captured with the golden light of the sun during the very last moments of daylight, just before the sun dipped below the horizon.

RIGHT: PHOTO © JIM MIOTKE. CANON POWERSHOT G7, 1/50 SEC AT ƒ/2.8, ISO 100, 35–210MM LENS AT 38MM.
BELOW: PHOTO © JIM MIOTKE. CANON 5D, 1/50 SEC AT ƒ/10 ISO 400, 28–135MM LENS AT 100MM

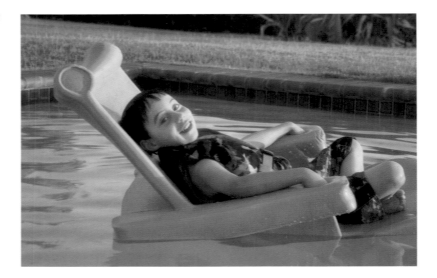

WARMING PHOTOS CREATED IN OPEN SHADE OR OVERCAST

Especially on blue-sky days, the overall color of the light can be cold, or bluish. Warming up this slight blue tint manually in the camera prior to taking the photo can make all the difference. You can correct white balance by using the Cloud or Shade white balance setting on your camera when taking child portraits in open shade.

Inevitably, though, we sometimes forget to set the proper white balance. When this happens, you can warm the image later, using digital image editing software. Furthermore, if you shoot in camera raw, you can adjust the white balance of each image as you import it into Photoshop, with much greater speed and ease than it takes to correct JPEGs using Levels or Curves later in Photoshop.

> **QUICK FIX TIP** The Warming Colors of Red, Magenta, and Yellow
>
> In Photoshop, you can increase the amount of red, magenta, and yellow to lessen cyan, green, and blue, respectively. In Levels or Curves, slightly increasing one, two, or all three of these colors often warms up a cool photo sufficiently.

Otherwise a delightful capture of a fun day, this "before" photo (above) shows that I captured it in open shade on a day with blue sky. It is slightly bluish. Using Photoshop, I was able to warm the image up. To create the "after" version (right), I adjusted the white balance setting in the camera's raw conversion window. With one quick adjustment, the photo lost its bluish cast.

PHOTO © JIM MIOTKE. CANON 20D, 1/60 SEC AT ƒ/5.0, ISO 400, 28–135MM LENS AT 28MM

Using Natural Light Indoors: Window Light

GETTING WINDOW LIGHT to illuminate your subject is another great way to create a beautiful, soft, glowing portrait. In addition to large windows, locations just inside an open garage or house door can provide this wonderful indirect light. The best time to work with window, door, and garage light is in the morning and afternoon, but shooting near a window anytime it is bright outside can provide you with satisfying and beautiful results.

Use window light when the sun is more or less overhead. When the sun is low in the sky and the light would directly hit your subject, use something to diffuse the light. Diffusion can be done with light drapes, opaque shower curtains, or professional diffusion devices available at pro camera stores.

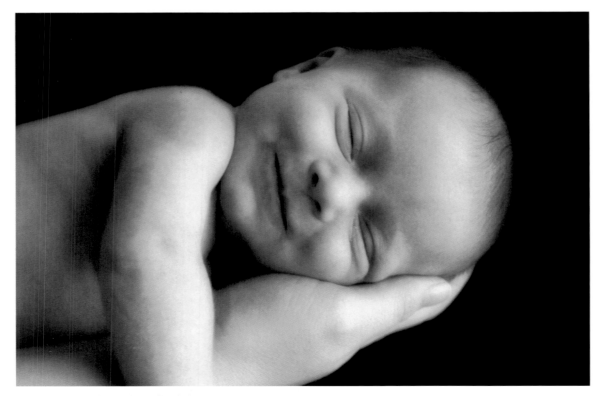

This photo was taken with window light in the parents' home and a black cloth as backdrop, which the photographer rigged to stay up. Part of it was draped over the mother's body as she was holding the baby.
PHOTO © ERINN ALOI. CANON 10D, 1/60 SEC AT f/5.6, ISO 200, 80MM LENS

TIP
When photographing babies, drape a cloth backdrop over the mother as she holds the baby to simplify the background. Your setup doesn't need to be fancy to get wonderful results!

TIP

One key is to position yourself so as to not have the light source in the background of your composition. A bright sky in the background pulls the viewer's eye away from your subject. If possible, use a point of view that allows you to make the most of indirect light without including the light source in the background.

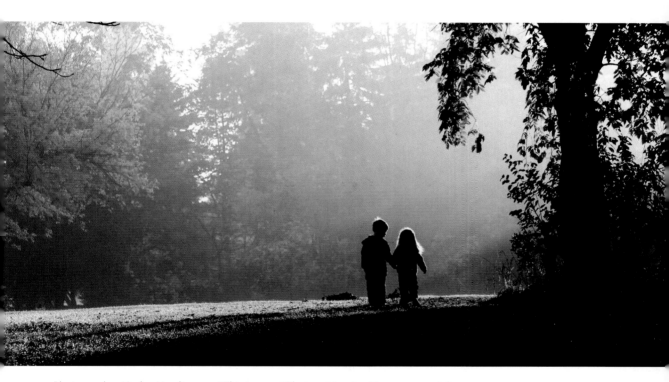

Photographer Hayley Hamlin says, "This image, 'Glorious Morning,' is a very special photo to me. I woke up one day and noticed in the field behind our house a glorious fog with the sun beaming through it. I knew it was lifting fast and time was of the essence, so I quickly got my kids dressed and rushed out the door. I let them lead the way and, just at the moment when they would appear silhouetted against the beautiful fog and light I snapped away. Afterward, I cropped the photo to a panoramic composition and added a soft light effect in Photoshop Elements to create more contrast."

PHOTO © HAYLEY HAMLIN. Canon 30D, 1/500 SEC AT ƒ/4 ISO 200, 28–75MM LENS AT 75MM

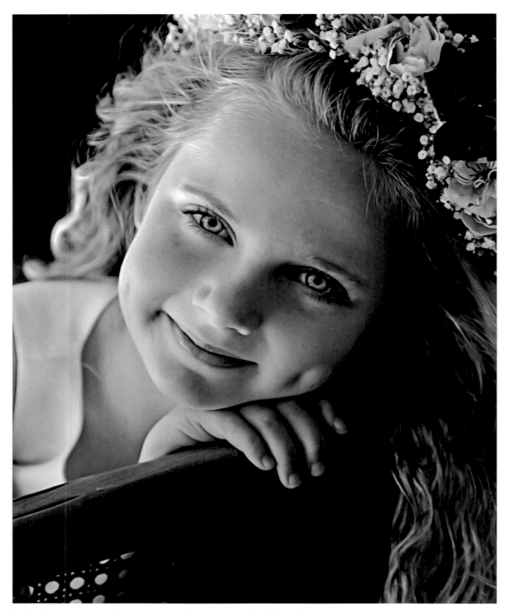

Light that streams in from an open door, such as the light within an open garage, acts like window light. Using natural light in a garage, Jennifer Short created this lovely head-shot. The light is truly soft and wonderful, but there are many other techniques being put to good use here. The styling is not overdone. The hand acts as a great posing element. She held the attention of the child and got great eye contact. Finally, the conversion of this color photo to black-and-white allows the viewer to enjoy the features of the girl without being distracted by color.

PHOTO © JENNIFER B. SHORT. CANON 5D, 1/100 SEC AT ƒ/5, ISO 300, 67MM LENS

Uneven Lighting

IF THE LIGHT IS STRONG, harsh, and directional, it can create problems for the photographer who wants to accurately capture detail in both the highlights (the bright parts of a photo) and the shadows (the dark parts). Problems occur when there is imbalance and the highlights are too bright, the shadows are too dark, or the exposure is thrown off and the overall photo looks milky and gray. Since cameras capture only a limited range of the tones we can distinguish with our eyes, you need to carefully watch for situations with uneven lighting. You need to know what

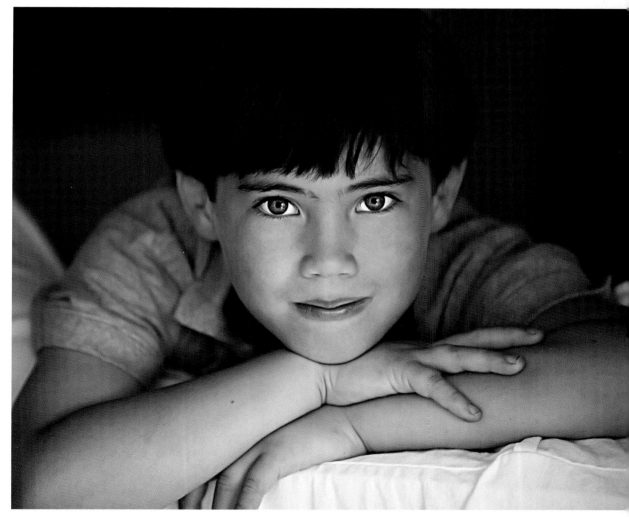

The white foreground acted here as a natural reflector, bouncing light back up into the subject's face.

PHOTO © JENNIFER B. SHORT. CANON 5D, 1/100 SEC AT ƒ/2.8, ISO 100, 195MM LENS

signs to look for and how to counteract these potential problems. Fortunately, identifying the situation is 90 percent of the battle. Once you've noticed the unevenness of the light, all you have to do is brighten the shadows and/or tone down the highlights to create a lovely, well-lit portrait. There are two primary ways to do this: with flash or with a device that reflects light into the shadows. As we will be discussing flash later in this chapter, let's first learn how we can balance natural light by employing a reflector.

BOUNCING LIGHT TO FILL SHADOWS

When you notice that you have too much light on one side of your subject and dark shadows on the other side, you can remedy this by placing a reflecting device in front of the shadowy side of your subject. Positioning it so that it bounces light back onto the darker side of your subject allows you to balance the bright highlights with the darker shadows without mixing light sources or resorting to flash. You can use something as simple as a piece of white foam core—the kind you can get at any crafts store—as your reflector, or you can purchase specialized reflectors from a professional camera store. You will need an assistant or a stand to hold it while you create the photos, always watching to make sure that the shadows are being filled in with just the right amount of light.

PLACE REFLECTORS ABOVE YOUR SUBJECT FOR A MORE NATURAL LOOK.

I use a combination 6-in-1 reflector and diffuser kit. This gives me one tool that I can use for both bouncing light into the shadows and diffusing light that is too harsh. Combined with a stand, I can position the reflector or diffuser in just the right spot, even if I do not happen to have an assistant.

The War on Clutter

TO KEEP YOUR NATURALLY LIT indoor portraits looking like professional portraits rather than like mere snapshots, you must eliminate clutter from the background. There are three ways to do this. Combine all three and you'll have a portrait that allows the viewer to focus on your subject without being distracted by the background.

❑ Use a shallow depth of field (more on this in chapter 3).

❑ Use a long focal length (100mm) and shoot from at least six feet away from the child.

❑ Use a simple backdrop.

We will talk more about depth of field and long focal lengths in subsequent chapters. For now, we can concentrate on the last of these three techniques. It is the easiest and quickest way to eliminate distractions.

One of the pitfalls of shooting indoors using natural light is the fact that, without proper planning, you will be stuck with whatever background surrounds the area where you do the shoot, and chances are it won't enhance your portrait. But you can solve this problem by setting up your own backdrop.

You don't need to purchase an expensive professional backdrop. You can start with nothing more than large seamless paper (found at most pro camera stores) or plain fabric such as a white sheet. Position your backdrop next to a bright window or a door, where you see a great amount of light coming in. Attach it to the wall or drape it over a couple of ladders. This method takes more trial and error than a professional backdrop system, but it will save you money. Using natural light and a reflector against such a clean background will immediately do wonders for your kid photography and in the most economical way.

So far, you have learned how to work with natural light and have come to understand how direction and diffusion affect your photographic results. However, sometimes the weather or other circumstance keeps you from being able to photograph with that natural light.

ASSIGNMENT **Make the Most of Natural Light**

Using a reflector, an assistant, and light just inside a window or garage door, create a collection of naturally lit child portraits. If photographing an infant, drape a makeshift backdrop or black cloth over the mother and have her hold the baby. If photographing a toddler or an older child, set everything up first and then invite them in to sit or lean on a chair. In either case, use a reflector (employing your assistant). Have him or her slowly move and tilt the reflector until you see the shadows being brightened in a convincing, natural way. Alternatively, try shooting during the last few minutes of daylight, right at sunset. If the weather is clear and beautiful, use this late-day light to produce portraits with a golden glow.

Using Your Flash

IF YOU ARE CONCERNED about the shadows on one side of the face, you can use flash to fill in those shadows and produce a more even-toned portrait. Flash is one way to even things out when you see shadows or mottled light. However, flash can often produce flat, unflattering light. Just as often, it blasts your subject, making him or her appear to have just seen a ghost. It's often just too powerful. That's why I prefer instead to use a reflector whenever possible. Let's explore the difference between using your flash and bouncing natural light.

Another nice benefit of using fill flash is that it will produce nice catchlights in the eyes.

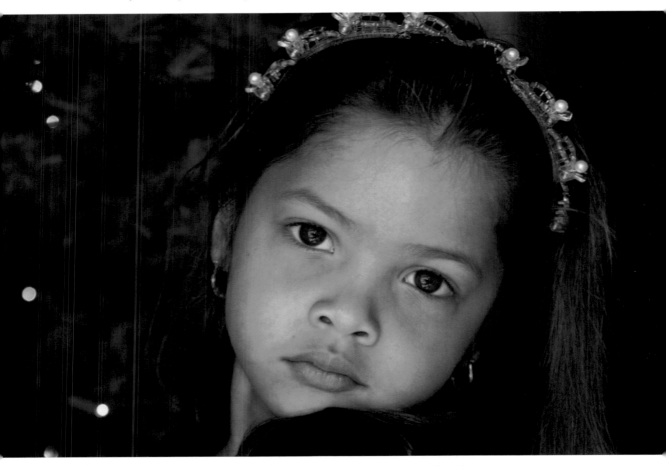

For this lovely close-up portrait, photographer Donna Cuic positioned her subject beside a sliding glass door in front of a Christmas tree and used a fill flash along with a gold reflector to bounce warm light into her subject. Note also how the head is tilted. Looking over the shoulder can be a great pose because it naturally creates an eye-catching diagonal line in the composition.

PHOTO © DONNA CUIC. CANON 10D, 1/25 SEC AT ƒ/5.6, ISO 100, 24–85MM LENS

CATCHLIGHTS

Often you might feel that something is missing from your child portrait. You can't quite put your finger on it, but the photo just doesn't sparkle. Often this is caused by the fact that the eyes are too dark—they reflect no light. Using a flash, you can add a tiny spark of light—a catchlight—that adds all this life to your portrait. Catchlights are small reflections of the light source in the eyes of your subject that provide a sense of life. Using a flash, strobe, or reflector, you can work to get that extra little sparkle in your subject's eyes.

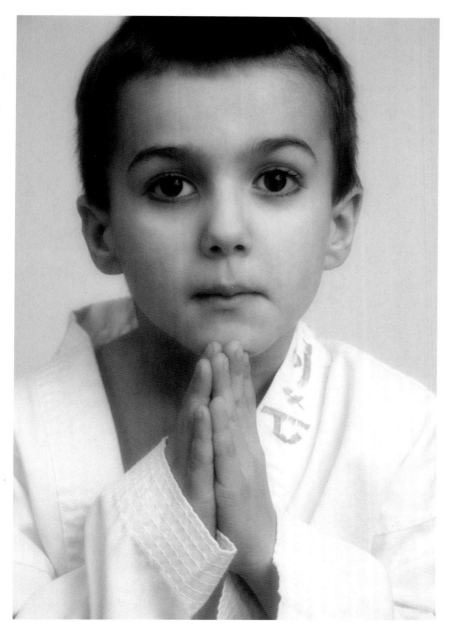

Note the catchlights in this close-up portrait of a praying boy in his karate uniform. A slight blur was added via Photoshop to create a soft-ening effect to the portrait.
PHOTO © JIM MIOTKE. CANON 5D, 1/125 SEC AT ƒ/10, ISO 100, 28–135MM LENS AT 117MM

For this series of pictures, my son Julian modeled indoors one evening while I tried a variety of sources of light. They illustrate the different effects you get in a low-light situation with a variety of solutions. For the first image (top, right), no steps were taken to correct the situation. The low light forced my shutter speed to be extremely slow, causing a combination of motion blur and camera shake. For the second photo (top, opposite page), I increased ISO (which we will learn more about in chapter 3). This allowed me to do a better job of stopping the action, but the shutter speed was still too slow. What's more, the high ISO caused the photo to have a less-than-pleasing texture, called noise. Also, the shutter speed is still somewhat slow, so the resulting image is still a bit "soft," or slightly blurry. I used my on-camera flash for the third picture (bottom, right) but felt this was too harsh: Notice the sharp shadow on the wall in the background. I then attached my external accessory flash and redirected the flash, aiming the light at the ceiling. This caused softer light to bounce all around my subject and resulted in one of my favorite images of my son (bottom, opposite page).

TOP LEFT: PHOTO © JIM MIOTKE. CANON 5D, 4 SECONDS AT *f*/4, ISO 100, 28–135MM LENS AT 47MM. TOP RIGHT: PHOTO © JIM MIOTKE. CANON 5D, 1/6 SEC AT *f*/5, ISO 3200, 28–135MM LENS AT 65MM. BOTTOM LEFT: PHOTO © JIM MIOTKE. CANON 5D, 1/60 SEC AT *f*/4, ISO 100, 28–135MM LENS AT 38MM. BOTTOM RIGHT: PHOTO © JIM MIOTKE. CANON 5D, 1/60 SEC AT *f*/4, ISO 100, 28–135MM LENS AT 41MM

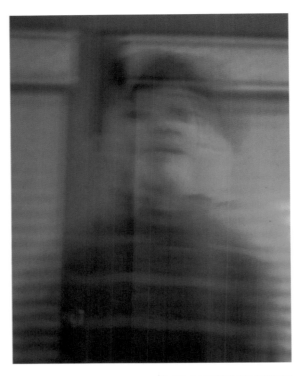

TIP

Avoid reflective surfaces in the background, especially when using flash. An unexpected image of the photographer or a bright starburst of light can show up in your photo if you are not careful.

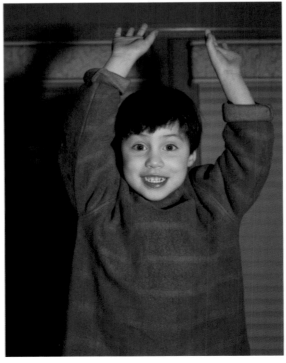

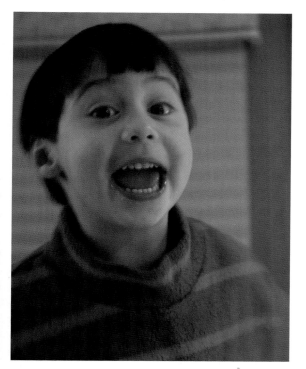

Sophisticated Flash

If you can easily see yourself growing as a photographer and developing your hobby over the years, you might want to look into a camera that has a port for an external flash, called a "hot shoe." This will give you the ability to put on an external accessory flash for more creative control. These external flashes are more powerful, allowing you to light subjects that are farther away. Also, they are often flexible, so you can redirect the flash to bounce it off of a wall or ceiling. An external flash with Through-The-Lens technology (TTL) can be of great help, as it can simplify the job of calculating a proper exposure when using flash.

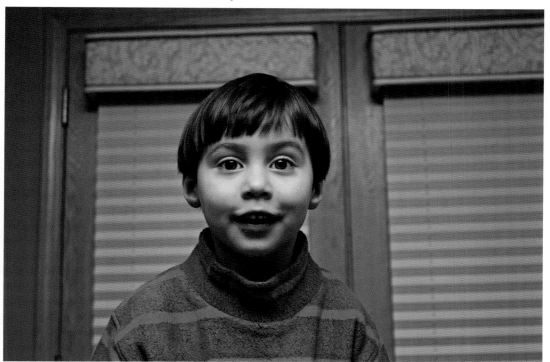

ON-CAMERA FLASH OFTEN PRO-DUCES POOR RESULTS

There is good flash and there is bad flash. I have found few on-camera flash units to provide satisfactory results. The problems with on-camera flash are these:

❏ It often leaves a strong shadow behind the subject.

❏ The subject's skin tones will often be too white.

❏ The subject's eyes will often reflect the flash, an effect known as red-eye.

AVOIDING RED-EYE

Red-eye is caused when light coming from your flash reflects off of the back of your subject's eyes, bouncing right back into the lens. In low light conditions, such as indoors at night, the pupils dilate and create a larger opening for light to enter the subject eyes. The burst of light comes at the eye so quickly the pupil doesn't have time to contract. There are three things you can do to minimize red-eye:

1 Minimize the dilation of the eye by flooding more continuous light into the area before you shoot. This is why some cameras flicker or issue a "pre-flash" before taking the picture.

2 Move the flash away from the lens of your camera, creating a wider angle and causing the flash to miss the lens when it bounces off the back of your subject's eyes.

3 Remove the effects of red-eye with digital image editing software. Programs like Adobe Photoshop Elements offer a red-eye removal function that can work quite well.

If you can illuminate your subject with natural light, or move the flash unit farther away from your camera, you'll get much better results than when using on-camera flash. One way to move the flash away from your camera is to use an external accessory flash unit—the kind that plugs into the *hot shoe* port on most professional-quality cameras.

EXTERNAL ACCESSORY FLASHES

Using an external flash unit instead of the on-camera flash will usually produce much better results. They provide greater power and more creative controls. With an accessory flash that swivels up and down and/or left and right, you can bounce the flash off a ceiling or wall to give your photo soft and even illumination.

TIP

If you use an external flash, use an off-camera shoe cord so you can move the flash off to the side. This requires a stand or an assistant, but, when the light is coming from a higher place off to the left or right of the camera, the results can look much more realistic.

Benefits of Studio Lighting

SETTING UP A STUDIO—even a small studio in your home or garage—takes money and a bit of courage. To expand one's horizons and try a new thing . . . that is no small feat. What's more, with cords, power, strobes, stands, umbrellas, etc., it can feel intimidating because it is so technical. The truth is that there is nothing to fear.

Photographing in the studio, you will find that you gain:

❑ Complete control over the light

❑ A variety of looks with the use of different backdrops and props

❑ The possibility to shoot what you want, when you want

The beauty of studio light is that you can control it and create beautiful child portraits at any time, regardless of the weather.

Whether you're shooting in a studio, in your living room, or out in the garden, you can use studio lights to sculpt the light and make masterful portraits of your kids. The following tips will help you regardless of where you set up your studio.

BASIC RULES FOR THE STUDIO

Over the years, I have learned to live by certain rules when working in the studio. I learned most of these from trial and error. You can save yourself a lot of time and benefit from my experiences. With these guidelines in mind, you can start shooting successfully in the studio right from the start.

1 Turn off the overhead lights. If you don't, you will likely see colorful hues in the shadows.

2 Select each shot more carefully than you would when shooting in natural light outdoors. The studio strobes need to recycle. You don't want to waste your strobe power on a dull moment or uninteresting expression, only to miss the great moment while your strobe is recharging.

3 Position your subject far from the backdrop. Six feet is a nice distance and will usually allow you to capture a sharp subject without allowing the backdrop to be rendered so sharp that it's distracting. Also, positioning your model far from the background will minimize eye-catching shadows behind your subject.

4 Watch your edges, making sure the area behind your backdrop is not showing up along the edge of the frame.

5 Use softboxes or umbrellas to diffuse the light. Place this softened light source close to your subject. Distance defeats the purpose of using a softbox (an accessory in which you place your light to diffuse the light it emits).

6 Don't have your model face the light. Instead, place the light so she faces away from the light a bit when looking into the camera.

7 Keep it simple. Especially when photographing kids, the key to success is to work quickly and keep things as technically easy as possible. Often it will be challenging enough just to keep them on the backdrop. I recommend using one light in a large softbox and a reflector, or at most two lights.

STROBES VERSUS CONTINUOUS LIGHTING

Most portrait photographers use strobes, but some photographers prefer to start with continuous lights (also called "hot lights" or "flood lights"). Strobes provide a momentary burst of light, just like your flash. The main difference is that they are much more powerful and offer greatly flexibility when lighting your subjects.

This was Jennifer's very first attempt at a studio shot. Quite nice! She says, "I was using blazing hot lights in my home studio in my living room. My backdrop was hung from a PVC pipe held up with bicycle hooks. Trying to contain and entertain a thirteen-month-old can be very difficult. When our son started getting fussy, I had my husband put him on his shoulders. This shot looks posed when in fact it is quite candid. I find my favorite shots end up being ones that are candid. I never put my camera down, even when the child is taking a break. Some of my best shots have happened during those breaks."
PHOTO © JENNIFER RALSTON. 1/200 SEC AT f/2.5, ISO 100, 50MM LENS

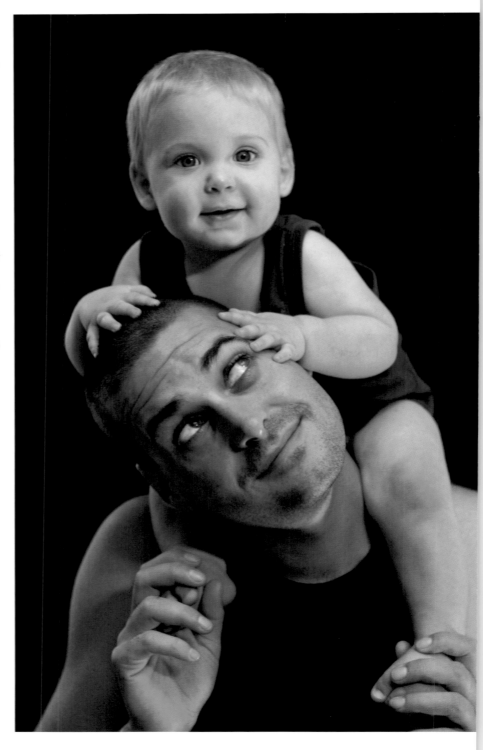



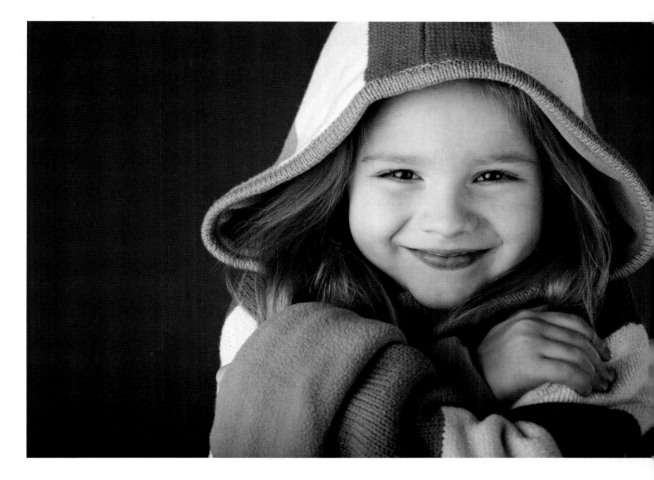

Continuous Lighting

Continuous lights are popular among beginning studio photographers because they are less expensive and are easy to find at most hardware stores. They can also have a beautiful, smoky quality.

The drawbacks of continuous lights are that they are on all the time, and this causes the studio to get hot. They're good for people starting out on a very tight budget, but, because the heat will cause your subjects to be uncomfortable, I do not recommend using them when photographing people. They're great for nonliving subjects (product photography, for example) but not for people, animals, flowers, or ice cream.

This charming portrait was captured with an Alien Bee 1600-watt light with a large softbox to the left of the camera and a large circular reflector to the right of the camera to fill in the shadows.

PHOTO © KIMBERLY J. WHIPPS. CANON 5D, 1/ 200 SEC AT *f*/8, ISO 100, 24–70MM LENS AT 70MM

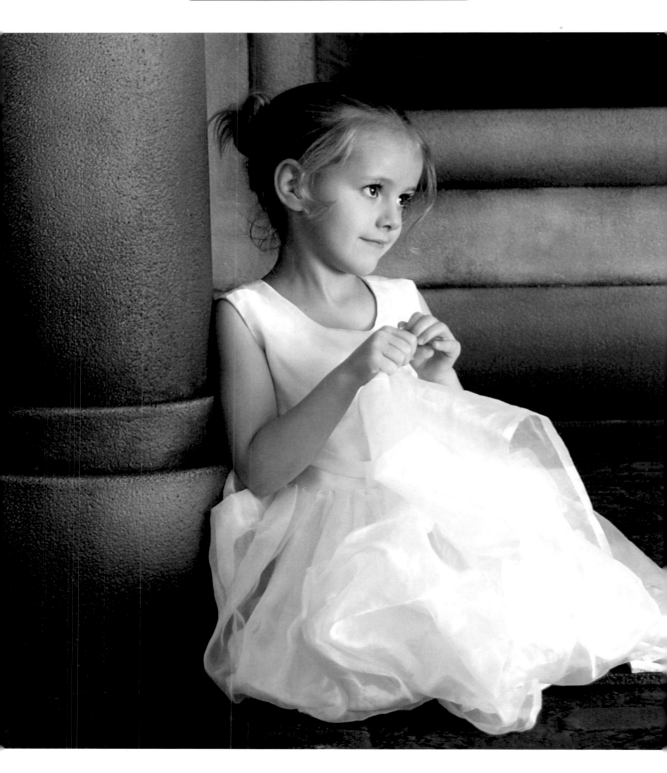

This portrait was created with one strobe to the right of the subject in a studio lighting environment. The image was later converted to black and white using Photoshop. Photographer Susana Heide writes, "I was doing a lighting test with my daughter in preparation for a session with a little flower girl the next day. I'd spent very little time getting her ready, maybe ten minutes to quickly put up her hair. I needed her to slip on a white dress, which is what the flower girl would be wearing. I didn't anticipate keeping any of the photos from this test session. But when she started giving me the sweetest poses and expressions, I knew right away that I would end up loving them! I attribute her relaxed pose to the fact that her mom was relaxed, too."

PHOTO © SUSANA HEIDE. CANON 1D Mark II, 1/100 SEC AT f/6.3, ISO 250, 28–70MM LENS AT 70MM

Strobes

Strobe lights are more expensive than continuous lights, but they stay cool. They are more powerful, allowing you to wrap light around your subject. Strobes are balanced for the daylight white balance so you can use the Daylight white balance setting in your camera. Lastly, they are easy to control and work with, making it so you can spend less time fussing with the lights and more time interacting with the kids.

Because strobe lights are more powerful and easier to control than continuous lights, you will likely find it easier to illuminate your subject with diffuse light that wraps softly around the form of your subject.

A light meter and an umbrella are two tools you will need, along with your lights and backdrop, to produce outstanding studio photos.

For most kid photographers, I recommend saving up your money to buy an entry-level strobe package. Two lights are nice, but all you really need is one light to get going.

OTHER STUFF YOU WILL NEED

To complete your studio setup, in addition to lights, you will need the following:

❏ A backdrop and a way to hold it up

❏ Stands to hold backdrops, lights, and perhaps a reflector

❏ A softbox or umbrella or other light-softening device

❏ A handheld flash light meter

❏ A hot-shoe-to-PC-port adapter (see photo on page 127)

WHERE TO GET IT ALL

Try your local professional photo store or your favorite online retailer to see which gives you the best combination of service and price. Many offer great packages for beginners. I started with a package by Photogenic and never regretted it. To possibly get a good deal on studio lighting equipment, you can shop for used equipment at swap meets or on eBay. If you're willing to research, take your time, and be less selective about what brand you get, you can end up with a great studio lighting system at a minimum of cost.

HOW TO SET UP STUDIO LIGHTS

Many people agonize over the placement of their studio lights. It need not be frightening. The basic starting setup for a typical studio looks like this:

Place the main light at a 45-degree angle to the axis going from your camera to your subject. If you rotate the subject so his or her feet and body point toward your left, place the main light to your right. (As we will discuss later, though, younger kids in particular are not likely to let you have

The key with studio lighting is to simply experiment, always watching the light on your subject. But these two simple studio lighting setups will give you a good place to start.

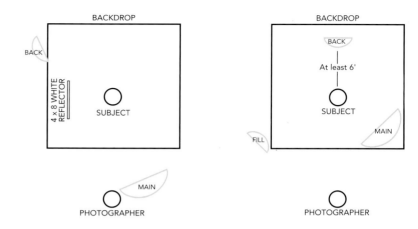

much of a say in how they stand.) Place the light as close as possible to the subject; just make sure it's not showing in the frame. Try photographing with just one large softbox. If the shadows on the dark side of the face bother you, brighten them up by positioning a reflector on the side opposite your main light. Use an assistant or stand to hold the reflector at a medium to high height. Don't place the light or the reflector lower than the face of your subject, as this will create an unnatural effect.

THE PROCESS

Once you have a basic setup in mind, one popular process goes like this:

1 Set up the backdrop, lights, and camera on tripod.

2 If using more than one light, set the second light to the slave mode so it fires automatically when the other fires.

3 Plug the other end of the PC cord that goes to your main studio light into a flash light meter.

4 Set the ISO of your flash light meter to 100 and the shutter speed to 1/125.

5 Press the button on the flash meter to cause the strobe to fire. When it does, you will get an aperture reading. (More on ISO and aperture in chapter 3.)

6 Set your camera to the "M" manual exposure mode and dial in 1/125 and the *f*-stop number the flash meter indicated.

7 Attach a hot-shoe-to-PC-cord adapter to the hot shoe of your camera and plug the PC cord into the hot-shoe adapter.

8 Take a test picture.

9 Review the LCD to make sure the exposure looks good. Change your settings if the exposure looks too bright or too dark.

10 Make any final adjustments to light intensity and position, if desired. If you make changes, take another reading and ensure your exposure is optimal.

11 Invite the child into the set, play a bit until he or she is comfortable, and, if everything seems to be going well, start making pictures.

How to Make a Portrait Radiate and Glow

TO GET THAT BEAUTIFUL SOFT GLOW that you often see in professional portraiture, you need to do a number of things:

❑ Use shallow depth of field. (See chapter 3.)

❑ Illuminate your subject with a softbox, bright overcast sky, or other diffused light.

❑ Use Photoshop filters after the fact to slightly sharpen your subject and slightly blur the background. Additionally, there are a number of other functions of Photoshop that you can take advantage of in order to brighten up your subject and darken the edges or background. Feel free to experiment.

A Home Studio Helps You Gain Cooperation

Here's another reason to avoid going to a formal studio and instead purchase your own studio lights: A professional studio can be a foreign and frightening environment to a young one. When you set up your own inexpensive studio, your children can get accustomed to it as you "play" and shoot in your studio over several occasions. In this way, they will feel safer, more relaxed, and therefore more cooperative.

ASSIGNMENT Studio Lighting

Set up a home studio and do your first photo shoot using controlled lighting. If you cannot afford lights at this time, start with a simple backdrop and a white foam core reflector, using natural light or continuous lights. If you can get your hands on a strobe or two, set up a simple studio layout such as one light to the left and a reflector to the right. Be sure to set up the entire studio before inviting your child. If your child is likely to get frightened or shy of the new environment, bring in several well-loved toys or other favorite stuffed animals. Surround the child with these familiar objects so he or she feels safe and comfortable. If you have a highly spirited child, make a game of the event; these kids love to dance and sing whether they are in front of a camera or not.

Create a Series, Collage, or Storybook

Try framing different portraits together to tell a larger, more encompassing story about the child. This is a perfect solution when just one portrait isn't going to tell the whole story. This gives the viewer the experience of knowing how the child acted throughout the entire shooting session. In addition to telling the story of an individual child, you can use a series or collage or storybook to express the relationship between two or more kids together, showing how they interact. Then do the same with each parent with the child and then one of the entire family together. As you can see, the possibilities are endless, limited only by the amount of time you can spend photographing your family.

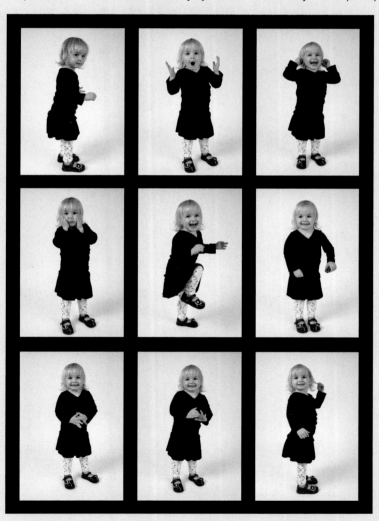

One morning, I photographed our daughter Alina in her new black dress. While my wife dressed her, I set up my home studio. This series of photos depicts the wide variety of her expressions and natural poses.
PHOTO © JIM MIOTKE. CANON 5D, 1/125 SEC AT ƒ/11 ISO 100, 28–135MM LENS AT 50MM

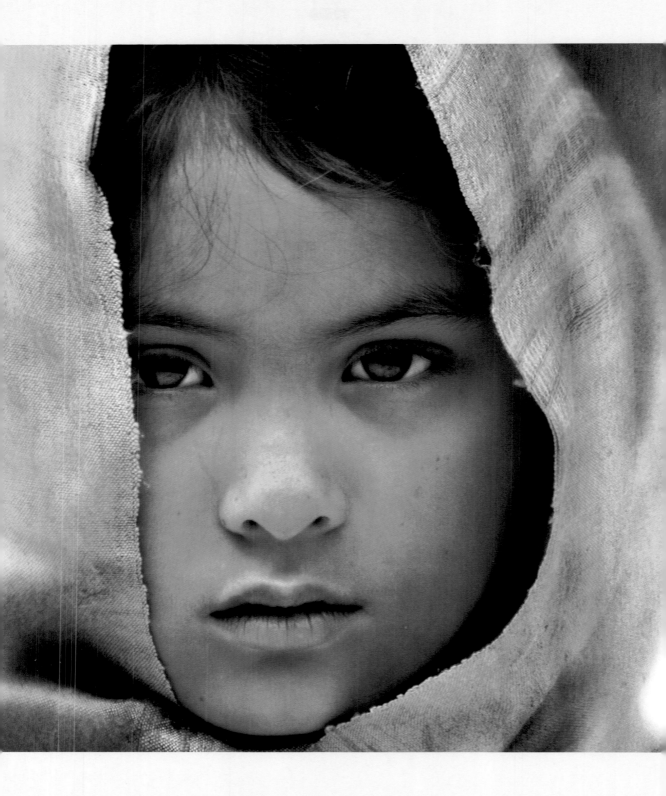

Composition

COMPOSITION IS ALL ABOUT how things are arranged and organized in your photo. You have great control over what gets included and what gets excluded, as well as the positioning of your subject in relationship to the other elements in the photo. The choices you make about what to include and where to position it greatly affects the overall success of your photo. Of course, the first trick is to make sure your subject is entirely in the picture rather than just partly in the frame as he or she darts away! To simply capture the moving child in the picture, you need to shoot a lot and use a fast shutter speed. However, good composition goes far beyond simply catching the subject. When you follow the rules relayed in this chapter, you'll get masterfully balanced child photos with subjects captured within the frame and placed in a way that results in a photo with an emotional effect on the viewer.

The photographer was captivated by the girl's eyes and wanted to make sure they stood out in the photo. Even though the background was already blurred with a shallow depth of field, Anna added additional Gaussian Blur and texture in Photoshop so that the scarf around her head and background would be more subdued and artistic. She erased the effect of the Photoshop texture from her face so her skin color looked natural. The picture was taken on a slightly overcast day, and the bright sidewalk acted as a reflector to bounce some light in her eyes. Placing those eyes to the right brought this beautiful image to completion by utilizing the "rule of thirds" for a lovely composition.
PHOTO © ANNA DIEDERICH. CANON 30D, 1/640 SEC AT ƒ/3.5, ISO 100, 180MM LENS

Getting Closer

IF YOUR PICTURES LACK IMPACT, the problem most likely has to do with composition. What's more, the problem is likely related to one particular aspect of composition: your proximity to the subject. If your subject is too far from the camera, this will cause the center of interest—whether eyes, face, or entire body—to appear too small in the picture. Most beginning photographers attempt to include everything in the photo in an effort to keep from missing some important detail. What's more, the viewfinder often seems to trick us into thinking we are closer to our subject than we really are. Don't believe it. The easiest and quickest way to give your viewer something that stops him in his tracks is to simply move in closer, even when you think you're already close enough.

If you're having a problem with your photos, more likely all you need to do is get closer to your subject (or zoom in) to make him or her larger in

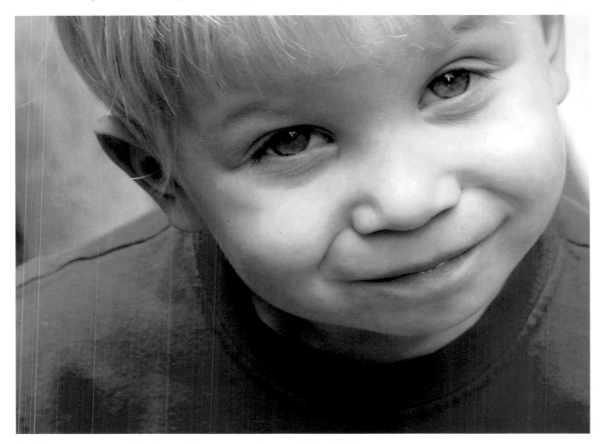

For this image, I zoomed in close with my compact camera, filling the frame with my subject. This makes it easier for the viewer to see the eyes and appreciate the child's expression.

PHOTO © JIM MIOTKE. CANON POWERSHOT G7, 1/100 SEC AT ƒ/4.5, 35–210MM LENS AT 160MM

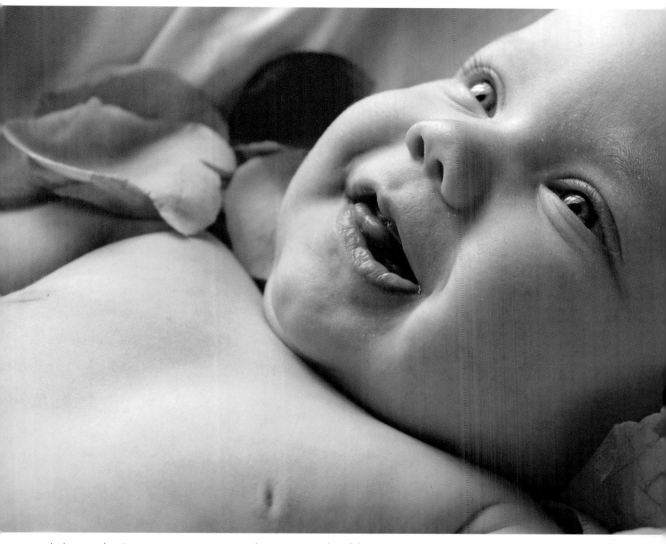

As long as the viewer sees engagement and emotion, it's okay if the eye contact is not directly with the camera lens. Look at this peaceful baby smiling at her mother (who also happened to be the photographer). The photographer's objective was to get a good close-up of her facial features. She placed the camera off to the side and made eye contact with her baby. She used natural light from a nearby window to illuminate the child and flower petals to frame her face. Most important, she achieved her objective of getting close to the subject. Imagine how much less emotional connection we would feel if we also saw the headboard, the wall, a lamp, a side table, and the like. This close-up composition, on the other hand, delivers the "wow" factor with great success.

PHOTO © KAREN R.KESSINGER. NIKON D50, 1/50 SEC AT ƒ/4.5, ISO 100, 50MM LENS

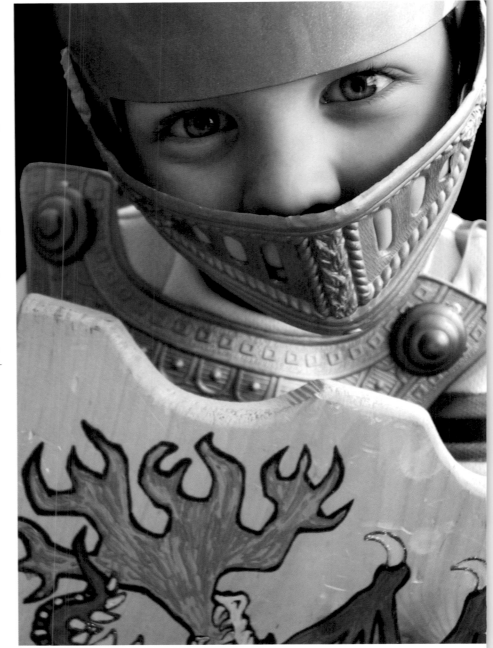

Is there any doubt about the subject of this photo? Photographer Christina Bowker did an excellent job of getting very close to her subject, or, more accurately, letting her subject get close to her. She explains, "Ricky was very persistent in that he really wanted his picture taken. I was actually lying on the couch and he brought my camera to me. He was at that age where he was always pretending, always wearing costumes around no matter where we went. He would say things like, 'Don't worry, Mommy. I'm not really a knight. It's just me, Ricky.'" In addition to filling the frame with her subject, Christina also captured a moment in which his body is bending into a dynamic, eye-catching pose. By stripping out the color later in Photoshop, she made this image even more complete and satisfying; the costume, which was colorful, here looks even more like a true knight's armor.

PHOTO © CHRISTINA BOWKER. CANON POWERSHOT G1, 1/320 SEC AT ƒ/2, ISO 800, 34–102MM LENS AT 34MM

the composition. Fight that urge to show the entire scene. You don't need to capture every detail or demonstrate what a wide-angle lens can do. Your most important job is to make your subject big, so your audience has no doubt as to the subject of your photo.

To get close and create photos with this "wow" effect, you first have to think. Look at your scene and decide what is most important. If you're photographing your child, perhaps you want to focus all of the viewer's attention on her eyes or her smile. Show this central subject. After all, how can we expect a viewer to enjoy that smile if it's just a tiny dot in that wide-angle scene with the Grand Canyon in the background? Instead of trying to capture everything you see, find the central subject and make this subject take up as much photo "real estate" as possible. The best photos result when the photographer first identifies her specific subject and then focuses on that one central subject excluding everything else. If your subject is your child's face, try to get as close to your child's face as possible. If you find, when shooting children on the go, that you miss part of the subject, then simply move back or zoom out and include more of the scene.

To capture this image, I got down on my son's level and went in very close to him with a wide-angle lens. This allowed me to get a tight composition of just his face and his favorite stuffed animal.

PHOTO © JIM MIOTKE. CANON 10D, 1/180 SEC AT ƒ/6.7, ISO 100, 16–35MM LENS AT 27MM

These two photos both capture my son's expression of delight when we started to get rained upon while traveling in England. The photos also illustrate the value of getting closer to our subjects. As photographers, we strive to get closer not only to increase the size of the subject in relation to the overall scene but also to eliminate distractions. Notice the many things in the background of the first photo that try to call the viewer away from the subject. By moving in closer, my wife eliminated the distractions, making it easy for the viewer to fully appreciate our son's joy as he felt the light rain on his face.

TOP: PHOTO © DENISE MIOTKE. CANON 10D, 1/125 SEC AT ƒ/5.6, ISO 100, 28–105MM LENS AT 55MM. BOTTOM: PHOTO © DENISE MIOTKE. CANON 5D, 1/180 SEC AT ƒ/4.5, ISO 100, 28–105MM LENS AT 105MM

TIP

Try to have something in mind before you start shooting. Take a few moments to imagine what your ideal photo of your child might be. Do you have an image envisioned? I find that, even though I often have to put aside my preconceived ideas once the shoot begins, it helps tremendously to have an idea of what I would like to photograph before I start.

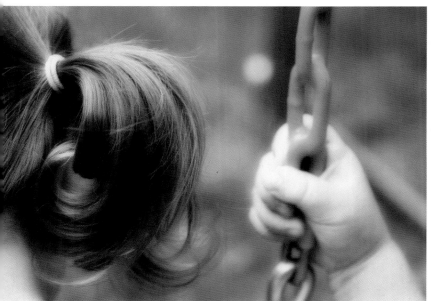

Utilizing the soft natural light of an overcast afternoon, both of these images are delightful. The closer version, though, tells a very different story. For the far image of the girl's face, the photographer used natural light found in open shade, got close enough to the subject for a standard portrait, and elicited perfect eye contact to successfully capture the cuteness of this little girl. She's charming. For the second image, Allison picked one detail—the pigtails—and composed close enough to eliminate everything but the child's hair and hand on the swing. This photo makes fantastic use of the power of only showing one detail and letting the viewer's imagination fill in the rest of the story.

TOP: PHOTO © ALLISON GAULIN. CANON DIGITAL REBEL XT/350D, 1/320 SEC AT ƒ/3.5, ISO 200, 50MM LENS. BOTTOM: PHOTO © ALLISON GAULIN. CANON DIGITAL REBEL XT/350D, 1/160 SEC AT ƒ/3.5, ISO 200, 50MM LENS

On grapefruit: "But where's the grapes, Mommy? Why's it orange, like lemons?"

These images illustrate the fun one can have moving in super-close to a detail. Hands and feet can be delightful to photograph. The final image of the toes peeking out of the blanket also illustrates how you don't need to use a digital camera to enjoy digital imaging. This photo was created with a film camera. The negative was then scanned so that the photographer could share the image in an electronic format.

TOP RIGHT: PHOTO © JESSICA HUGHES. CANON DIGITAL REBEL, 1/30 SEC AT f/5.6, ISO 200, 40MM LENS. BOTTOM LEFT: PHOTO © JANET JONAS. PENTAX X1P. BOTTOM RIGHT: PHOTO © JIM MIOTKE. CANON 5D, 1/40 SEC AT f/5.6, ISO 1600, 28–135MM LENS AT 135MM.

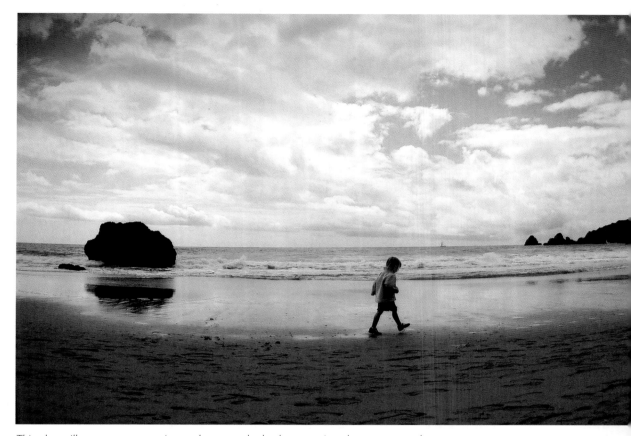

This photo illustrates an exception to the general rule about getting closer to your sub-
ject. There are times when a wider, more expansive view works best. The important thing
is to be thinking about proximity and making a conscious decision about how wide or
tight to make your composition.

PHOTO © ILONA WELLMANN. NIKON COOLPIX 5700 ,1/1000 SEC AT f/7.1, ISO 100, 23.7MM LENS WITH FISH-
EYE CONVERTER

TIP

To double-check your composition, glance at the
LCD screen on the back of your camera after
taking a picture. One of the great advantages of
shooting digitally is that you get immediate
feedback just after shooting. Use the LCD to
ensure you are not accidentally including dis-
tractions or placing too much emphasis on any-
thing other than your subject.

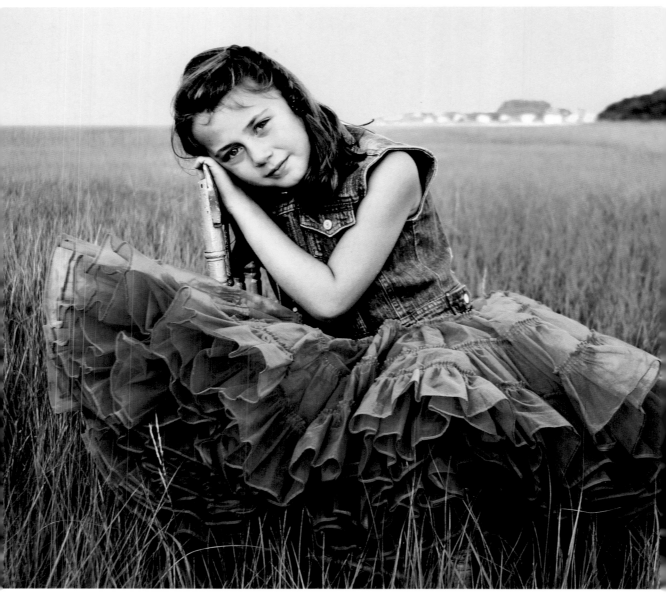

I love the outdoor background in this image. The white sky, which often detracts from the composition, works here because it is clean, pure, and reminiscent of a retro portrait. I also enjoy the combination of colors. The orange dress is balanced perfectly with the blue top.

PHOTO © MEGAN PECK. CANON DIGITAL REBEL XT, 1/160 SEC AT ƒ/3.5, ISO 100, 28MM LENS

Get Close, and Then Get Even Closer

Often getting close entails filling the frame with the face of your child, allowing the viewer to enjoy his or her eyes and expression. You need not stop there, however. You can move in even closer in an effort to capture meaningful details. This can be a lot of fun. First, select a detail of your whole scene that suggests the overall story, and then move in as close as you can to photograph it. I have only two precautions:

1 Make sure that your lens can still focus properly on your subject. If you get within the *close focusing distance*—the minimum distance your lens can be to the subject before it loses its ability to focus—then you may need to go into a macro mode or employ a specialized macro lens.

2 As you get closer to your subject, *depth of field*—the amount of your scene in focus, from closest to farthest elements—becomes shallower. If you focus on the nose, for example, the eyes may be out of focus. (We will talk more about aperture and depth of field in the upcoming chapter on exposure.) For the time being, watch for problems regarding this depth of focus. If you would like to get more things in focus, set your camera to aperture priority mode and select a larger f-stop number. If you use a large f-stop number, I recommend using a tripod and being careful to shoot moments when your subject is relatively still.

Get super-close, and you can have a lot of fun. Try photographing eyes from a close distance. Baby fingers and toes are also awesome subjects.

Erasing and Reformatting Memory Cards

I recommend not erasing the images from your memory card until after you've confirmed you have transferred and backed up your images. Additionally, every month or so, I reformat my memory cards. Erasing doesn't totally remove everything, so it is good housekeeping to reformat the card occasionally. (Note: If you ever find yourself in a bind after accidentally deleting a "keeper" or two, fear not. You can often still recover images after they have been accidently erased. Search online for data-recovery software for photographers, and you will find several free and shareware solutions. The trick is to stop using the card as soon as you become aware of the problem. If you continue to use the card, you could overwrite the images you have accidentally deleted. Put that memory card to the side, shoot with another card for the time being and use the data-recovery software to see if you can recover your favorite photos.)

Rule of Thirds

THE RULE OF THIRDS has been guiding photographers and artists for centuries, and yet it is still one of the best kept secrets in the photography world. Many beginning photographers, without thinking about it, place their subject in the center of the photo. Often the photo can take on new meaning when the subject is placed off to the side. If you center the subject, the viewer's eye has nothing to do but look at the subject and then drift off the edge of the photo. When you put the subject off to the side, the subject relates to the background in an interesting and dynamic way. But there is more to it than simply placing your subject off-center in the composition. For a classic rule of thirds photo, divide the frame with two horizontal and two vertical lines, then place your subject on one of the intersections of these lines.

In close-up images of people, where the face is highly visible, the eyes always attract the most attention. For this reason, they should both be sharply in focus and placed on one of the rule of thirds intersections. The head attracts most of the viewer's attention in full-body portraits, and therefore the head should be on an intersection for more distant child photos. Note the placement of the eyes and head in the following examples.

Using a graphic overlay, this pair of images illustrates the rule of thirds. Place the most important part of your photo on one of the intersections to create a more eye-catching composition.

PHOTO © JIM MIOTKE. CANON 5D, 1/125 SEC AT *f*/7.1 ISO 100, 28–135MM LENS AT 135MM

Don't Hide the Eyes

Be careful with baseball caps and sunglasses. Hats often produce dark shadows around the eyes. You can turn on your flash or use a reflector to bounce light into those shadows and brighten up the eyes. Sunglasses should only be used for an intentionally stylistic look, not when your model simply wants to wear them because they make him or her feel more comfortable. When an objective viewer is blocked from seeing the eyes of the subject, there is a greater feeling of disappointment and a loss of connection between viewer and subject.

LOOKING INTO THE SCENE

When you place your subject off to one side or the other, the general rule is to have the child looking into the picture. Compose so the viewer can see where the subject is looking or traveling. This gives the viewer a more serene emotional experience. Placing a subject near an edge and looking toward the closer edge creates an unsettling reaction in the viewer.

LOCKING FOCUS

It's important when you're taking a picture of an off-center subject to make sure that you don't focus on the central background and accidentally cause your subject to be out of focus. In this situation, you can lock your focus on the subject and then recompose until the subject is back in the position you desire.

What do we mean when we say "lock your focus"? Your camera is designed to focus on what-

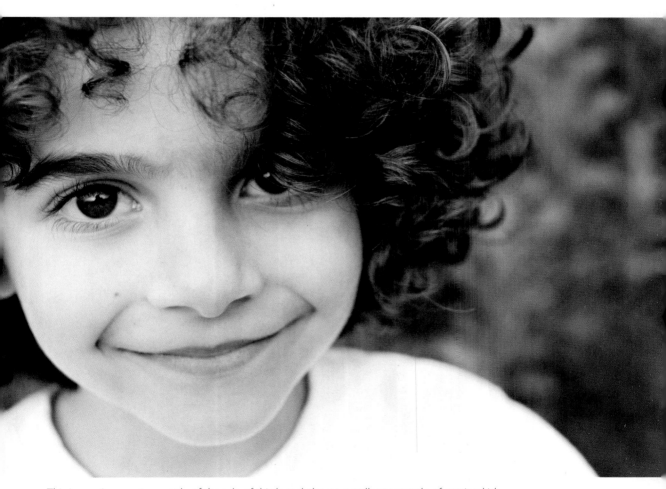

This image is a great example of the rule of thirds and also an excellent example of getting kids to cooperate. Kimberly says that toward the end of the session, she could feel her subjects relaxing with her: "I started asking them to do all these crazy things, like singing at the top of their lungs, making goofy faces, etc. This boy's sister was doing something totally hilarious next to us, but I aimed the camera at him and he gave me this totally calm, connected look."
PHOTO © KIMBERLY PECK. CANON 20D, 1/160 SEC AT f/4, ISO 200, 35MM LENS

This photo illustrates how the eyes most attract the viewer's attention in head-and-shoulder portraits. When photographing vertical head shots and close-up portraits, place the eyes two-thirds up from the bottom of the frame. In such photos, the eyes do not need to be arbitrarily placed to the right or the left. As long as they are vertically placed on the upper third, they can be centered horizontally.

PHOTO © JENNIFER B. SHORT. CANON 5D, 1/80 SEC AT ƒ/4, ISO 100, 105MM LENS

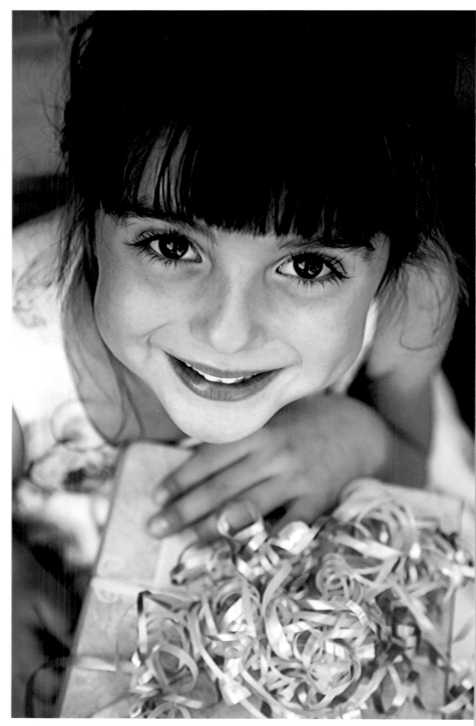

ever is in the central part in the scene. So if you just take the picture without thinking about it, unless your subject is centered, you might end up with an out of focus subject. Most cameras feature a "focus locking" functionality to avoid this problem. To lock focus, you usually press the shutter button down halfway. When you want your subject to be off-center, follow these steps:

1 Temporarily center your subject.

2 Press your shutter button down halfway until your subject is in focus.

3 Recompose to your desired composition while holding the button down halfway.

4 Take the picture.

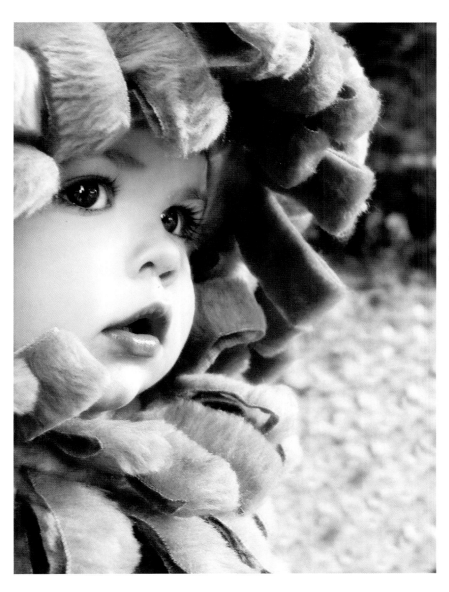

For this image, the photographer used Photoshop to remove distracting elements in the background, even out skin tones, and enhance the eyes. The post-processing added the final touches to this excellent composition, where the child is looking into the scene. This positioning of the subject helps the viewer fully enjoy the captivating curiosity and charm of this little character.

PHOTO © ANGIE SIDLES. SONY CYBERSHOT DSC-H5, 1/100 SEC AT ƒ/3.5, ISO 250, 70MM LENS

Backgrounds

WHETHER YOU'RE PHOTOGRAPHING children indoors or outside, often there are simply too many distractions in the background. If not handled correctly, these steal the viewer's attention away from your subject. You can arrange things in the background so they add meaning to your portrait without causing unnecessary distraction. Another technique is to reposition yourself or your subject to eliminate the distracting background. Alternatively, you can place a clean and simple backdrop behind your subject. With the subject against a seamless paper backdrop, muslin, or another kind of plain material, you can completely eliminate distractions.

Also, note that the viewer's eye is usually drawn toward the brightest area in a photo. If you have an excessively bright background, the audience will not be able to concentrate on your subject. Look for darker tones, avoiding sky or other bright areas in the background that could distract your viewer's eye from the subject. Select your background with care, remembering that any distraction—regardless of how small it may appear in your viewfinder or LCD screen—will appear bigger and more of a problem in your enlarged final image.

Antlers in the Background

We've all see the proverbial "antlers growing out of the head" problem, where a tree branch or other element is positioned behind your subject, making it appear that he is growing antlers! Watch out for strong shapes and lines such as these. Even when you're photographing with a small f-stop number to isolate the focus on your child (as we will learn in the next chapter), distracting elements like trees, branches, poles, telephone wires, and other elements can still be a big problem, especially if your subject is somewhat close to these background elements. Linear objects are especially bad because perfectly straight lines have visual power since they are rarely seen in nature. The best tactic is to watch like a hawk for distractions in the background and, whenever you notice any hint of a distraction, recompose to eliminate them.

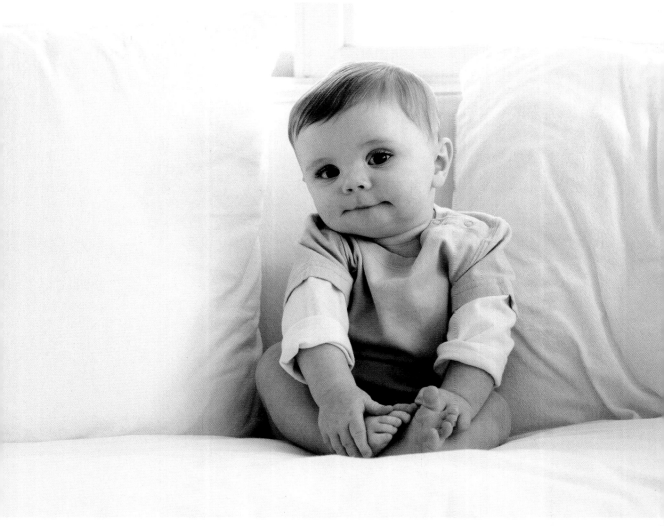

In this portrait by Megan Peck, we see how something as simple as a white sofa can pro-vide a perfect, clean background. The child was happy and behaving like a gem, so Megan had no problem placing him on the sofa, in the break between two pillows. During the shoot, Megan underexposed the image and later, in Photoshop, she used Curves and Levels to boost the exposure. She then converted the image to black and white to further simplify the background, allowing the viewer to give his attention entirely to this six-month-old baby.

PHOTO © MEGAN PECK. CANON 5D, 1/250 SEC AT f/1.4, ISO 400, 50MM LENS

Point of View

ANSEL ADAMS USED TO SAY that good photography was all about knowing where to stand. The placement of the camera is even more important when you're photographing children than it is when you're photographing landscapes. That's why I recommend that you experiment with unusual points of view. Try to play with your perspective, moving up and down, getting closer or to the side of the children, always looking for the composition that focuses the attention on the child while minimizing distractions in the background.

GET DOWN ON THEIR LEVEL, OR EVEN LOWER

Most people photograph kids while standing up and looking down at them from a typical grown-up height. They forget to experiment with their point of view, and this often results in uninteresting photos. It's often much better (and more fun!) to get down until you're at eye level with your subject. Photograph them from a low point of view for a more emotionally engaging child picture.

One note of warning: When shooting from a low point of view with a wide-angle lens, be aware of your background. Scan your background, looking for distracting elements, before pressing the shutter button. Change your position if you notice anything that might steal away attention from your subject. When you find a low point of view that is free of distractions, fire away. Outside on a nice day, once you find that perfect perspective, you can capture a beautiful blue sky in the background, and still make use of the interesting and unusual perspective on the child.

Of course, you don't have to stop at lowering to the child's eye level. You can also get even lower, for a view of your child that makes them look impressive and larger than life.

I just love this view of our son's friend. My wife got down on the floor to photograph this excellent example of shooting from a child's perspective.

PHOTO © DENISE MIOTKE. CANON 10D, 1/45 SEC AT f/4.0, ISO 400, 28–135MM LENS AT 28MM

To get this wonderful child portrait, photographer Cindy Wong had to do all sorts of silly things such as blowing up balloons and playing with bubbles. She says that the boy "was laughing at me like he was watching a funny movie." The work was worth it. When Cindy noticed he was laying down in the grass, giving his attention to her, she got very low and photographed a beautiful portrait at his eye level.

PHOTO © CINDY WONG. CANON 5D, 1/200 SEC AT ƒ/3.2, ISO 250, 70–200MM LENS AT 105MM

Especially when shooting with a wide-angle lens, you need to watch the background, carefully making sure that all potential distractions are eliminated. For this photo of a triumphant dinosaur hunter, I got down even lower than Julian's eye level. I wanted to make viewers feel impressed—like they were looking up at an explorer or historical figure they greatly admired. Once in this super-low position, I then moved around a bit to ensure that trees filled up as much of the background as possible. By getting down low and shooting up, I was able to accentuate the emotion I was after, and by moving to the side, I was able to eliminate the white sky from the composition.

PHOTO © JIM MIOTKE. CANON 5D, 1/60 SEC AT ƒ/5.0 ISO 160, 28–135MM LENS AT 33MM

GET UP HIGH

After shooting from an extremely low point of view where you are looking up at your subject, try shooting from a high point of view looking down. Shooting from a high vantage point can be an effective way to simplify the background. In addition to making it easier for your audience to admire your subject—free of distraction—the high point of view takes your child portrait away from the ordinary. It's a creative technique, fun for both you—the photographer—and your models, and it results in creative, unique child portraiture.

To gain a higher point of view, you can use a step ladder or chair. You can also photograph from a play structure at the playground, a second-story window, the top of stairs, or any location where you happen to be higher than the child. As you shoot, trying moving around (being careful of course) until you discover an unusual, nontraditional angle that seems to work.

On this day, I wanted to capture an image of Julian as he dressed up and became "The Delivery Guy." Notice how much more you can appreciate and enjoy the expression and spirit of the moment in the photo taken from a high perspective (right).

ABOVE: PHOTO © JIM MIOTKE. CANON 20D, 1/60 SEC AT ƒ/5.0, ISO 400, 28–135MM LENS AT 28MM. RIGHT: PHOTO © JIM MIOTKE. CANON 20D, 1/100 SEC AT ƒ/6.3, ISO 400, 28–135MM LENS AT 50MM

When photographing kids, your point of view is crucial. It has a big influence on the psychological reaction in your viewer. When we find ourselves looking down on a subject, we may feel they are smaller, cuter, and less imposing. When we look up at our subject, they will likely feel larger than life, more grand, and impressive. This carries into your use of language. Think of how often you hear someone say, "I really looked up to him as my hero" or "I felt he was looking down at me, and I didn't like it one bit." There is nothing wrong with photographing your kids from a high point of view. The important thing is that you remember the importance of point of view and think twice before taking a picture from the standard human height without thinking about point of view.

Using a step ladder, I worked to minimize and simplify my background for this photo of my son with his friend. By getting up high and shoot-ing down, I could fill the background with the simple pattern of the deck behind the subjects. It's a great idea to get many great photos of your kids with their friends for future reference. Making this kind of investment in recording the memories of their childhood will bring much joy when looking back over the years as they grow.
PHOTO © JIM MIOTKE. CANON 10D, 1/125 SEC AT ƒ/5.6, ISO 400, 28–135MM LENS 50MM

I photographed this image in the studio, standing on a three-foot step ladder. I used an extreme wide-angle lens to playfully distort the subject, making his head appear larger than the rest of his body. Kids love doing this and enjoy the comical results. Be sure to show them the fun results in your LCD screen, so they can see how they are contributing to the photo shoot. Most kids love this and will pose more after they see how their "work" is contributing to the end product.

PHOTO © JIM MIOTKE. CANON 5D, 1/125 SEC AT f/7.1, ISO 100, 16–35MM LENS AT 26MM

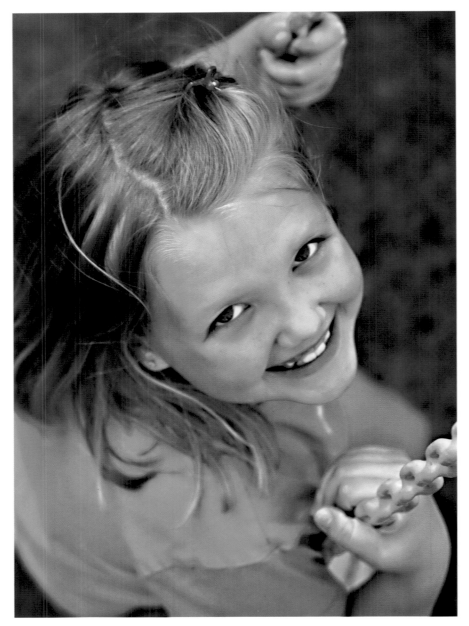

This child, explains photographer Michelle Frick, is "used to having my camera in her face, and sometimes she is a willing model. Since this particular shot was taken on Mother's Day, she was being cooperative—her gift to me. I climbed up into the play structure to capture this shot from above. In the process, I bonked my head on the wooden frame when trying to get into the fort area. My daughter made sure I was okay and then laughed at me once she was sure all was well. This shot was my reward."

PHOTO © MICHELLE L. FRICK. CANON EOS 5D, 1/250 SEC AT ƒ/3.5, ISO 100, 85MM LENS AT 73MM

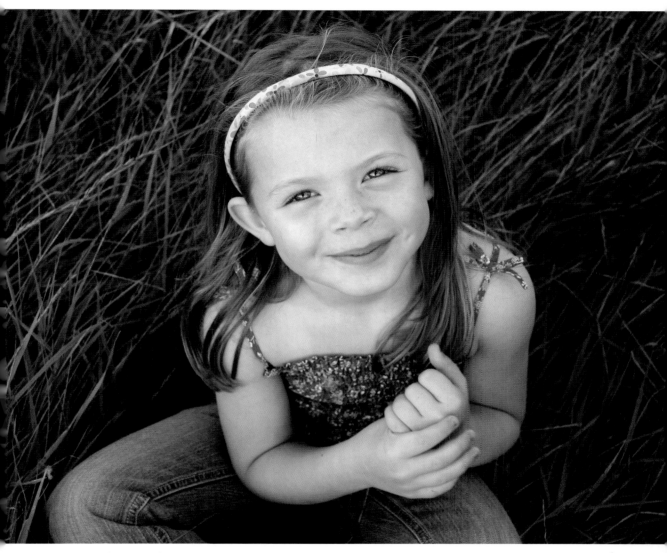

The value of shooting from a high point of view is well illustrated by this story related by photographer Kimberly Peck regarding how she captured this image: "We were almost done with the session and I wanted to take a few more images of just her from this angle. Once I got her to sit down, she said to me, 'Okay, just one more picture and then I am done.'" (Five-year-olds are pretty confident on where they draw the line.) "She gave me this smile, then she got up and ran off. It was certainly one of those situations where you had just one moment to get the image you want."

PHOTO © KIMBERLY PECK. CANON 20D, 1/50 SEC AT ƒ/5.6, ISO 100, 17–85MM LENS AT 41MM

Vertical Orientation

WHEN MAKING PORTRAITS, don't forget to turn your camera to the vertical position from time to time. Sometimes this produces a more natural and balanced composition, as the subject better fits the orientation.

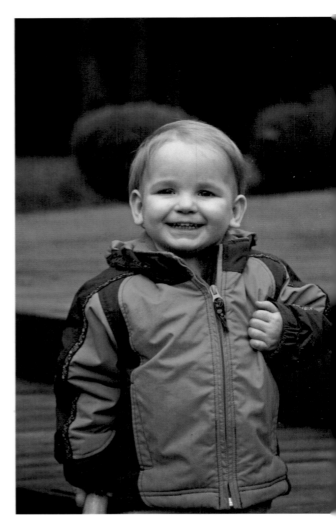

These images show that sometimes a vertical image is just as good as or even better than a horizontal one. Develop the habit of trying both during every shoot. The result will be an album filled with a variety of wonderful photos in a variety of formats.

ABOVE: PHOTO © JIM MIOTKE. CANON 5D, 1/320 SEC AT ƒ/5.6, ISO 800, 28–135MM LENS AT 135MM. RIGHT: PHOTO © JIM MIOTKE. CANON 5D, 1/125 SEC AT ƒ/5.6, ISO 400, 28–135MM LENS AT 135MM. OPPOSITE PAGE: PHOTO © JIM MIOTKE. CANON 10D, 1/60 SEC AT ƒ/4.5, ISO 400, 28–135MM LENS AT 75MM

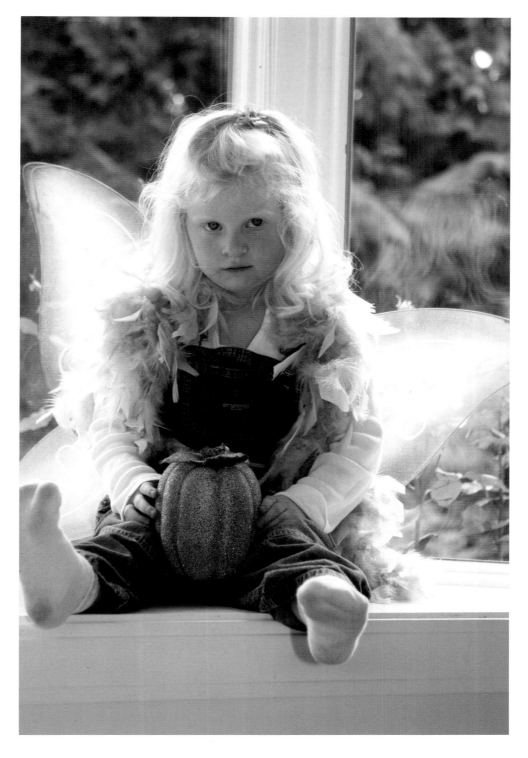

Line, Shape, Pattern

WHEN COMPOSING YOUR PHOTO, pay attention to the elements of design such as line, shape, and pattern. Line provides the photographer with a wonderful way to lead the viewer's eye through the photo. Ideally, strong lines will lead to your subject. This provides your audience with a sense of reward and satisfaction. Shapes such as triangles, circles, and squares can also add depth and meaning to your compositions. A triangle connotes power and victory, circles represent the eternal and infinite, and squares just seem to make sense. Whenever you have a number of graphic elements together, see if you can capture the pattern and use it to frame or provide an interesting context for your photo.

The triangle is one of the most powerful shapes in graphic design. When photographing three or more people, arrange the heads at a variety of heights and aim to create a triangle if possible. This is satisfying to a viewer as it gives the eye a closed-loop path to follow, as it travels almost instantly from face to face. The result is a composition that makes use of shape and connotes balance, strength, victory, and power.

PHOTO © DENISE MIOTKE. CANON 5D, 1/50 SEC AT f/5.0 ISO 3200, 28–135MM LENS AT 70MM

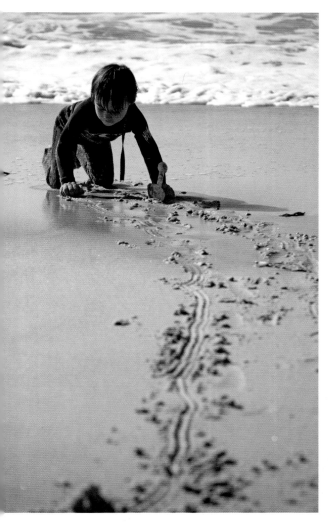

In these two photos, note how line leads the viewer's eye up to a payoff—the subject. Both are vertically oriented to make the greatest use out of the line that presented itself as I photographed these two senses.

ABOVE LEFT: PHOTO © JIM MIOTKE. CANON 5D, 1/400 SEC AT ƒ/7.1, ISO 100, 28–135MM LENS AT 135MM
ABOVE RIGHT: PHOTO © JIM MIOTKE. CANON 5D, 1/200 SEC AT ƒ/4.5, ISO 3200, 28–135MM LENS AT 56MM

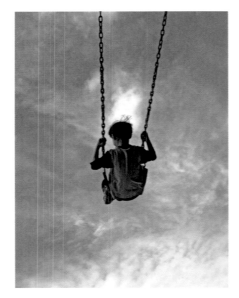

How you place line in your photo also has great psychological effect on your audience. Whenever you compose to cause the line to travel diagonally through your photo, you add drama, visual interest, and intrigue. The "before" version (left) is interesting because I shot from a low point of view, under the swings, just before darting back out of the swing's path. However, the "after" version (below) is more successful because the diagonal line of the child and swing is more gripping. Both versions are good, but the diagonal line, combined with the inclusion of the tree as a frame of reference, serve to help the viewer emotionally connect with this second photo even more than the first.

LEFT: PHOTO © JIM MIOTKE. CANON POWERSHOT G7, 1/1600 SEC AT ƒ/5.6, ISO 35–210MM LENS AT 35MM. BELOW: PHOTO © JIM MIOTKE. CANON POWERSHOT G7, 1/1600 SEC AT ƒ/4.5, 35–210MM LENS AT 35MM

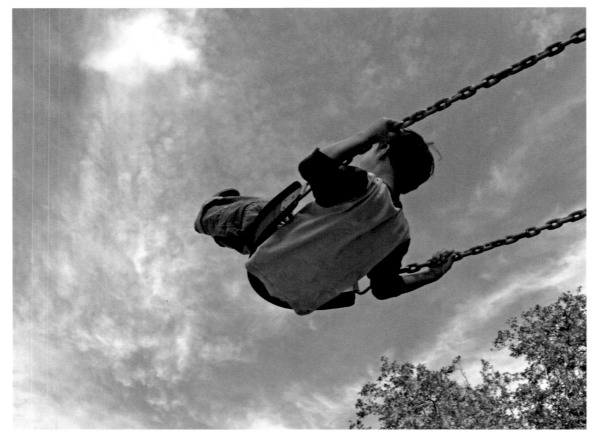

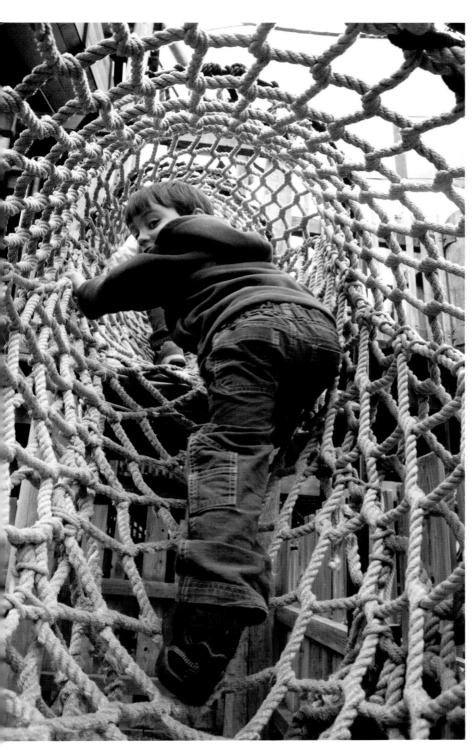

I followed my son Julian into the nets for this image. Quickly getting set up, I called to him to get his momentary attention and made a few exposures. This image most successfully shows the perspective and framing power that came from this fantastic pattern of lines. Remember, take your camera with you everywhere you go!

PHOTO © JIM MIOTKE. CANON 5D, 1/40 SEC AT f/10, ISO 400, 28–135MM LENS AT 28MM

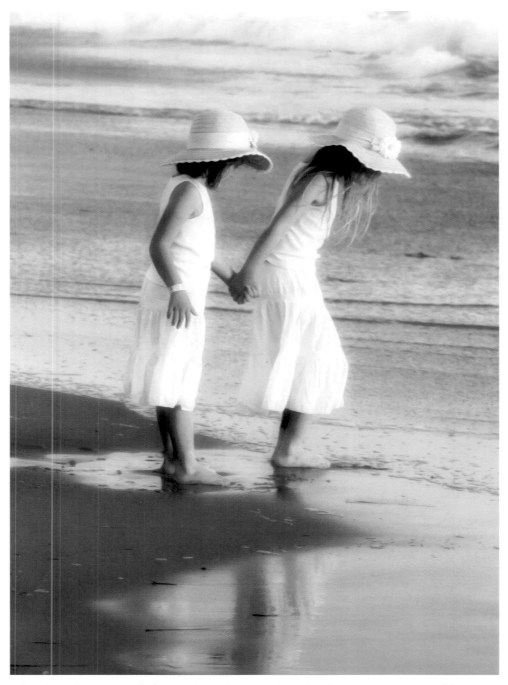

Taken about thirty minutes before sundown, this image shows how line is even more powerful when found in multiples. The two lines of the girls mirror each other and add to this charming scene.
PHOTO © JENNIFER B. SHORT. CANON DIGITAL REBEL XT, 1/200 SEC AT ƒ/7.1, ISO 100, 80MM LENS

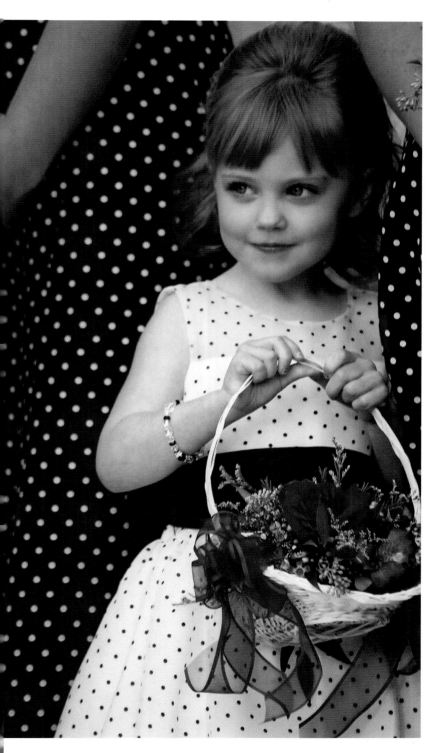

When this lovely candid was captured, the child was unaware of the photographer's camera. The contrast of her white dress with black polka dots against the background of the black dresses with white polka dots is a fun study of pattern. This juxtaposition of patterns, in combination with the soft light and the coyness of the child's expression, makes this a wonderful capture.

PHOTO © BENICA WALSH. MINOLTA ST si, 1/125 SEC AT *f*/4, ISO 400, 105MM LENS

Composing on a Diagonal

You can get an implied sense of line simply by shooting from a slightly diagonal orientation. This can give the photo more dynamic energy. If you do this, it is important to exclude the horizon or anything that would orient the viewer to an off-balance horizon. Plain foliage or sky works best, giving viewers dynamic line without disorienting them and making them feel unsettled.

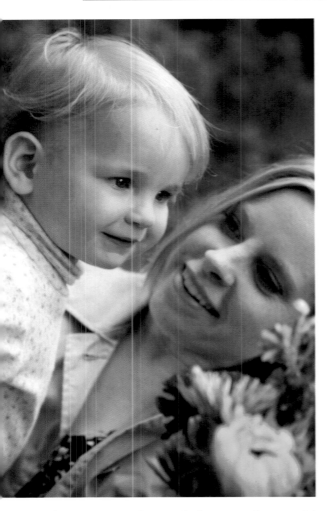
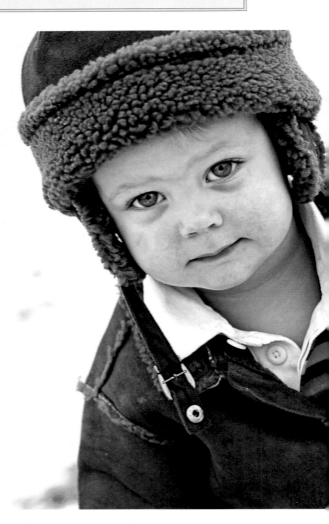

These two images illustrate the fun you can have—and the great photos you can get—when you slightly rotate your camera to photograph from a diagonal orientation. It doesn't always work. Avoid including any sign of the horizon in your composition and you may get results you like.

ABOVE LEFT: PHOTO © JIM MIOTKE. CANON 5D, 1/100 SEC AT ƒ/7.1 ISO 320, 28–135MM LENS AT 135MM.
ABOVE RIGHT: PHOTO © KATHY WOLFE. NIKON D70s, 1/250 SEC AT ƒ/2.5, ISO 400, 50MM LENS

Perspective and Lens Choice

YOUR CHOICE OF LENS allows you to capture a photo where the subject appears closer to or farther away from the viewer. Most people have experienced photography enough to know that a telephoto lens makes your subject larger in the frame than when shot with a wide-angle from the same distance. How close you get to your subject, though, is only one aspect of which lens you use. Your lens choice affects another important quality of the photo: perspective.

Your choice of lens allows you to control how your foreground subject relates to your background. When you use a telephoto lens, the background gets compressed with the foreground. With a wide-angle lens, the background seems to be way out in the distance. If you think of each photo as telling a story, your lens choice plays a big part because it allows you to place more or less emphasis on different objects or characters in the scene. When doing traditional portraiture, the general rule of thumb is to use a focal length around 100mm. This semi-telephoto 100mm focal length renders portrait subjects in the most natural, non-distorted way while generally doing a good job blurring the background. Having said this, you can always bend or break the rules. You can have fun getting very close to your subject with a wide-angle lens. This can result in comical distortion and give you fun, happy-go-lucky photos. Your choice of lens depends on the effect you're after or the story you want to tell.

Feel free to arrange objects, reposition your subject, or reposition yourself until you have a pleasing composition. Don't hesitate to remove distractions, add complementary objects, and organize the various elements in your scene. At times you will be able to make these arrangements; at other times, you will have to go with the flow, following and recording your subjects as they arrange themselves into a good composition. With one method, you make the adjustments until you get a composition that's aesthetically pleasing. With the other method, you carefully watch for those moments in the various moving parts of your scene to come together into a composition that will be enjoyable for all who view the image.

ASSIGNMENT Get High, Get Low

When you're feeling creatively stuck and looking for new ideas, this fun assignment will be just what that doctor ordered. Find a nice location and make several photographs of your child while looking down on your subject with a wide-angle lens. If necessary, get up higher than your subject. Note that you will likely have to get surprisingly close. This will distort their features, but if it is done correctly, you can end up with a fun, wacky, playful portrait of your kids. The wider the lens, the closer you will have to get and the more distorted will be the subject's features. I find 28mm to be a great focal length for this wide-angle project. Then use a normal to semi-telephoto lens (such as a 50mm or 80mm lens) and get very low. Lie down with your belly on the ground, if possible. Use a tarp if you want to protect your clothes from dirt.

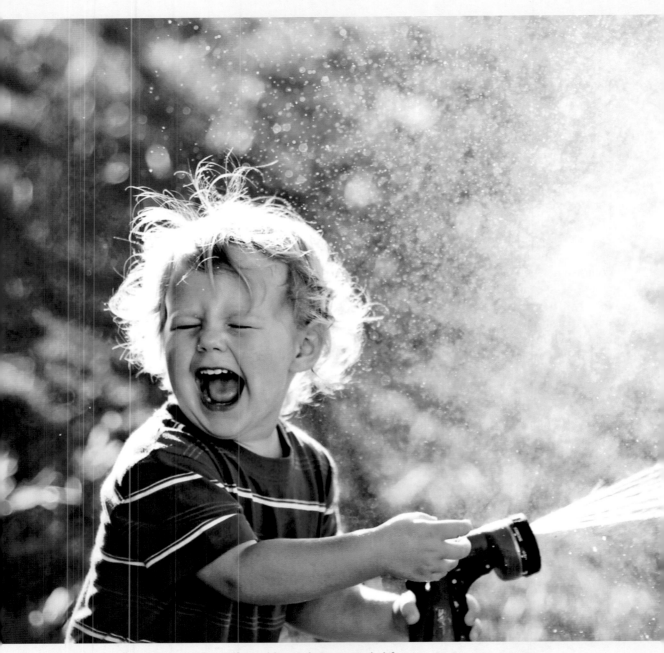

This photo by photographer Kathy Wolfe would never have succeeded if she had not used a fast shutter speed. She photographed in bright light, used a small f-stop number, and set her camera to a higher ISO of 400 to shoot with the fastest possible shutter speed she could use. Note that the photo utilized the extremely fast shutter speed of 1/5000 second.

PHOTO © KATHY WOLFE. NIKON D200, 1/5000 SEC AT ƒ/2, ISO 400, 85MM LENS

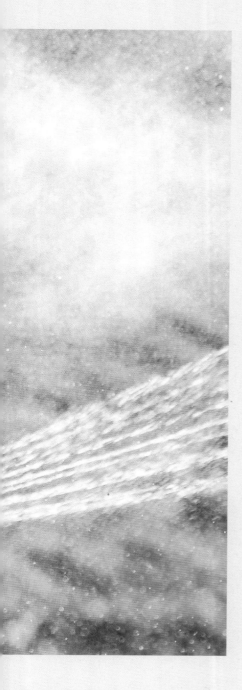

Digital Exposure

EXPOSURE CAN SEEM INTIMIDATING but it need not be. When it comes to photographing children, you will find it most helpful to understand shutter speed, but a mastery of aperture and ISO will come in equally handy. With these three components of exposure you will be able to control each of these elements:

❑ The sharpness of moving subjects

❑ How isolated the focus is to one part of your scene

❑ The texture of the photo

The fun part about creative photography is that you can alter these without changing the overall brightness of the photo. All you have to do is understand how these three components work together. When you do, you can get a proper exposure that is also creative (with the isolated focus, motion blur, sharpness, or other effects you envision).

Let's begin by exploring how shutter speed affects the sharpness of fast-moving children, as well as the other two components of exposure. You will soon be able to use all three components—shutter speed, aperture, and ISO—to creatively affect our photos. Note that the scope of this book forces this to be a brief primer, designed to help you get started. If you feel you would like to explore exposure more, read my first book in this series, *The BetterPhoto Guide to Digital Photography*, or take an online course on exposure at BetterPhoto.com.

They Move So Quickly!: Capturing the Action

THE REASON WE FEEL SUCH STRESS when photographing kids often has to do with focus. If we've prepared for the shoot in every other way beforehand, the only thing left to do as you shoot is focus and take the picture. Focusing on these fast subjects is often not as easy as it sounds. You need to focus quickly and use a fast shutter speed to get a clear picture before your subject moves into another focal plane.

Like many others, you may conclude that the need here is to get the child to stop moving. It's true that sometimes a static photo is better than an action shot, but only for one kind of child portrait. For the others, you don't want your subject to be too still. That results in dull, standard photos. You actually want them to be animated. Especially when shooting photos of a subject in action, you need an understanding of exposure and a mastery of shutter speed to be successful.

SHUTTER DELAY

There are two pitfalls for many photographers that result in failure to stop the action at exactly the right nanosecond. One has to do with the speed of the shutter and the other with the responsiveness of the autofocus.

Photographers with a simple compact digital camera may find that when they push the shutter button down, they miss the action as the camera lags for a few moments before it takes the picture. Shutter delay is an all too common problem. It happens to everybody who has ever used a compact digital camera. There are two potential solutions.

1 You can learn to anticipate the action and actually press down the shutter button before it happens. That takes a little bit of a prophetic sense: You have to be able to anticipate the moment.

Exposure Modes

Automatic exposure modes can be great. They often allow one to capture a properly exposed picture in a rush. However, adjusting the camera from automatic exposure to a semiautomatic mode allows the photographer to take the wheel, so to speak. In addition to the automatic or program exposure mode, the best of digital cameras offer a variety of exposure modes. *Shutter priority* is a mode that allows you to set the shutter speed, while the camera does the rest of the work, automatically selecting the corresponding aperture for correct exposure. This gives you control over how blurry or sharp the objects appear in your photos. You could use shutter priority mode to set a slower shutter speed when panning, for example. Most often, though, you will choose to set a faster shutter speed to freeze the activity of your child subject. There are other modes that can be equally effective in controlling shutter speed. I often use aperture priority, setting an aperture that I know will cause the camera to choose a fast shutter speed. I recommend either shutter or aperture priority. For fast-moving subjects like children, I don't recommend using the "M," fully manual, mode. The only time I use the fully manual mode, where I dial in both aperture and shutter speed, is when I am shooting in the studio. In such an environment, I use a handheld flash meter and manual exposure mode, as they are required for my camera to properly sync up with the momentary burst of light coming from the strobes.

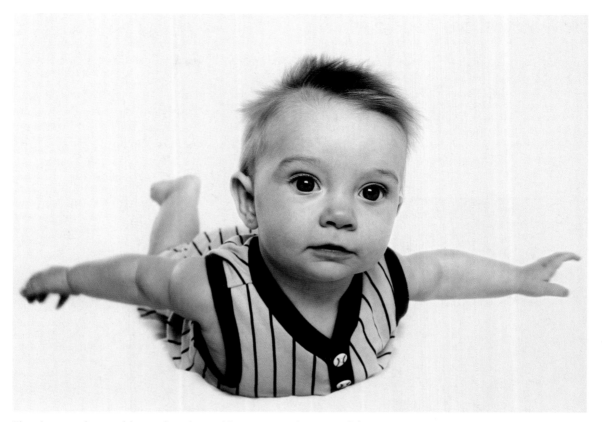

The photographer would never have been able to capture this image if she were using a camera with shutter-release lag.

PHOTO © JESSICA HUGHES. CANON DIGITAL REBEL, 1/30 SEC AT *f*/5.6, ISO 200, 28MM LENS

2 Alternatively, you can upgrade to a faster compact camera or an SLR camera. Some of the more expensive compact cameras do a much better job at responding quickly. SLRs act immediately as well. Immediately upon pressing down the shutter button, the SLR takes the picture. Additionally, SLRs also offer other great features such as the ability to exchange lenses and see exactly what you will get when you look through the viewfinder.

Gear-Driven Lenses Are Slow

If you're using a Canon digital SLR camera, I recommend getting a USM lens. If you are shooting with a Nikon, the 28–70mm VR and 70–200mm are both great lenses for portraits and candid photos of people and kids. The most important requirement is that the lens focuses very fast. Any delay could cost you the photo.

SLOW AUTOFOCUS

On some cameras, the autofocus (AF) system will just not keep up with you, regardless of what kind of camera you use. When the autofocus can't keep up with the action, the trick is to pre-focus on a point where the subject will be. Focus on an object at the same distance that your subject will be and then turn your autofocus off. Or you can focus on this distance manually. Whether you lock focus or focus manually, turning off the AF system will allow you to rest assured that, when the subject arrives there, the camera will fire instead of waiting until it gets the subject in focus.

This problem of delayed response affects composition more than anything else. The camera delays taking the shot and causes you to miss the moment. But what about those times when you indeed catch the subject in your composition but unfortunately the image is too blurry?

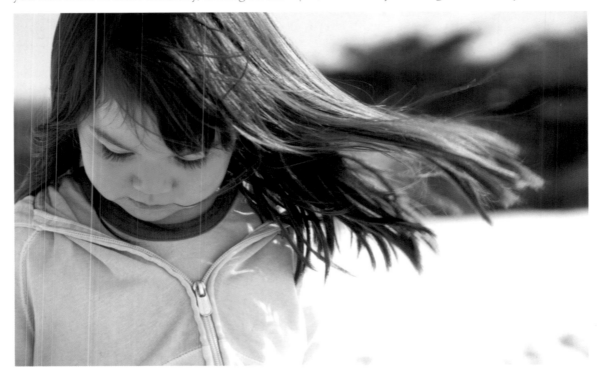

When viewing this image, we don't mind at all not seeing the eyes of this windswept girl. The value and meaning of this child photo is in catching the perfect moment when her hair was blowing in the wind. This kind of photo requires a relatively fast shutter speed and many exposures to get one winner. Additionally, the use of the continuous shooting mode is highly recommended. Also note how the bright sand acted as a natural reflector and brightened up the shadows on her face.

PHOTO © JIM MIOTKE. CANON 5D, 1/160 SEC AT f/7.1, ISO 100, 28–135MM LENS AT 130MM

TIP

After you shoot, quickly check the LCD to ensure you got the composition you intended (not suffering from problems such as shutter lag). Also check for slight blur caused by a slow shutter speed. Most cameras allow you to zoom in on part of a picture. I often zoom into the area with the eyes or head to ensure that they are as sharp as can be.

STOPPING THE ACTION WITH A FAST SHUTTER SPEED

Shutter speed is the amount of time your camera lets light in to expose an image on your sensor. Especially with subjects that constantly move around, such as toddlers and preteens, using a fast shutter speed makes all the difference between an "almost" shot and a total winner—a photo that both captures a great expression or moment, and is tack sharp.

If you have ever wondered why so many of your kid pictures end up blurry, the simple answer is that you're using a shutter speed that is too slow. Try setting your camera to the aperture or shutter priority mode instead of the fully automatic mode. I recommend using shutter speeds around 1/250 second or 1/500 second to try to stop the fast action of a child on the go. If the child is stationary, you may be fine with a shutter speed in the vicinity of 1/60 second.

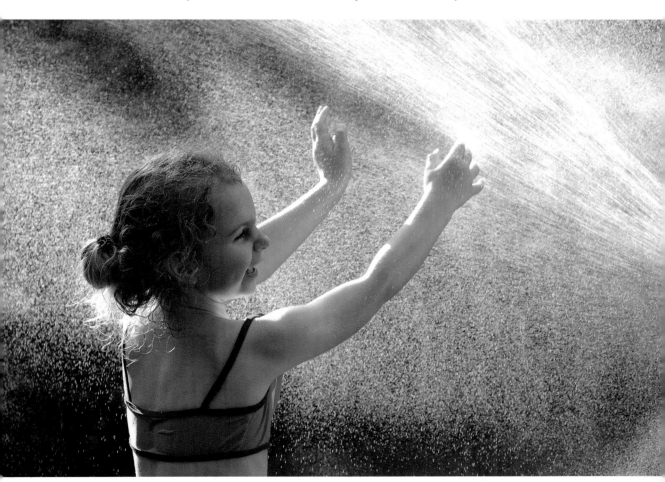

To freeze the action of both the child and the water, photographer Monika Sapek used a fast shutter speed of 1/500 second. The result is a sharp and delightful example of what you can do with a fast shutter speed. The dance of the water, girl, and light are all perfectly captured in time in this photo.

PHOTO © MONIKA SAPEK. NIKON D70, 1/500 SEC AT ƒ/4.5, ISO 200, 90MM LENS

Saving JPEGs vs. Camera Raw

THE FIRST CHOICE YOU HAVE when it comes to exposure actually has to do with digital file formats. Most cameras, by default, save images in the JPEG file format. This allows many images to be squeezed into a small memory card. Also, using JPEG is convenient because the images are processed in the camera and are universally viewable. They are easy to deal with on your computer and easy to share with friends and family.

However, some cameras offer the option of saving images as plain, unprocessed data. This is referred to as *camera raw* because you're capturing the raw data, straight out of the camera. Camera raw may require more processing work and it is not viewable to all people, but it allows you get an exposure with the best overall balance of brightness.

I highly recommend shooting in camera raw, if your camera gives you this option. It will allow you to fine-tune exposure, white balance, and other settings long after you have captured the image. Interpreting raw files can be difficult and time-consuming. One of the first advantages of camera raw, one that applies to our study of exposure, is that you have great latitude when it comes to the overall brightness of your image. When you save your images as JPEGs, digital capture has about the same latitude as color slide film. There's very little "wiggle" room, creating a need to be perfect with your exposure. One stop under and your shadows will appear far too dark; one stop over and your highlights will be burned out. When shooting in camera raw, on the other hand, if your exposure is somewhat off the mark, no problem. You can fix it easily as you import the image into a program like Photoshop. You can easily increase or decrease contrast and other characteristics of your image.

Metadata Is for Learning

You can use EXIF information, or *metadata*, to tag your photos with such data as your copyright. But, even more important, metadata can help you learn how to be a better photographer. Make a habit of studying your favorite and least favorite photos, associating each picture with the exposure settings and other facts you find in the metadata. If you do this regularly, you will greatly accelerate your education process.

The Problem of Unwanted Blur

MANY PEOPLE THINK that blur is a bad thing. Most of the time, your goal is to get a sharp photo, as you assume the image will fail to be effective if blurry. If your entire photo is blurry, the problem is often *camera shake*—your hands moving while making an exposure with a slow shutter speed. The solution in this case is to use a tripod and/or flood the scene with light if this is at all possible. When just one part of your photo is blurry—the child, for example—the cause may very well be that he or she moved during exposure. In this case, using a tripod will not be of much help. With or without the assistance of a tripod, you have to make the shutter speed faster to freeze the activity of a fast-moving child.

Blur is not good if it's occurring in your images against your will. However, sometimes photographers use blur to their advantage. The intentional use of blur can create impressions of speed and motion. Professional photographers know that if they intentionally blur the subject or background in a convincing way, it often results in an image that is energetic and lively. Let's finish our examination of the ingredients of a sharp photo and then explore the possibilities of going in the other direction—choosing a slow shutter speed to purposely blur your backgrounds.

TO USE OR NOT TO USE YOUR TRIPOD

Generally, my rule is to always use a tripod, although I do make exceptions when I am photographing fast-moving subjects such as children. With these subjects, a tripod can occasionally be impractical. As soon as the child can walk, for example, you may find it much easier to leave your tripod behind and handhold the camera. This will allow you to follow the child with greater ease and flexibility.

Before you abandon your tripod, however, first make sure you're using the best one you can afford. If you have been frustrated by the inflexibility and cumbersome nature of tripods, the solution may be to get a different tripod or a different head for your tripod. Most inexpensive tripods are unnecessarily difficult to adjust. More expensive tripods by companies such as Bogen/Manfrotto and Gitzo feature quick-release controls that make the tool much more user-friendly. Additionally, I recommend trying a ball head instead of the traditional three-way pan/tilt head. Some even feature a joystick grip that you squeeze to release the lock on the head. This can be very useful when you need to quickly recompose while photographing children.

What Do Photographers Mean When They Call an Image "Soft"?

When judging or critiquing photos by others, I often find myself saying that the photo is charming but unfortunately "too soft." By *soft* I mean that the subject or overall photo is too blurry. The same standards apply to my own images, and I must admit that, in the end, I throw away a lot of near-winning photos because they are too soft. Fortunately, I shoot often enough and strive to keep my shutter speed as fast as it can possibly go. These tactics allow me to often get action-freezing moments.

If you choose to put aside your tripod, do remember to make sure your shutter speed is fast enough to both stop the action and curtail any semblance of camera shake. In addition to the general guidelines provided above (1/250 for a fast-moving child), another important rule of thumb dictates that you use a shutter speed faster than 1 over the focal length of your lens. For example, if you are using a 100mm focal length, it's recommended that you keep your shutter speed at 1/125 or faster when handholding the camera. This will minimize the chances of your photos suffering from camera shake caused by the weight of your lens and its maximized focal length.

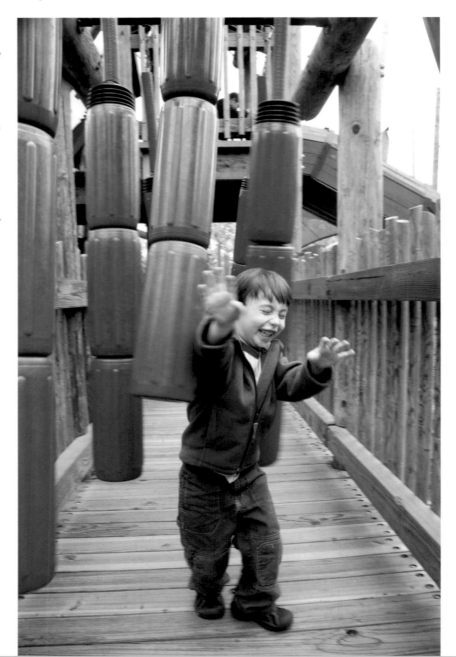

This example illustrates the action-stopping power of a fast shutter speed. I love the expression of joy in Julian's face as he bounds through blue obstacles on a play structure at Legoland in Southern California. There is no way I would have been able to capture this expression and split second of activity with a slow shutter speed.

PHOTO © JIM MIOTKE. CANON 5D, 1/50 SEC AT ƒ/10, ISO 400, 28–135MM LENS AT 28MM

STABILIZING THE CAMERA WITH OR WITHOUT A TRIPOD

If you don't have a tripod but still need to do something to minimize camera shake, there are a few tricks you can use. One is to simply lean against the wall. This way, you create a natural tripod with your own body. Hold the camera close to your face, breathe in, hold your breath for a second, and take a picture. Another trick is to set your elbows on a table. This will also help stabilize your camera if you don't have a tripod.

Regardless of whether I'm shooting in the studio or out in the field, I always start with a tripod. In addition to providing stability, it allows me to come out from behind the camera and interact with the child. If the child moves a lot, I often quickly release the camera from the tripod and shoot handheld.

At times, whether I am working in the studio or outdoors, I take the camera off the tripod. With toddlers in particular, this often helps me get an image of the child before he or she darts off. I just have to make sure that my shutter speed is fast enough to both curb any possibility of camera shake and freeze any activity in the subject.
PHOTO © JIM MIOTKE. CANON 5D, 1/125 SEC AT ƒ/7.1, ISO 100, 28–135MM LENS AT 85MM

Panning for Intentional Blur

SOMETIMES, BELIEVE IT OR NOT, you will actually want your pictures, or at least part of the picture, to be blurry. The truth of the matter is that freezing the action with a fast shutter speed can at times cause the picture to appear dull or lacking in energy. If the shutter speed is fast enough, for instance, a speedy race car can appear parked to an objective viewer. By intentionally using a slower shutter speed, and moving while you take the picture, a technique called *panning*, you can capture a relatively sharp subject against a blurred background. It's not easy and you have to shoot many shots to get one keeper but, when it works, the results can be amazing.

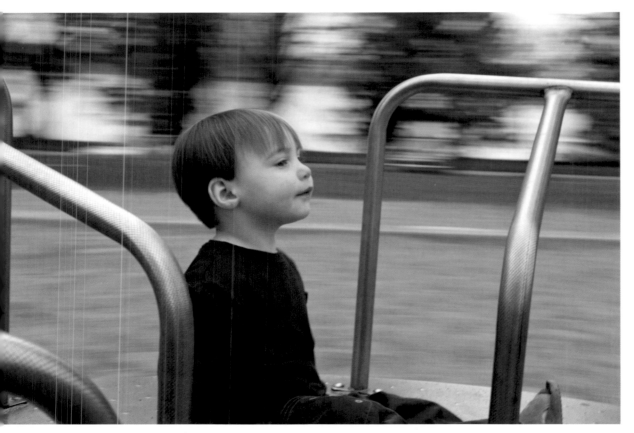

This is a textbook example of panning, where the subject is relatively sharp and the background is blurred. This conveys a sense of movement much more successfully than would a photo with a fast shutter speed, where the background was rendered perfectly sharp. If that were to happen, there would be no way to tell that the subject was not simply sitting on a stationary merry-go-round at the park.
PHOTO © JIM MIOTKE. CANON 10D, 1/30 SEC AT f/11, ISO 100, 28–105MM LENS AT 35MM

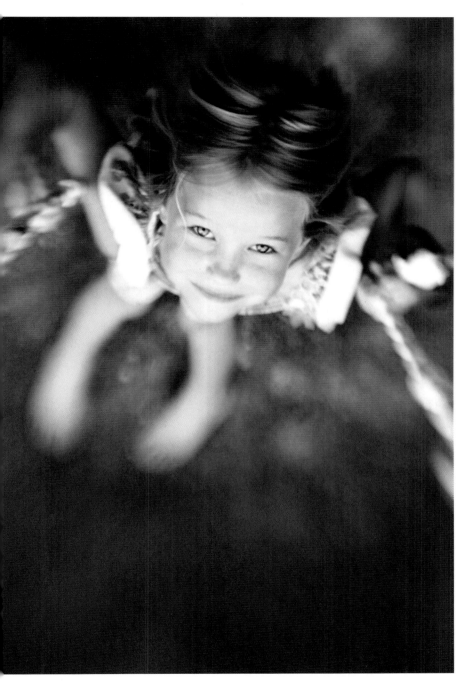

This image was taken in the late afternoon—a favorite time of day for natural light photographers. While the girl was swinging, Candy, the photographer, climbed to the top of our swing set and asked the girl to stop momentarily and look up. Using a Lensbaby lens to get the selective sharpness of her subject, Candy was able to place the child's eyes in the rule of thirds sweet spot and make a very memorable picture.

PHOTO © CANDY E. AVERA, CANON 5D, 1/800 SEC AT ƒ/2.8, ISO 250, 70–200MM LENS AT 200MM, WITH LENSBABY 2.0

The photographer used a slow shutter speed in this image to create a sense of movement. However, this slower shutter speed in the first version causes every part of the picture to blur. For the second image, Jane increased the shutter speed enough to have one part of the picture—the child's face and upper body—relatively in focus. This gives the second image an effective balance. There is just enough blur to convey the impression of movement and speed and yet the subject remains relatively sharp. Jane writes that her son "now has this picture hanging in his bedroom as a reminder to get moving in the morning for school!"

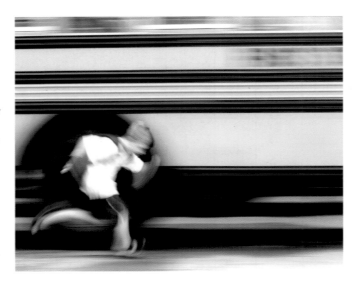

LEFT: PHOTO © JANE McDONAGH. CANON XT. 1/13 SEC AT ƒ/11, ISO 100, 70–200MM LENS AT 73MM. BOTTOM: PHOTO © JANE McDONAGH. CANON XT, 1/40 SEC AT ƒ/11, ISO 100, 70–200MM LENS AT 73MM

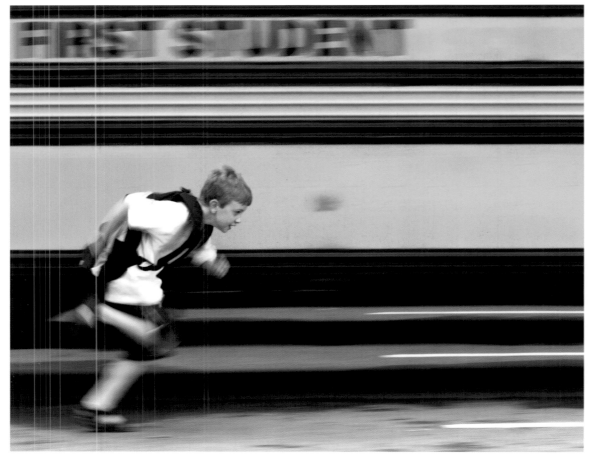

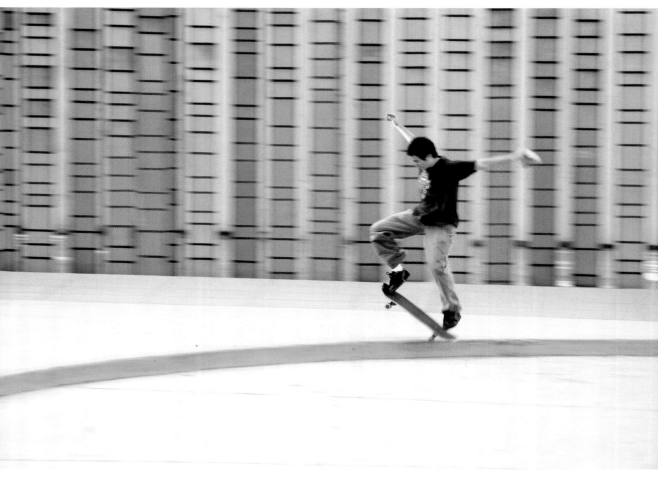

Getting great pictures of your kids at sport is not easy. They're often at a distance, mov-
ing fast, and rightly focused on the game or activity. Preoccupied with their own chal-
lenges, they usually do not put much thought into helping you get the shot. To get the
great images of sports and activities, get as close as possible and/or shoot with a tele-
photo lens. Then use a faster shutter speed to freeze the action. Of course, these are
rules that you may choose to break. In this image, I used a slower shutter speed to pur-
posely blur the action and accentuate the impression of speed.

PHOTO © JIM MIOTKE. CANON 20D, 1/40 SEC AT f/5.6, ISO 100, 28–135MM LENS AT 135MM

Aperture

APERTURE IS THE SIZE of the opening through which light passes to enter your camera and strike your sensor. Aperture affects *depth of field*—how much of your picture is in focus from front to back. The larger the *f*-stop number, the smaller the hole. The smaller the hole, the deeper the depth of field. I recommend that you make things easier on yourself by simply remembering this: "larger *f*-stop number = larger depth of field." That's all you need to know about aperture.

Aperture is your tool for isolating your focus. Unlike with most landscape photography (where you might strive to use *f*-stop numbers like *f*/22 or *f*/32), you will often want to use a small *f*-stop number such as *f*/1.8 or *f*/2.8 to cause your focal plane to be relatively thin while photographing kids. Thin depth of field isolates focus on your subject and allows the background to blur enough so all the attention will stay where it belongs—on your subject. *Shooting wide open* is an expression photographers use to mean that they used the smallest possible *f*-stop number (creating the largest or widest opening). Just make sure you use a higher *f*-stop number if you need greater depth of field, as when you're photographing two or three children who are different distances from the camera. If you have a Depth of Field Preview button on your camera, use it to get a better idea of how much of your scene will be sharply in focus.

Kathy Wolfe powerfully captures the joy of this child without even focusing on his face. By using a small f-stop number of f/1.8, she utilizes a shallow depth of field to keep the focus on those yummy candy canes. The face of the child is just visible enough for us to know he's thrilled with the prospect of tasting one of the treats.

PHOTO © KATHY WOLFE. NIKON D70s, 1/250 SEC AT *f*/1.8, ISO 400, 50MM LENS

Focus on the Eyes

The eyes are always the most important part of the picture when you're doing portraiture or kid photography. When some-body views your photo, the eyes are always going to be the most attractive item in the composi-tion. Because this is what their eye is naturally drawn to the most, make sure that the eyes are the sharpest point in the photo.

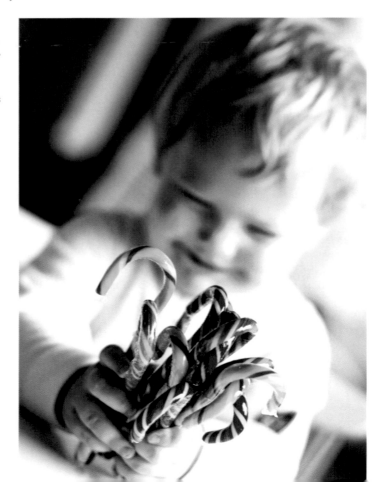

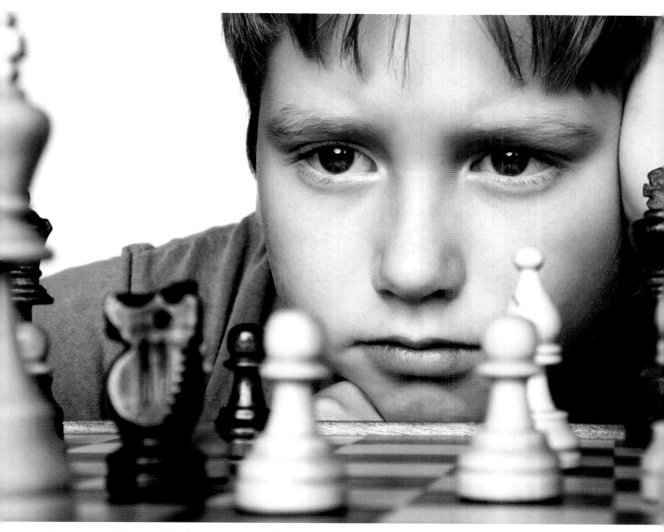

Photographer Heather McFarland explains that her intention for this photo was "to capture the intensity and concentration her son showed trying to beat his father in a chess match. I used natural light and a shallow depth of field with the focus point on his eyes. Using an aperture of only f/3.5 allowed me to have the chess pieces in the foreground in soft focus while keeping my son's eyes sharply in focus. I felt this would draw the viewer into the image and direct their focus to his face. If the foreground chess pieces had been sharply in focus, too, I don't believe the image would have worked as well."

PHOTO © HEATHER McFARLAND. NIKON CP950, 1/30 SEC AT f/3.5, ISO 100, 70MM LENS IN MACRO MODE

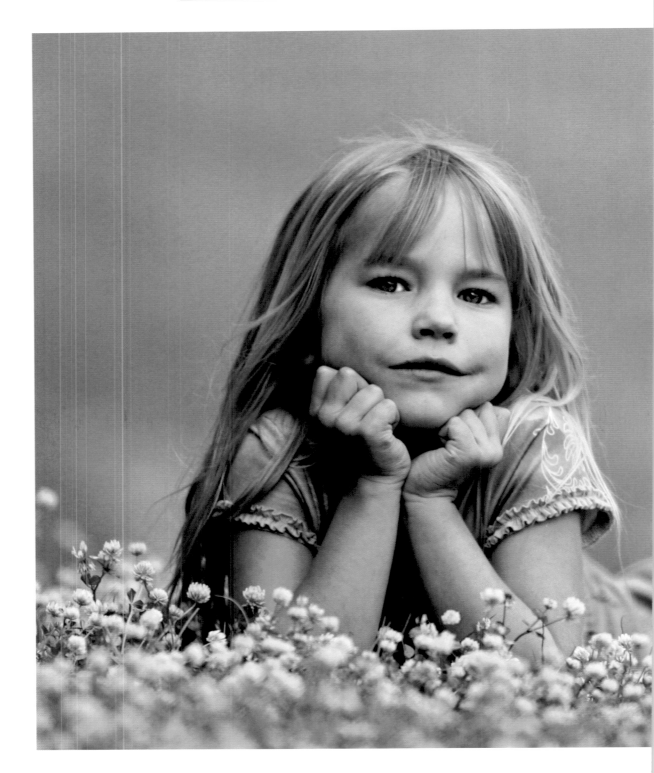

This image was taken on an early spring day in a beautiful field of fresh clover. It was a late afternoon, the "golden hour" producing wonderful natural light. The photographer and family were picking clover to feed to the horses across the street. When the photographer noticed her daughter lying in the grass, she used a wide aperture (small f-stop number) to isolate the focus on the subject against a softly blurred background.

PHOTO © CANDY E. AVERA. CANON 5D, 1/800 SEC AT f/2.8, ISO 250, 70–200MM LENS AT 200MM

ISO

ISO LEVELS DETERMINE how sensitive your camera's sensor is to light. The beauty of ISO when digitally photographing kids is that you can change it at any time. In addition to being able to adjust aperture and shutter speed, you can change ISO to directly affect your photo or influence aperture and shutter speed. For example, using a higher ISO such as 1600 or 3200 can come in handy in low light situations, allowing you to get faster shutter speeds. When my shutter speed is a little slow and I can't make it any faster by increasing the amount of light or going to a smaller *f*-stop number, I increase my ISO. When I do this, though, I unfortunately introduce another problem—*noise*. Noise is a grain-like texture that causes the photo to appear less distinct and less rich in color.

CHANGING ISO ON THE FLY

One tremendous advantage of using a digital camera is that you can change your ISO on the fly. That way you get an increased shutter speed so you can catch the action without having blurry photos.

Flash When ISO Is Not an Option

There will be times when you need a fast shutter speed *and* a low ISO. If you want to keep noise to a minimum, use your flash and see if that allows you to stop the action sufficiently without resorting to a high ISO. In addition to stopping action, your flash can add a bit of fill light. When done right, it can both stop the action and brighten up the shadows without making the light look unnatural.

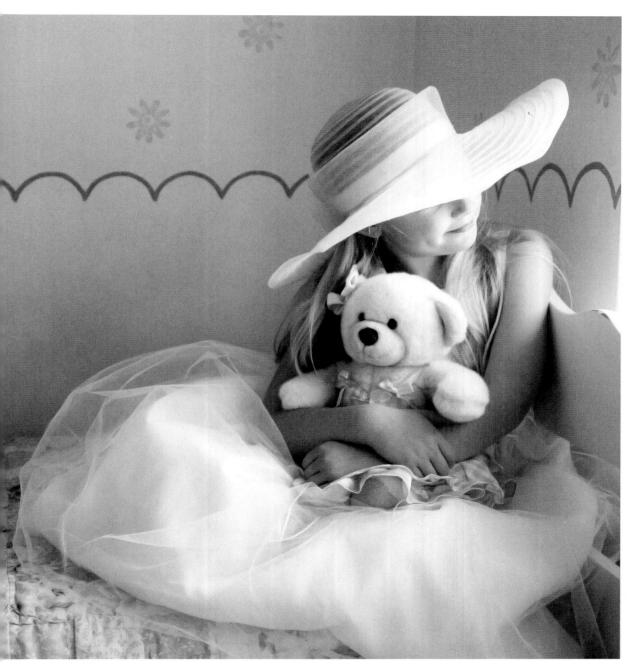

Sometimes, noise can complement a photo. For this image, the photographer was faced with very low light from a cloudy day. She found it necessary to bump the ISO up to 1600, but, as you can see, the result added interest to the overall impression created in this photo.
PHOTO © JENNIFER B. SHORT. CANON 5D, 1/160 SEC AT ƒ/5.8, ISO 1600, 40MM LENS

Overall Brightness

SO FAR, WE HAVE EXPLORED how we can use the three components of exposure—shutter speed, aperture, and ISO—to freeze our subjects, isolate focus, and creatively alter photographic results. The other goal regarding exposure is to make sure that the overall image is not too dark or too light. If you overexpose your image, you will risk losing detail in the highlights (referred to as "burning out the highlights"). If you underexpose the image, your shadows will "block up," and the

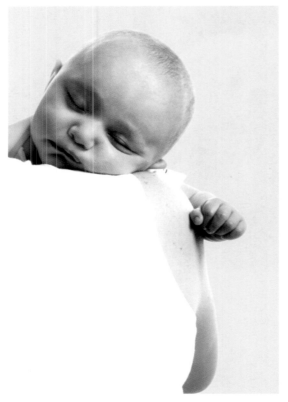

Jessica Hughes overexposed this image to create an overly white, "high key" treatment. This look complements the subject by exaggerating impressions of purity and innocence.

PHOTO © JESSICA HUGHES. CANON DIGITAL REBEL, 1/250 SEC AT *f*/8, ISO 200, 53MM LENS

overall image will appear dark and unappealing. As with every other rule, there will be times when you want to purposely underexpose or overexpose your image for creative effects. An overly bright image is referred to as *high key*, while darker images are called *low key*.

When you're photographing with a bright light source in the background, such as a window, the camera doesn't know that the foreground is really what you want to be photographing. It treats all elements the same. In attempting to expose the background properly as well as the foreground, the camera will cause your subject to turn out dark while the outdoor scene outside the window is perfectly exposed. In a situation like this, the easiest solution is to reposition yourself or your subject so that there's no bright window in the background. If you have a camera that allows you to lock exposure, you can lock exposure on the foreground element and then recompose. This will cause the background to be blown out while the subject is properly exposed.

Bright Backgrounds and Exposure

If your intention is to get a standard child photo with an evenly lit subject, keep an eye out for bright backgrounds. An extremely bright sky in the background of your composition, for example, can easily trick the camera into underexposing the scene. If you do get the exposure right, rendering the subject with realistic tones and pleasant colors, the background will be overly bright or washed out. When trying to capture details in your subject, a bright background will take the viewer's attention away from your subject.

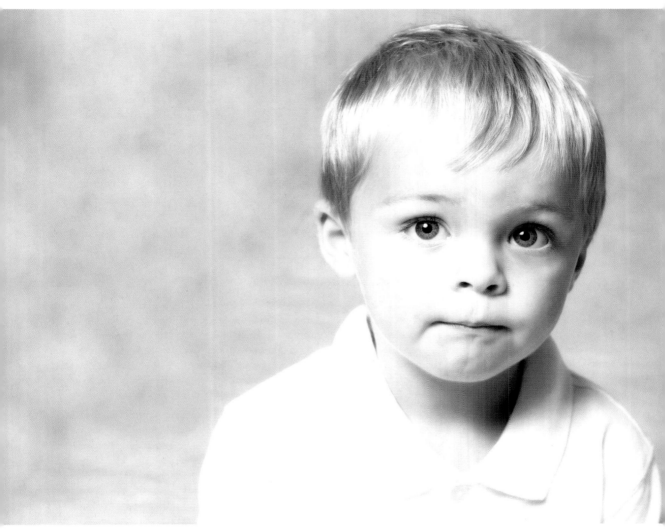

Photographer Michael Swaffar used strobes in the studio to light this subject. When the child stepped forward into the light, the photographer liked the way the light made the boy's eyes pop, even though it made the overall exposure a little bright. He then used a selective coloring technique to bring further attention to the boy's eyes.

PHOTO © MICHAEL S. SWAFFAR. MINOLTA MAXXUM 7D, 1/125 SEC AT ƒ/8, ISO 100, 50MM LENS

The Histogram

WHILE SHOOTING or when converting raw files, photographers can judge exposure (the overall brightness of their images) by viewing the *histogram*. A histogram is a graphic representation of all of the pixels in your digital photo. Think of it like a simple bar chart. The horizontal axis represents the spectrum of brightness levels available in your photograph—from darkest to the brightest. Along the vertical axis, you are presented with the number of pixels in your photo that consist of that particular tone. The most practical way to interpret the histogram is to watch the extreme left and right ends of the graph. Look for a histogram with a spike at the extreme left or right ends. If you see a one-pixel line going up the left edge, this translates into an image where the shadows do not contain satisfying detail. A one-pixel line going up the right edge indicates an image where the highlights are blown out and don't contain satisfying detail.

The histogram comes in handy when photographing kids because it gives you a way to judge exposure that is more scientific than examining the

ASSIGNMENT Panning for Gold: Intentional Motion Blur

For this assignment, I would like you to capture panning shots. Make several exposures with the goal of coming away with one winner—the textbook panning photo where the subject is in focus and the background is blurry. You have great creative flexibility as to subject. You can photograph your child walking, running, bicycling, swinging, playing on the teeter-totter . . . you name it. My wife and I created one of our favorite panning images of our son while I was swinging him in a circle and she was hanging onto my back and shooting from over my shoulder (check out *The BetterPhoto Guide to Digital Photography* to see this example). Whatever subject and situation you settle upon, here are the steps to making your own great image utilizing intentional motion blur:

1 Turn off your flash and turn your camera to the shutter priority mode. Another exposure mode, such as aperture priority, will also work, as it too allows you to override the camera's automatic functions and dictate the shutter speed. For this technique, you want to select a purposely slow shutter speed such as 1/30 second or 1/60 second, depending on how fast your subject is moving. For a kid running or bicycling by at a fairly rapid pace, I might start at 1/60 second and review the results to see if I need to use a faster or slower shutter speed. For a toddler ambling by at the playground, I might start at 1/15 or 1/30 second. The goal is to find the shutter speed that allows you to get the subject in focus while creating a pleasant sense of blur in the background.

2 Select a subject that is moving in a straight line and position yourself so that you are at a perfect right angle in relation to the subject as they pass by.

3 You may find it helpful to pre-focus the camera to ensure a sharp main subject amidst all the blur. In other words, focus on an object located exactly where the subject will be, and then turn off or lock your focus during the rest of the panning exercise.

4 I also recommend that you use the continuous shooting mode when panning. This will also you to take several photos during each pass of your subject, maximizing your chances of getting that one perfect shot. You only need one shot to make the exercise successful, but it often takes several attempts to get that one winning photo.

5 If your camera has an optical viewfinder, use it to frame your panning shot instead of the LCD screen. Since the LCD screen can give you a slightly delayed view of the scene, the optical viewfinder can be better. Unfortunately, most compact cameras no longer feature an optical viewfinder, so if all you have is the LCD, use it and make the most of the tools you're provided with.

LCD on your camera. When the bright sunlight makes it difficult to view the LCD screen or when you want to confirm that no important parts are underexposed or overexposed, you can turn to the histogram. My only caution is that you check the histogram and LCD quickly so you can get back to the subject and keep from missing any great photos.

I use the histogram often when shooting. Use it to make sure you're not losing detail in the highlights or shadows. If that detail is important, use the exposure compensation feature to adjust exposure. Compensating for overexposure requires the exposure compensation to be set at a negative number. On my camera, this negative number is to the left of the center of the exposure compensation indicator. This makes it easy for me to remember: When I want the spike in the histogram to go left, I move the exposure compensation to the left.

So far, we've learned a lot about how to take better pictures of children. We've learned how to make the most of any light and how to create better impact by moving in close and composing with the rule of thirds. We've learned how to freeze the action by using a fast shutter speed and purposely blur action with a slow shutter speed. Now let's talk about camera equipment and why I recommend an SLR camera for digitally photographing children.

6　When doing any kind of motion-blur photography that involves moving the camera during exposure, I recommend doing a "dry run" with your camera before you shoot. Move the camera along the path you will likely move it along during exposure to make sure there are no excessively bright areas in the background. If white sky comes into the composition at any point, for instance, reposition yourself or your subject so you get a somewhat dark, even-toned background throughout the exposure.

7　Now you're ready to actually make many exposures. Track the subject as it's coming toward you and, just before it passes, press down the shutter button. Be sure to keep tracking the subject as it passes you, following through to get a good panning exposure. Ideally, your panning photo will have the most important point—your main subject—relatively in focus while the background of the photo blurs into a beautiful motion effect.

8　As you fire off several exposures, aim to place your subject so that there is more space in front of him or her than behind. When you compose so that your subject has more negative space in front than behind, you give the viewer a more satisfying psychological impression. It's unnerving for the viewer to see a subject just about to leave the frame of the composition.

9　If you have time before your subject is ready to stream by you again, take this opportunity to quickly review the images in the LCD monitor to see if you got the shot—that one shot where the face is relatively in focus and the background is blurry. You may find that many shots are unacceptable. And that's just the fact of life when photographing any fast-moving subject in this panning technique. Actually, it's true even when you're shooting with a fast shutter speed and trying to get a great sharp photo. One of the best-kept secrets in the world of photography is that even the pros have to take many photos to get one good shot.

Note: When reviewing images on your LCD screen, you will be tempted to start deleting photos right there in the field. You may see several right away that just aren't going to work. But I encourage you to resist that temptation for two reasons:

1　You could be wrong, and you don't want to make that mistake when your emotions might be caught up in the excitement of the moment.

2　There will likely be many more photo opportunities happening around you. If you spend too much time behind the camera deleting images, you will likely miss more great shots.

I encourage you to keep your thumb off that "Erase" button and simply keep shooting.

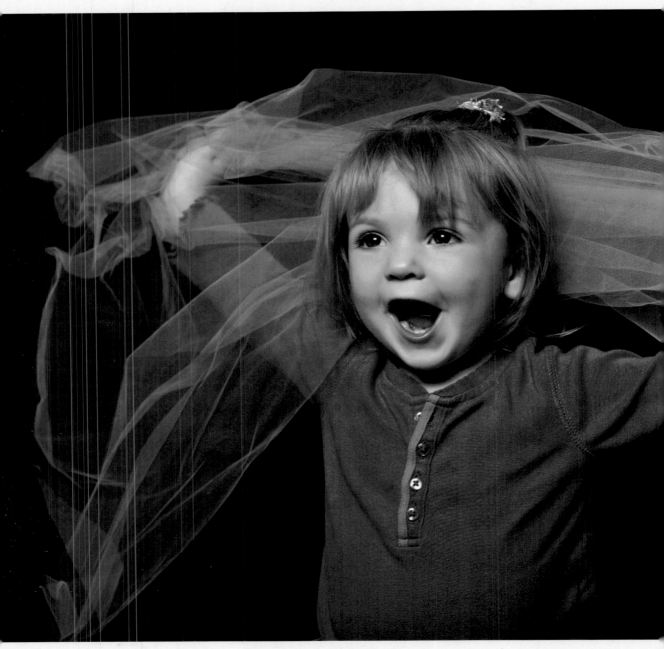

Photographer Terri Beloit would never have been able to catch this quick
expression if her camera had suffered from shutter delay.
PHOTO © TERRI BELOIT. CANON 5D, 1/160 SEC AT ƒ/5, ISO 100, 70–200MM LENS AT 70MM

Equipment

NOW THAT WE'VE COVERED the basic principles of our art, it's a good time to talk about equipment. What you're about to read is the straight truth about gear; I'm not affiliated with any camera manufacturer. The following is my own personal opinion about what I look for in gear—what is and what is not important to me when I'm shopping for cameras and equipment.

When people compliment a photographer and then ask "What kind of camera did you use?" this innocent-enough exchange often offends the photographer. He senses that the subtext is that the equipment is all-important, that anyone can take great pictures as long as he or she can afford an expensive professional camera.

Here's the truth of the matter: While the photographer is the artist—the one making all of the creative decisions that combine to create a great photo—the equipment does make a difference. Just as a master painter would choose the best brushes he can afford, a master photographer works with the best cameras and gear he can afford.

Whether you shoot with a compact camera or an SLR camera, you can get good pictures. A good SLR simply makes it easier for you to consistently capture great photos.

Compact Cameras

LET'S TALK FIRST about compact point-and-shoot cameras. These are, by far, the most popular cameras on the market. If your budget or other considerations motivate you to get a compact camera, there are just a few things you want to make sure that your camera features.

Make sure that your compact camera features include the following:

❑ Manual control of aperture and shutter speed

❑ A powerful telephoto zoom lens

❑ Absolutely no shutter delay

❑ Portability

The most important of these three features is the ability to control aperture and shutter speed—your exposure settings. If your camera doesn't allow you to control aperture and shutter speed, you'll never fully be in the driver's seat when it comes to making artistic and creative decisions.

Another feature that you want to look for is a powerful telephoto zoom lens. Look for at least 3x. A 10x zoom is a fantastic feature as long as you have a firm tripod to use with it. If you hand-hold the camera while it is extended to the 10x range of your zoom, you will likely end up with blurry photos.

If your camera only features a fixed or limited zoom, you'll be restricted in how you can compose your photos. Especially when it comes to taking pictures of kids, a zoom lens comes in very

This image, along with all of the other photos captured with my wife's Leica D-Lux 3 or my Canon Powershot G7, was created with a compact camera. While we love the creative options and camera raw format available in our digital SLR cameras, we have found that we do not take these bulky SLRs and all of their accessories with us everywhere we go. For that reason, we purchased compact cameras for family photography. We now have a camera with us at all times and have been collecting a multitude of photos we would not have captured without our compact cameras.

PHOTO © DENISE MIOTKE. LEICA D-LUX 3, 1/500 SEC AT ƒ/5.6 ISO 200, 28–112MM LENS AT 100MM

handy. If, at the touch of a button, you can zoom in close or come back wide, you'll be able to have more flexibility when your subject is running around and changing positions quickly.

You also want to make sure that the camera doesn't suffer from shutter delay—when pressing the shutter down doesn't immediately trigger the exposure. Especially when you're taking pictures of kids, you want to get the picture the instant you press the button. A delay could easily cause you to miss the great shot.

Most of all, you want a compact camera that you find highly portable. It must be small enough that you will take it with you when you go out. Balance compact size with usability. If the buttons or dials are too small for your fingers, try another camera on for size until you find one that is both portable and easy to use.

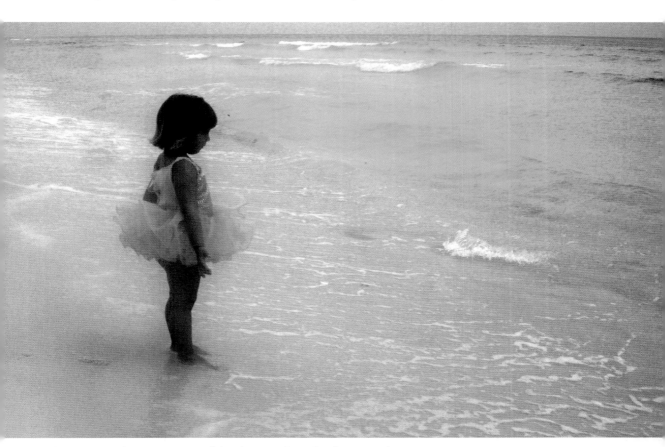

This picture, a charming capture of the photographer's daughter, was taken with a compact digital camera at Dune Allen Beach, Florida. The girl was playing dress-up that afternoon. Darby took her outside for an impromptu photo shoot and made great use of softened overcast light as the photo was created around 3 P.M. on a cloudy day.

PHOTO © DARBY STRUCHTEMEYER. SONY CYBERSHOT DSC-W1, 1/1000 sec at ƒ/5.6 ISO 100
38–114MM LENS AT 38MM

SLR Cameras

SHUTTER DELAY MIGHT BE one reason that you would end up wanting a digital SLR camera.

Before you decide what brand of SLR camera to buy, you will probably want to first decide which lenses you will be using. The quality of the lenses will make the biggest difference in your photos. Discover your preferred lenses by consulting friends or online forums, such as those at BetterPhoto.com. (If you are transitioning from film to digital, you might have a collection of lenses already.) Then buy the camera body that syncs up with that brand of lens. Ideally, get a body made by the same manufacturer that makes your lenses.

As far as camera body features go, you want to make sure you get one that has a very fast autofocus system, so that you won't lose shots due to the failure of the autofocus to keep up with you.

Make sure your SLR camera features the following:

❏ A fast and quiet autofocus

❏ Manual control of aperture and shutter speed

❏ Easy, intuitive controls

❏ A camera body that feels comfortable in your hands and is small enough that you will actually carry it with you . . . everywhere you go.

When photographing children, it's essential that your camera and lens can focus in a matter of nanoseconds. I recall that when autofocus first emerged on the market, and I upgraded from a manual to an automatic focusing system, the quality of my kid photos soared. For such fast-

Two Great SLR Features

One of the greatest features found on SLR cameras is the ability to use a variety of lenses. When photographing distant subjects, such as a child playing in the distance, you can use a strong telephoto lens to get in close to the action. You simply twist off the previous lens and twist on the lens you want to use. In this way, SLR cameras are highly scalable: As your photographic interests and abilities grow, the SLR can grow with you. Lenses can be pricey, though. Over the long run, enjoying a variety of lenses can mean a sizable investment.

Another great feature of the SLR is you see through the viewfinder exactly what you are capturing with the camera. SLR stands for single-lens reflex, which refers to the fact that you view the scene through the same lens that the camera uses when taking the picture. This gives you what is referred to as a WYSIWYG experience (pronounced wizzy-wig) and refers to the fact that "What You See Is What You Get." Most compact cameras, on the other hand, use two separate lenses: one for the viewfinder you look through and another for the capturing mechanism. For example, if the subject is not in focus, you'll be able to see this in the viewfinder of an SLR just before taking the picture. Most compact cameras don't give you this kind of feedback.

moving objects, you simply must have a fast auto-focus system. It's also nice if the autofocus system is very quiet, so it's not a disturbing camera when you're focusing. You want something that doesn't disturb or distract your subject. I have found that gear-driven autofocusing systems tend to be both slow and noisy. If you can hear your lens moving as it slowly gets into focus, explore your options and see if you can get a lens and/or camera with a faster focusing system.

You're also going to look for features like aperture and shutter speed control. Other things that I like are easy controls and a body that feels comfortable in your hands. If size matters to you, you want to make sure it will fit in the kind of camera bag you're going to use. The last thing you want to have happening is that you leave the camera at home because it's too bulky. If you think that an SLR system is just going to be too big to take with you, by all means, get a compact digital camera. The most important thing is that you have your camera with you at all times.

Regardless of which kind of camera you get, I recommend looking for a particular kind of port called a *hot shoe*. This is a port, usually on the top of the camera, that allows you to attach an external accessory flash. If your camera has a hot shoe, you can greatly expand your creative possibilities when taking flash photos. When you need to control the amount of light that's hitting your subject, you can sync up your camera with a studio strobe or set of studio lights. Studio shooting is easy and can produce fantastic results regardless of the weather or the lighting conditions outside.

A hot shoe.

A hot-shoe-to-PC-port adapter helps when using strobes in an indoor lighting setup.

Additional Equipment

When photographing children, you will find it is worth the extra expenditure to purchase a few key items of additional equipment. An additional lens or two will open up new worlds of photographic possibilities. An external accessory flash will allow you to capture much more pleasing portraits indoors at night as well as outdoors on a bright sunny day. A tripod will increase your photographic yield, reducing the number of images you have to throw away due to unintentional blur. I recommend investing in all this and more, if you can afford it.

LENSES

The lens I use the most is one I call my street zoom. It goes from a focal length of 28mm to 135mm. By simply twisting the ring, I can quickly recompose from a wide-angle shot to a semi-telephoto shot. My main lens also has an image-stabilization feature. That allows me to keep the camera a little more stable when not shooting with a tripod.

The lens I use next most often is my super-wide-angle lens. This is a zoom as well, and it goes from 16mm to 35mm. This wide-angle lens allows me to get even more extreme wide-angle shots.

When I'm photographing distant kids, I need extreme telephoto magnification. I use a super-telephoto lens in the 70–300mm or 100–400mm range. This allows me to get a very close image of distant children and is therefore excellent for creating the kind of candid photos that occur when subjects are unaware they are being photographed.

If I need to zoom in even more, I can also use what is called a 1.4x or 2x teleconverter. By placing this in between my lens and the camera body, I double the magnification level. However, the downside of using a teleconverter is that often the autofocus system is disabled.

Note: When used on most digital SLR cameras, lenses show a narrower field of view, causing the final image to appear magnified about 1.5 times.

This is great when shooting telephoto but limiting when your goal is to capture a wide-angle view.

When it comes to buying lenses, you can buy ones made by the manufacturer of your camera body or those made by another company. Some people choose the latter because the lenses are less expensive. They can buy an assortment of lenses without breaking the bank. However, I personally find that the lenses made by the camera manufacturers are sharper and produce more outstanding results. If you can get a Canon lens for your Canon camera or a Nikon lens for your Nikon camera, even if this means you have to wait and save up, you'll ultimately get better results.

FILTERS

Filters can become a black hole for the beginning photographer. Many photography enthusiasts get caught up in filters—buying a bunch and putting too much time, money, and energy into them. In truth, you only need two essential filters when you're first starting out. One is a UV, or Skylight. Put this clear filter on the outside of your lens and it will protect your lens, made with expensive glass, from potential damage. This filter doesn't affect the colors or exposure of your photo much. Its main purpose it to simply protect your lens.

The other essential lens is a polarizer. This lens is designed to cut down haze and glare in the air. The polarizer allows you to get richer, deeper colors in your subject. There are two types of occasions when you are most likely to use this filter. One is when you're shooting a scene that includes the sky. The polarizer causes the blue in the sky to become more pronounced and intense and the white in the clouds to become more clean and pure. The other time you might use a polarizer is when photographing wet subjects, such as rain-drenched autumn leaves on a forest floor. In such a situation, the polarizer increases color saturation by reducing glare.

Don't keep this filter on your lens all the time. It blocks out a lot of light, often causing your shutter speed to slow. As one of the most important needs when photographing kids is a fast shutter speed, only turn to the polarizer when you absolutely need it, and when the exposure conditions are bright enough to allow for a fast shutter speed.

EXTERNAL ACCESSORY FLASH

If you find yourself getting particularly interested in photography, I recommend that you invest in an external accessory flash. This kind of flash attaches to the hot shoe port on the outside of your camera and gives you more creative control over how light hits your subject. In addition to an accessory flash, I often use an accessory device that allows me to diffuse the light. I sometimes use a Lumiquest Bouncer, which causes the light to be reflected onto my subject. If I shined the light right onto my subject, it would produce a too harsh, white, flat light. When I bounce it, I render the subject in a softer, more complementary light.

CAMERA BAG

You need some way to carry your gear and keep it protected from the elements. Basically, you just want to find a camera bag that fits your equipment. If you're using a compact camera, a small camera bag will allow you to store the camera and a compact flash card in the accessory pocket. If you have a slightly larger digital camera, you might find a more medium-sized camera case to be exactly what you need. You can put the camera body in the main compartment and some accessories off to the side.

If you go on extensive photo shoots, you may find that a backpack is a practical solution. It allows you to place one or two camera bodies, several lenses, filters, batteries, flash, and everything else you might need in the backpack. I prefer to use a camera backpack. When I used a shoulder bag, stuff would often fall out when I leaned over. This way, when I'm traveling, I keep everything safe in my backpack and my camera and street zoom lens on my neck when I'm shooting. If I get to a spot where I end up shooting with a wide variety of lenses and accessories, I take my backpack off so I can easily get to my gear.

TRIPOD

A tripod is absolutely essential. When I tell beginning photographers to use one, I often get resistance. The fact is that tripods are cumbersome and difficult for most people to carry around. However,

Camera on tripod

this is the one essential accessory that will most help you get sharper pictures. I highly recommend that you do not skimp when it comes to purchasing a tripod. Get a good sturdy model with easy and quick controls.

When you get a tripod, make sure that you also purchase a remote control for releasing the shutter on your camera without having to touch it. When you're shooting with very slow shutter speeds, any camera movement, such as that which can easily be caused by even the most careful photographer's hand, can result in a blurry image.

A remote shutter release allows you to take a picture without touching your camera.

REFLECTOR

Professional photographers often use reflectors when shooting. This device allows you to control the amount of light hitting your subject. If you have part of your subject in bright light and part in shadow, you can use a reflector to bounce light up into your subject. This is a great way to fill shadows and create a much more evenly lit subject.

If you don't want to actually spend the money to invest in a specific specialized reflector, you can go to almost any craft store to purchase a piece of white foam core. This is a great accessory for any parent to have while they're photographing their children. While around the house or doing portraits by the window, you can use this inexpensive reflector to bounce light back up onto your subject.

Without reflector.

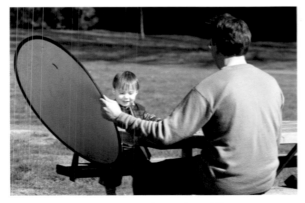

Reflectors can really make a tremendous difference in evening out the light on your subject's face!

ABOVE: PHOTO © JIM MIOTKE. CANON 10D, 1/350 SEC AT ƒ/5.6, ISO 100, 100MM LENS. TOP RIGHT: PHOTO © JIM MIOTKE. CANON 10D, 1/500 SEC AT ƒ/6.7. BOTTOM RIGHT: PHOTO © JIM MIOTKE. CANON 10D, 1/350 SEC AT ƒ/5.6.

With reflector.

PRINTER

I use an easy and convenient 4 x 6 printer for fast production of fun kid photos for the scrapbook. I can both place these quickly produced 4 x 6 photos in my photo albums and use them as proofs. When I see a photo I really love, I can print a larger version on my larger inkjet printer.

A small portable 4 x 6 printer.

You can also use online services to have your images printed or use a kiosk or photo lab service. I recommend finding a solution that is most convenient for you. Seeing your images come to full fruition is an important ingredient to keep you going on your life-long creative enjoyment of photography.

If you do your own printing on a home computer, I recommend that you invest in color calibration software and a colorimeter. Colorimeters are small mouse-like devices that measure the light coming from your display so you can easily create an accurate color profile.

CARD READER

Another accessory that I get a lot of mileage out of is a card reader. This plugs into the back of my computer and allows me to insert my memory card so I can transfer the files very quickly. This makes it so that I don't have to rely on the cables and connections that come with the camera, which is usually a much slower way to transfer images from camera to computer.

Other Things Found in My Camera Pack

❑ **Extra batteries.** I never go anywhere without at least two or three extra sets of batteries. One time at a workshop, when I first started in photography, I didn't have an extra battery for my camera. When my battery died, I just sat there twiddling my thumbs during the whole workshop. I learned then and there the importance of having a spare battery.

❑ **Extra memory.** Every digital photographer needs backup memory cards. The kind of memory card that you use is going to be determined by what kind of camera you use. There's Compact Flash, SD, Smart Media, and more. The type you use is determined by the camera body that you buy. The only other decision that you have when it comes to buying a compact flash or smart media card is how much memory it can hold. If you can afford a multi-gig card, you will be able to store many more pictures before running out of room.

❑ **A 4x loupe.** Loupes are magnifying devices traditionally used to view slides. I like to carry a loupe with a magnification factor of 4x with me when photographing. This allows me to look at the LCD screen on my camera so that I can see the picture better. It also acts as a hood, blocking out light and making it easier to see the LCD in bright sunshine.

❑ **A lens cloth or hand-blower.** It's a good idea to have a few accessories to keep your camera clean.

❑ **Shower caps.** In case it gets a little misty, I want to keep my camera from getting wet.

Props

IN ADDITION TO ALL THIS camera equipment, I collect props that I can use when photographing children. As you want the child to remain the star of your photo, without being overpowered by props, simple, timeless toys are often best. Basic, colorful items—anything with a little splash of color—can come in handy:

❏ A red baseball cap

❏ A bold, evenly colored umbrella

❏ A stuffed animal

❏ Hats, gloves, and sunglasses

❏ A washing tub or blanket for babies

You can also get a lot of fun out of creative activity toys, such as building blocks, clay, and paint. I recommend trying anything that makes the child feel more at home. Objects that add a little splash of color, or a little extra meaning to the photo, can provide a gold mine of photo possibilities.

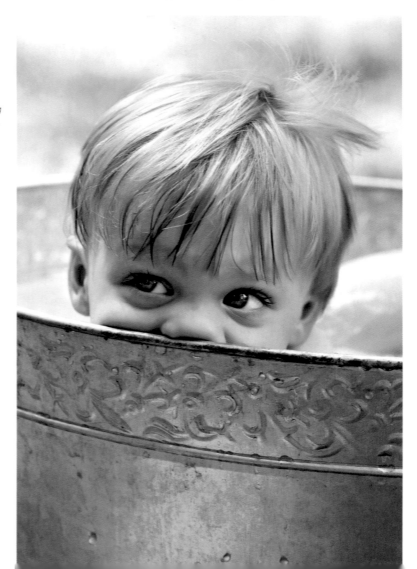

A metal tub—filled with water or empty—can be a wonderful prop to get images that express the idea of bath time. Photographer Denise Kappa explains that "this photo came a little later in the session when he was tiring of me taking photos. I always keep the camera to my eye and watch for moments like this one."

PHOTO © DENISE KAPPA. CANON DIGITAL REBEL XT,1/500 SEC AT f/4, ISO 200, 70–200MM LENS AT 70MM

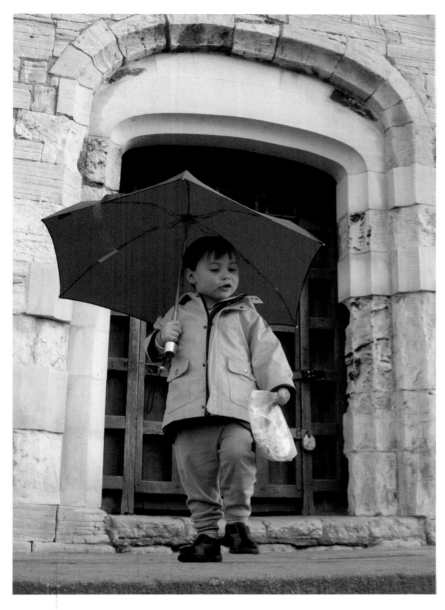

I carry a red umbrella in my camera pack for times like this. When traveling in England with my family, I went out one early morning to photograph the ancient city of York with my son. This splash of red, especially when combined with his yellow rain jacket, added just the right touch of color.
PHOTO © JIM MIOTKE. CANON 10D, 1/90 SEC AT f/5.6, ISO 200, 28–105MM LENS AT 28MM

ASSIGNMENT The Next Eleven Days

Your next assignment is to carry your camera everywhere you go for the next eleven days. If you have tried to get into the habit of doing this but stopped after a while, perhaps you need to get a smaller camera. Big digital SLRs are fantastic tools for creative photography, but a point-and-shoot "family" camera is certainly worth the investment if it means you'll always have a camera when those once-in-a-lifetime moments present themselves.

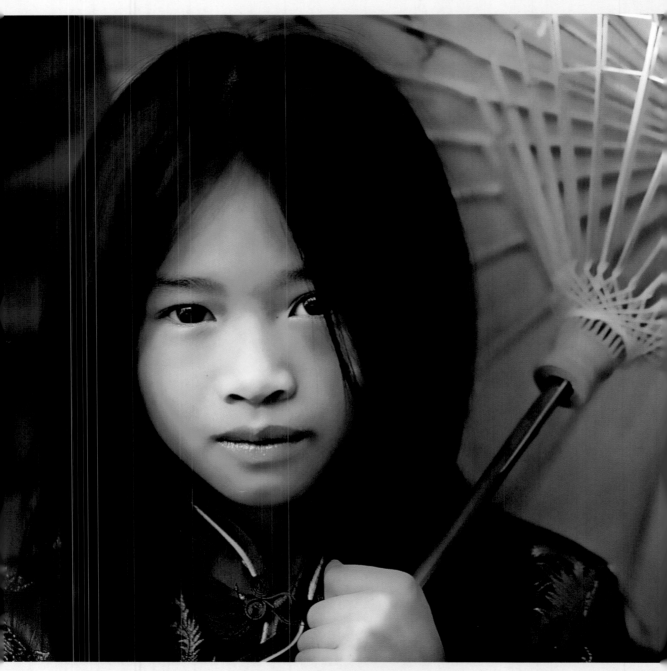

Children need not always put on a big smile in every picture. Sometimes a face with a more subdued, serene expression can do a better job showing off the inner beauty of a child. Aim to capture every expression—happy, sad, indifferent, and anything else you happen to notice as it passes across your child's face.

PHOTO © CRAIG J.C. PHOTOGRAPHY. CANON 30D1/1250 SEC AT ƒ/2.0 ISO 400 100MM LENS

Cooperation: Being the Boss

PHOTOGRAPHING CHILDREN DEMANDS great flexibility and patience. You need to learn how to work with kids when they are being difficult. Sometimes they refuse to smile. At other times, they do not sit still long enough for you to make a selection of good photos. To handle these challenges with grace, you have to go with the flow and take each session on a case-by-case basis. Although there is no written-in-stone formula, there are several tricks of the trade that will help you elicit cooperation and make great kid pictures time and time again. In this chapter, we'll discuss how to interact with children for best results. The lessons will include developing patience, working with difficult subjects, playing games, and engaging with the child.

At this time in your life, you may not feel up to the challenge. That's okay—you can start by photographing candid images of kids and later move up to the challenges and rewards of child portraiture.

First, let's assume you feel shy and don't want to make waves when photographing kids. If this is how you feel, no problem. You can still take great kid pictures and have a lot of fun. All you need to do is concentrate for the time being on capturing candid photos.

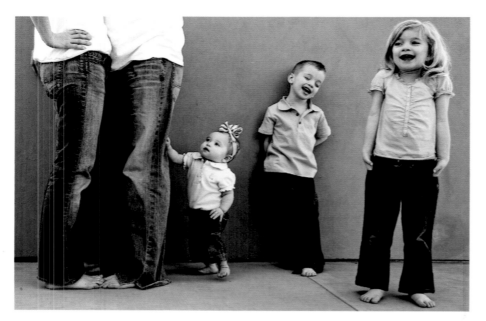

Here are just a couple of examples of the kinds of photos you can get by actively engaging with your child when taking pictures. Candid photos, on the other hand, can be delightful. Just be sure to augment your collection of candids with portraits that require the cooperation of your subjects. It's hard work, but the variety in your photos of children will make your overall collection so much more wonderful.

ABOVE: PHOTO © KERRY HOGLE. CANON 20D, 1/125 SEC AT *f*/4.5, ISO 100, 70–200MM LENS AT 73MM. RIGHT: PHOTO © JESSICA HUGHES. CANON DIGITAL REBEL, 1/50 SEC AT *f*/4, ISO 100, 47MM LENS

Resist Checking the LCD Too Much

Use the LCD screen on your digital camera to review the photos that you just created. The LCD can be a fantastic tool, allowing you to make sure you have good exposure or composition. However, if there is still energy or activity to be photographed around you, make sure you don't bury your face behind your camera to check your photos. You don't want to miss any photos due to your attention being directed into your LCD.

Cooperation for Portraiture: The Challenge

THE KEY TO TAKING FANTASTIC photos of children is great eye contact and expression directed at the camera. To achieve this, you most often need the cooperation of your subject. Besides lighting, the number-one topic people need to learn is cooperation. In this chapter you will learn how to do the following:

❑ Get your subjects to cooperate.

❑ Get your children to sit still long enough for a few good exposures.

❑ Make your models think they want to have their picture taken . . . or better yet, help them not think about the picture-taking process at all.

❑ Capture genuine smiles and expressions that reveal true character and emotions such as joy, laughter, contemplation, wonder, and love.

The challenge is great. Typically, parents and photographers find themselves in the predicament described as follows:

All you are asking is to take a few pictures, have a generally decent time, and walk away with a few pictures to send to Grandma. Minutes into your shoot, however, tempers flare and tantrums abound. Your daughter bursts into tears and tattles on your son, who is bouncing off the walls and screaming that he did not do anything. All you want is to get a photograph with natural expressions and instead you get is chaos—a fight for everyone involved. And this is supposed to be a happy occasion!

Another scenario is the one in which you can't seem to get your child to settle down and sit still, even for a moment. And a seasoned parent has learned that chasing the children around does not work, especially if you fall into the trap of losing your cool. If you are forced to chase after a child, she will pick up that you are out of control. If you, the captain, have lost control, she senses only two options: (1) a mutiny where she takes the helm, so to speak, or (2) a breakdown where she loses control over her emotions. These are two strong reasons to not lose your composure. It's imperative that you keep your cool and stay composed in order to retain control and help everyone feel safe and secure throughout the shoot.

One may think that you simply need to get your child to sit still for a few moments. But when your child is bouncing off the walls, does it ever

Good Versus Bad Manipulation

Most kids pick up on dishonesty and pushy manipulation. Though, let's face it, getting great photos often requires manipulation. The difference really has to do with whether the manipulation is loving or self-interested. If your intention is to genuinely work hard to make beautiful images for children and their parents, your efforts to manipulate will likely take on a fun, enthusiastic flavor and not be spotted as fake or selfish. The key is to play nice with children and focus on their good qualities.

You can have a lot of fun if you augment your abilities behind the camera with a skilled use of Photoshop. The photographer captured delightful expressions in these two children by photographing them playing with bubbles. Later, she added fairies in Photoshop to give us the extraordinarily creative image we see here.

PHOTO © JANE McDONAGH. CANON DIGITAL REBEL XT, 1/100 SEC AT f/7.1, ISO 400, 50MM LENS

work to yell at him to sit still? No. Instead of getting great portraits with natural expressions, you get angry faces of a kid in rebellion. Instead of an image that reflects the true character of the child, you capture a memory of a battle. The picture will remind you of the fight that occurred and all the difficulties and challenges of raising a child. This is not what you want.

Another common scenario occurs when the child simply goes on strike. The scene may be less chaotic but equally frustrating. One universal truth applies to children on strike: Trying to force your subjects to do something they don't want to do simply won't work. When the child will not smile, you need to change tactics. If you have been asking her to smile, abandon that usually ineffective request and instead work on connecting and entertaining the child. If you are already doing everything in your power to connect—and it is not working—employ the services of a friend/ assistant or reschedule the shoot for another time.

Here's another common situation: Older kids in particular often put on what I call a *camera face*. Over the years, these kids have been conditioned by photographers, parents, and relatives to grimace when facing a camera. It's not their fault; they have been unwittingly trained to do this whenever they find themselves having their picture taken. When your goal is a natural, easy expression where the true child's character comes through, this child needs to be coaxed out of his camera face and led to a place where he forgets that he is having his picture taken—even if only for a moment. You might start a discussion by asking him what he most enjoys doing, where he went on a recent special vacation, what his special pet likes to eat, etc.

These experiences are in no way unique. Parents and professional photographers experience these conditions often.

To capture charming portraits in which genuine personality or character comes shining through, you need to be prepared, shoot quickly, and get the kids to cooperate. No easy task, but with the following tricks and techniques, I'm confident you'll be getting great child portraits in no time.

1 Get a helper to wrangle the kids.

2 Be ready first—with your equipment turned on and your desired settings and accessories all in place—before inviting the child onto the set.

3 Before beginning to shoot, spend a few minutes getting to know the child.

4 Play.

5 Start shooting and don't hold back. Shoot a lot, for as long as the child can last before he starts to fall apart.

As long as you work with a helper, or "kid wrangler," get ready before children are brought into the scene, remain flexible and playful, and shoot a lot, you can count on getting fantastic photos of the kids—ones that reflect the fact that the kids were enthusiastic about the experience.

Get a "Kid Wrangler"

DEPENDING ON THE AGE of the child, you may be able to sometimes get great shots without a "kid wrangler." But these successes will be sporadic and more difficult to achieve by yourself. To get the best possible kid photos, you need to have an assistant entertaining the children while you work with the elements of light, composition, and digital exposure.

I prefer the term "kid wrangler" to "photographer's assistant" because the former is clearer. If a person is called the kid wrangler, he immediately knows what he is being asked to do. He may not immediately know exactly how one wrangles kids, but with very little training, any outgoing person can do it.

For this important job, don't settle for the closest warm body at hand. For success with child portraiture, you need to select your kid wrangler with care. So, what makes a good kid-wrangling assistant? The most important qualities are an outgoing personality and a willingness to make a fool of oneself. Ideally, your kid wrangler will be somebody who is really a kid at heart. The best wranglers have no problem being pretty goofy—almost like clowns.

For images with good eye contact, your wrangler needs to be comfortable getting physically close to you. In fact, the wrangler will often need to be right above your head—almost breathing down your neck. The best kid wranglers don't mind being goofy and making funny noises extremely close to your camera. There is no place for shyness and no such thing as "personal space" when it comes to this all-important job. If you are noticing that your subject's eyes are looking up just a bit, instruct your wrangler to get lower and closer, and to play with attention-getters near your camera or even mess up your hair . . . whatever it takes to get those eyes to appear like they are looking right into the camera.

Doing the Wrangling Job Yourself

What do you do if you don't have anyone who can help you, if you have to wear both the wrangler hat and the photographer hat yourself? Even though this is not ideal, it can be done.

When you are doing your own wrangling, a tripod is a must. Also, ask the parents to move to a location that is far from the photographic activity. It's good if both the parents and subject can see each other, but if the parent cannot help they should give you the floor so you can do your work without uncontrollable distraction. If a parent stays within the subject's sight, be sure to brief him or her before the shoot that parents need to be observant without being interactive. Explain that this will help you face the challenging task of both wrangling and photographing the little one. And be prepared to work triply hard . . . you'll be dancing around and shooting so quickly that you will likely be exhausted at the end. If done well, though, the results will be worth the work.

BE PREPARED

Trying to get the exposure correct while your subjects are on the set will cost you valuable time. More often than not, once you have your exposure, focus, white balance, and other settings set, you will have lost their attention. Time is of the essence when photographing children. Before you involve your subject, you must first take care of all non-shooting items on your checklist.

Pre-Shoot Checklist

The movement of kids is often unpredictable. You want to be prepared for anything. The following is my personal checklist that helps me make sure the most important preparations are completed before I begin the shoot:

❏ Set a low ISO.

❏ Set a fast shutter speed.

❏ Select aperture for isolated focus or deep depth of field.

❏ Evaluate the light sources for brightness, softness, and color.

❏ Make sure your kid wrangler is ready to clown around.

❏ Set up your tripod.

Remember, whenever you're photographing any action, it's really important that you keep your shutter speed up. Start with a low ISO, but be willing to increase it if you need a faster shutter speed than your current ISO/aperture combination allows. Be careful that you keep your shutter speed fast, or use strobes or flash to capture the moment. Once these items are checked off your list, you are ready to invite the child onto the "stage."

Invite a Friend

More than anything else, older kids are interested in their friends. Let them invite a friend and make it an educational session where you will teach the friend how to be a kid wrangler. This puts the spotlight on the friend and will make your subject feel more at ease. When you're done embarrassing the friend (and getting great pictures of your subject), you can turn the tables and let your subject get behind you and the camera.

KID QUOTE

Playing with my microphone and headphones, Julian pretends to host his own radio show: "And now, in Russia, it's going to be sunny, and sunny, and sunny, and sunny, and sunny, and sunny, and now for today, I don't want to upset you, but it's going to be a couple days of rainy."

Engage with Your Subject

ONCE YOU'RE READY—all equipment in place and all the dials and buttons set the way you desire—then you need to make a connection with the child and get ready to do some fancy footwork. You have to stay on your toes when photographing these fast-moving subjects. But first, you need to make sure they are "with you" and interested in you and the task at hand.

The first step required in engaging the child, especially if you're working alone, is to come out from behind the camera. Set up your tripod. This will allow you to engage your subject, and also, depending on the age and height of the child, it may make it easier for you to shoot from his eye level. If you have one, use a remote control to further allow you to keep your face out from behind

this unfamiliar, foreign black box. The logic here is simple: If I'm always burying my face behind the black box of the camera, I cut off the interaction that can happen between me and my subject. By using a tripod, I need not worry about accidentally shifting my composition when I take my face out from behind the camera.

Then work to mold the child into a quick pose, if possible. If you want him to do a certain pose or action, do it with him. This will both give him an example he can follow and show him that it's safe—that you're not asking him to do anything that you wouldn't do yourself. Once you see things shaping up, quickly go back behind the camera and shoot. Don't wait for everything to be perfect. Head back to the camera as soon as you see your subject heading toward the position, angle, and action you are hoping to capture.

HOW TO TALK TO KIDS

Want to elicit natural, fun expressions? It's simple: Just talk to your child subjects in a genuine way. Talk with the child about the things that interest him. Ask him about a few of his favorite toys, his favorite subject in school, or favorite action hero. Get him engrossed in a conversation so he forgets that you are trying to take his picture. When you see the right unguarded moment, shoot! Resist the urge to say "smile." Ideally, you want genuine engagement, rather than a reaction to a requested expression.

"Daddy, stop typing—look at this— now another click!"

These three images were captured in my home studio one day when Julian was willing to put on an impromptu "fashion show" featuring a few of his new outfits.

FAR LEFT: PHOTO © JIM MIOTKE. CANON D30, 1/90 SEC AT f/11, ISO 100, 28–105MM LENS AT 43MM.
CENTER: PHOTO © JIM MIOTKE. CANON D30, 1/90 SEC AT f/11, ISO 100, 28–105MM LENS AT 43MM.
NEAR LEFT: PHOTO © JIM MIOTKE. CANON D30, 1/90 SEC AT f/11, ISO 100, 28–105MM LENS AT 38MM.

Keep the Energy Level High

FOR MOST CHILD PHOTOGRAPHY, you need to keep up a feeling of enthusiasm because that creates a sense of engagement in the eyes. If the subject gets bored or tired, this will be obvious in the final photos. In addition to moving and talking quickly and energetically yourself, you can keep the energy level high by having the children do the following:

❏ Dance to upbeat music.

❏ Jump on a fitness trampoline.

❏ Run around a chair three times.

❏ Stretch and/or do callisthenic exercises.

❏ Sing a favorite song (for this purpose, I recommend keeping CDs of popular kid music at hand).

For images with the greatest sparkle in the eyes, do whatever it takes to keep the energy up and the subjects feeling light and enthusiastic. The key is to just be loose and goofy, responding to the moment. If something strikes you as humorous, say it. This is your opportunity to let your hair down. Don't try too hard to be funny. The best reactions come from funny noises and sight gags. It's all about getting the child to react to your behavior, so you need to be in the right spirit, watching for opportunities to make light of something.

SIZING UP THE CHILD

How you behave to elicit an expression depends on the child or children you're photographing. That is why it's important to first size up the subject, even when the subject is your own child. Beyond assessing the age group of the child, you will find it very helpful to consider beforehand how shy or sensitive the child is at that particular moment. A highly spirited child will be able to handle a lot more teasing and loud interactions. Ask her some basic questions (favorite color or favorite food, for example), and judge her character and mood by the way she answers.

GOING BIG OR SMALL

Once you have an idea in your mind about what kind of person you're dealing with at the particular moment, you can tailor your interaction to get the best results. To get a big smile from an outgoing child, for instance, go big and loud. Make your facial expressions and gestures extra animated and speak with bravado. To get a subtle or soft and pensive expression from a shy child, go small and talk softly.

When Kids Are Too Cool for School

What do you do with a kid that really doesn't want to be there or who is purposely trying to sabotage your shots by frowning or making faces? Or when your subjects are at that age when squeaky toys and goofy grown-ups are no longer "cool"? When kids are proving to be challenging, bring out the big guns. If you feel they can take it, tease them playfully. They will often get more relaxed the more you tease. Then they realize that you are not taking this picture-taking business so seriously. Don't try to be cool yourself. Just show them that this is fun, not work, by picking on them with a playful attitude. This can backfire if your child is shy, so it's important to first size up the child and mood quickly before the shoot. But if you are being faced with outbound rebellion, teasing may just be your best and only option.

As children get older, they quickly become intolerant of anything that smacks of being treated like a baby. Be careful to not use "goo-goo, gah-gah" baby talk with toddlers and refrain from any kind of baby voice with older kids. Feel free to mold the child and direct them to a photogenic place, but be sure to stay genuine at all times and choose a form of manipulation that best suits the subject at hand. Trying to force a smile may not work. Look for the tender and relaxed expressions in addition to the joyful moments.

TO GET ATTENTION, GIVE ATTENTION

If you want children to give you their time, be prepared to give generously of your time. Don't be in a hurry. Take your time and enjoy the moments leading up to the time when your subjects open up to you (or forget about you altogether!). While you're waiting, give them what they most desire—attention (or sensitivity and personal space for shy kids). If you want to get their attention, you must lavish attention on your subjects. Engage with the children and give all sorts of praise to make them feel good about themselves.

As photographer Jean Hildebrant explains, "When photographing children, it helps to keep them laughing, and watch for those relaxed moments when their unique personalities can shine. This photograph was taken on an afternoon in early September when I was visiting my nieces and nephew. I was caught without my tripod, and so this image was captured handheld. I love the contrast of their skin tones—the rich warm hues of the siblings against the fair, pink tones of their cousin. The aqua blue of the water was such a beautiful complement to the complexion of the children on either side of the central girl with her wonderful red hair. They were having so much fun that even though they were less than excited about getting their photo taken, they all smiled naturally and joy seemed to radiate from their faces."

PHOTO © JEAN HILDEBRANT. CANON DIGITAL REBEL XT, 1/80 SEC AT f/5 ISO 100, 18–55MM LENS AT 39MM

KID QUOTE

"This is the bestest time I ever had!"

How to Clown Around

THE BIGGEST KEY is to just be loose and goofy, responding to the moment. If something strikes you as humorous, say it. This is your opportunity to let your hair down. Don't try too hard to be funny. The best reactions come from funny noises and sight gags. It's all about getting the child to react to your behavior—your sight gags, jokes, teasing, and funny noises. You need to be in the right spirit, watching for opportunities to make light of something.

Prepare your kid wrangler by stocking up on a variety of smile-provoking tools. Some of the most effective wrangling tools include the following:

❑ Noisemakers

❑ Hand puppets

❑ Feathers

❑ Funny noses

❑ Funny hats

Funny Questions to Ask a Five-Year-Old

"Are you married?"

"What do you do for a living?"

"Did you hear the weather report? They say it's going to rain pancakes tomorrow!"

"Do you know how to thread a Johnson rod through a cantilever?"

"Look discombobulated, okay?

Five Surefire Knock-Knock Jokes

These have been tested and found to be the most laugh-provoking knock-knock jokes for kids.

"Knock, knock."
"Who's there?"
"Shelby."
"Shelby who?"
"Shelby comin' round the mountain when she comes, Shelby comin' round the mountain when she comes!"

•

"Knock, knock."
"Who's there?"
"Japan."
"Japan who?"
"Japans are falling down."

•

"Knock, knock."
"Who's there?"
"Hutch."
"Hutch who?"
"God bless you."

"Knock, knock."
"Who's there?"
"Boo."
"Boo who?"
"No need to cry; it's only a joke."

•

"Knock, knock."
"Who's there?"
"Interrupting cow."
"Interrupting c..."
"MOOOOOOOOOO!"

Varying the animal will cause you to get more mileage out of this . . . dog, cat, sheep, frog . . . anything that makes a sound. Keep in mind that any silly joke is usually only funny once. Pick your favorite one or two jokes from the above and use them sparingly.

As with all toys, keep these laugh-getters stashed away in a toy chest or closet so they remain hidden out of sight until it is time to put them to use. At the end of the session, you can optionally reward the child who has been an absolute angel, letting her play with their favorite wrangling tool for a while.

Additionally, asking kids for their contributions and ideas will go a long way in fostering a cooperative spirit and will often lead to some of your best images, especially when photographing older children. Most kids yearn to be heard and to be taken seriously. If you welcome or invite their contributions, you will make the experience more fun for both of you. Just be prepared to follow through and try out at least one of their ideas. Give them the gift of having a say and you will often be rewarded with wonderful photos that have great memories attached to them.

Get them involved. Play and have fun pretending. Before taking this photo, I asked my son to try to pull the anchor. If this kind of thing is done in the spirit of fun, and you're willing to do some silly things yourself, too, this is a fantastic way to get great photos of your kids having fun.

PHOTO © JIM MIOTKE. CANON 5D, 1/4000 SEC AT $f/4.0$, ISO 400, 28–135MM LENS AT 47MM

Let Them Get in on the Process

It's helpful to involve your children in your picture-taking, whenever you can. That's one of the fun things about using a digital camera. By using the LCD screen, you can show your subjects the photo after you take it. You can tell them what you are going for—"Wouldn't it be fun to have a photo of you making a pirate face!"—and get them into the idea of acting, or participating in the photo shoot in a more active manner. In this way, they become a part of the process. It's no longer them just staring at that unfamiliar black box we call a camera. They get involved and feel creative themselves. Then as they grow older, they come to enjoy the picture taking process. The problem actually becomes that they love looking at the pictures so much that you end up having a hard time keeping them from going *behind* the camera. Sometimes they will seem to become so interested that you have to do some extra work to get them back onto their marks. Kids often love to come behind the camera and look at the LCD screen. This is a great thing. Sure it takes more time and occasionally a greasy-fingered kid will touch your LCD screen. But that's a small price pay for the great expressions you'll get in exchange for inviting the children into your space.

Make More Kid Photographers

If you encourage your kids to be interested in photography, you just might have a fun hobby to enjoy together.

Kids greatly enjoy being invited into the picture-taking hobby. They get to be creative and spend more time with the ones they most love. What a great benefit of shooting digitally, where they can take as many images as they like without added expense.

ABOVE: PHOTO © DENISE MIOTKE. LEICA D-LUX 3, 1/100 SEC AT *f*/4 ISO 100, 28–112MM LENS AT 28MM. RIGHT: PHOTO © DENISE MIOTKE. LEICA D-LUX 3, 1/100 SEC AT *f*/3.6 ISO 100, 28–112MM LENS AT 28MM

I love how photographer Sher Skinner placed this subject—it's a perfect example of using the rule of thirds for a full-body portrait. Sher explains that the child "wanted to have her photo taken with some old tractors in a field and claimed that to be the perfect shot. We had to pass this old truck to get to the tractors. I asked her to take her photo with the truck, but she would not to have any of it. The pouting started and then the long look toward the tractors, which is what I captured. I could not have planned it that well. The setting sun was the final touch."

PHOTO © SHER SKINNER. CANON 20D, 1/320 SEC AT ƒ/13, ISO 400, 27MM LENS

What a great way to have fun with your older backup camera! For this beautiful child photo, Jennifer Short used natural light from a large bay window to light her subjects. She let them play with a spare camera—providing both a prop for great pictures and a creative endeavor that kept the kids interested.

PHOTO © JENNIFER B. SHORT. CANON 5D, 1/100 SEC AT ƒ/4, ISO 100, 60MM LENS

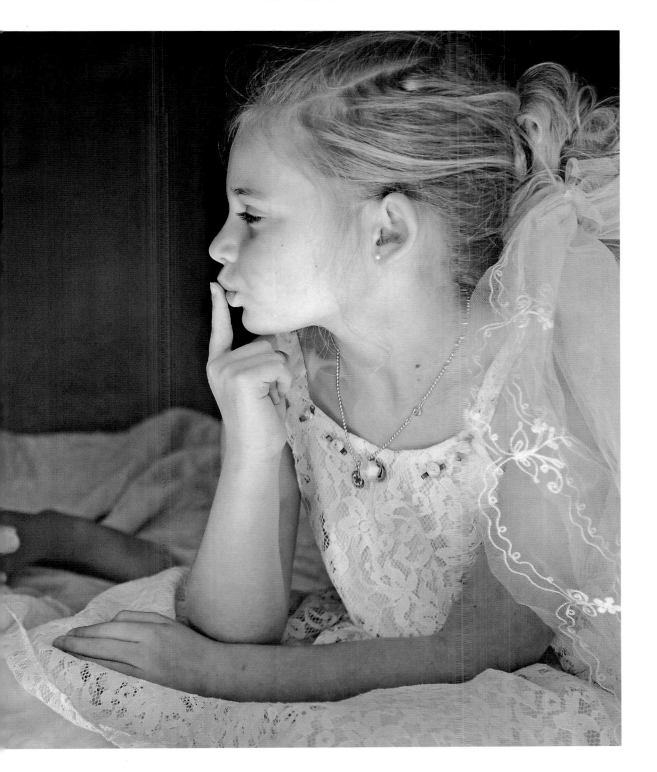

Have Fun Playing with Your Kids

THE FOLLOWING ARE A FEW SUGGESTIONS to help you find ways to play with your kids. Of course, the opportunities are endless. Anything you or your children can imagine (and afford) could very well provide an awesome opportunity to take pictures. A few to get you started include swimming in a pool, playing at the beach, blowing bubbles, playing peek-a-boo, playing hide-and-seek, playing dress-up, or simply goofing around without a plan.

PLAYING IN AND AROUND WATER

If you purchase a soft underwater case or other protective housing for your camera, you open up all sorts of fun opportunities for taking pictures of the kids.

My wife photographed me as I captured images of our son playing in the pool and in the waves. Sometimes you have to get your feet wet, both figuratively and literally! To protect my camera in such shooting environments, I use a soft underwater camera housing.

TOP LEFT: PHOTO © DENISE MIOTKE. LEICA D-LUX 3, 1/400 SEC AT ƒ/5.6 ISO 200, 28–112MM LENS AT 75MM. BOTTOM LEFT: PHOTO © DENISE MIOTKE. LEICA D-LUX 3, 1/400 SEC AT ƒ/5.6 ISO 100, 28–112MM LENS AT 105MM. TOP RIGHT: PHOTO © JIM MIOTKE. CANON 5D, 1/60 SEC AT ƒ/10 ISO 100, 28–135MM LENS AT 28MM. BOTTOM RIGHT: PHOTO © JIM MIOTKE, CANON 5D, 1/200 SEC AT ƒ/9.0 ISO 160, 70–300MM LENS AT 70MM

BLOWING BUBBLES

A perennial favorite, blowing bubbles, works every time. It's a great way to delight kids of all ages. My only advice is to save it for last, when the energy of the shoot finally seems to be dissipating. This will allow you to keep kids' attention longer (as they will be looking forward to the bubbly reward), and it keeps everyone clean. Bubbles can get a bit messy.

For this profile, the photographer engaged with the child by blowing bubbles with her. She used the natural light inside a garage. Like window light, light coming in from an exterior door can provide a softness that lends itself perfectly to child portraiture. This photo also provides an example of how much a photo can be improved by simply cropping. The "before" version is fine, but the "after" version has much more impact. It is ideal to move in close or zoom in at the time you take the picture, but if you need to, feel free to trim off the edges later. Your file will not be able to print as large as the original; other than that, there is nothing wrong with cropping an image to improve its composition and overall effect.

PHOTO © JENNIFER E. SHORE. CANON 5D, 1/50 SEC AT ƒ/7, ISO 100, 105MM LENS

*I love the composition of this bubbly photo. Also, the intense expression of curiosity is
perfectly recorded by photographer Monika Sapek.*

PHOTO © MONIKA SAPEK. CANON POWERSHOT G1, 1/60 SEC AT *f*/3.5, ISO 100, 34–102MM LENS AT 85MM

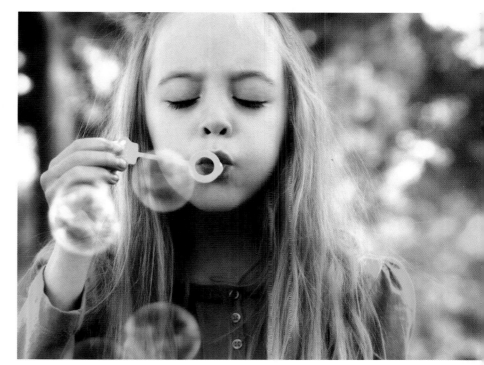

"I usually shoot in open shade whenever possible," says photographer Amy Parish. "My daughter here is less cooperative when it comes to pictures, so I have to give her something to do, like bubbles. I had her stand on a log, so she was closer to my eye level without my having had to get down at her level, and that way I was able to get the foliage in the background."

PHOTO © AMY PARISH. FUJI S3 PRO, 1/90 SEC AT f/4, ISO 200, 28–75MM LENS AT 70MM

Make Them Wait for the Silly Photo

Some parents have a hard time getting their son or daughter to take a "serious" picture, one in which they are not goofing off and making faces at the camera. To find a solution, I asked my son this question (since he is often guilty of doing the same thing): "Why do kids act goofy instead of taking a serious picture?" He said, "Because it's fun!" His solution: Say "Hold off on the goofing off until later. We will do a bunch of fun photos at the end, as soon as we've done a good job getting the kinds of pictures your mom and dad want."

Photographer Alison Greenwood says her daughter "was being very mischievous that day, going out of the gate when she knew she wasn't supposed to. Hence the crafty little smile on her face."

PHOTO © ALISON GREENWOOD. CANON 40D, 1/100 SEC AT ƒ/4.5, ISO 800, 50MM LENS

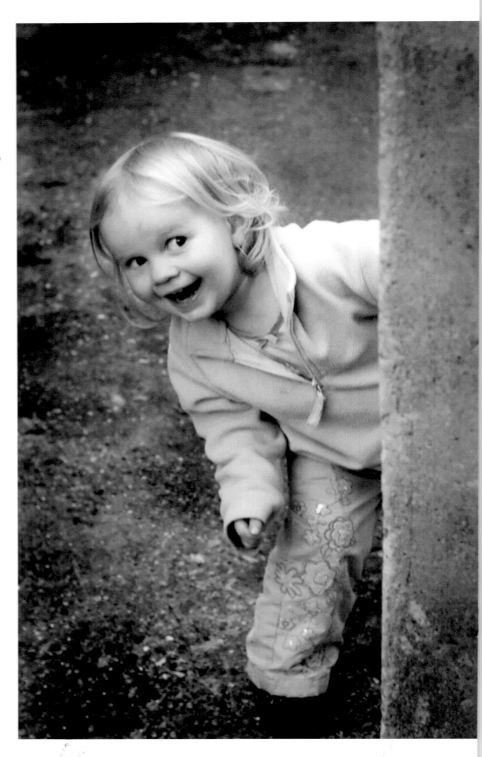

PLAYING PEEK-A-BOO AND HIDE-AND-SEEK

When your kids are not connecting with you because your face is hidden behind the camera, change tactics and make a game out of it. It's easy to play hide-and-seek or peek-a-boo darting back behind the camera from time to time. Kids love it and the images can be enchanting. Just be sure to keep your shutter speed fast. Start with a shutter speed around 1/125 second and make it faster if your first images appear blurry. If the light is so low that your shutter speed cannot be made any faster, even when shooting with the smallest *f*-stop number, use a higher ISO. Or better still, see if it's possible to move the game to a brighter location.

GOOFING OFF

Kids don't need a planned activity to have fun with their parents. They love it when we spend time with them—with or without a plan. Feel free to throw your plans out the window and just let the kids get goofy. It can be an especially effective strategy to use the "goofy time" as a reward at the end of a more serious portrait session.

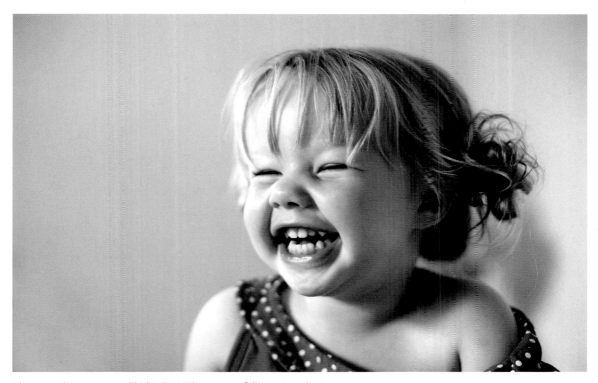

Photographing in natural light, Erin Tyler successfully captured a textbook case of the giggles for this shot. What parents would not be delighted to have a record of the beautiful laughter of their little girl?
PHOTO © ERIN TYLER. CANON 5D, 1/320 SEC AT *f*/2.3, ISO 800, 50MM LENS

KID QUOTE

"In college, do they have recess?"

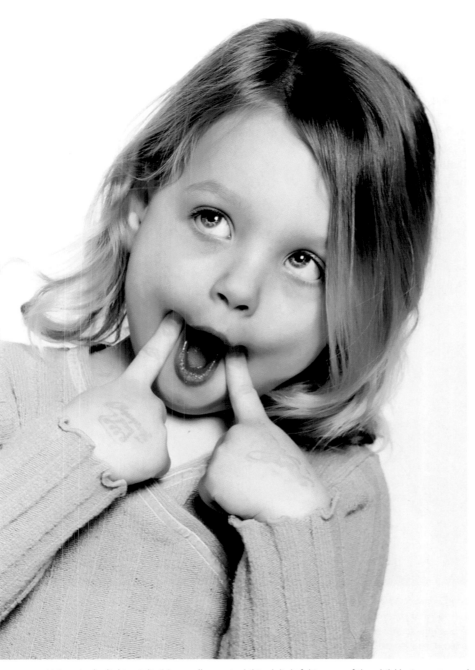

Using studio lights, Julie Monacella created this delightful image of the child being cute and funny—just goofing around. Note the diagonal composition adds energy to the portrait. The photo succeeds because Julie captures the expression that best engages the audience.
PHOTO © JULIE MONACELLA. CANON DIGITAL REBEL XT, 1/160 SEC AT ƒ/5.6, ISO 100, 24–70MM LENS AT 54MM

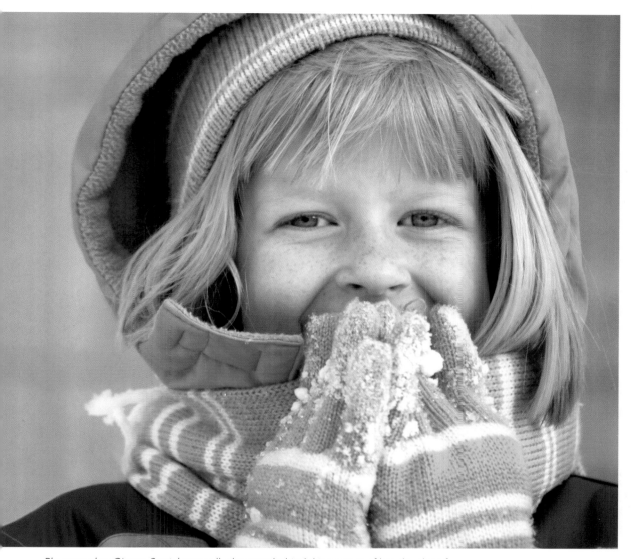

Photographer Gianna Stadelmyer tells the story behind this portrait of her daughter for a BetterPhoto.com class assignment: "She was cooperating, but every shot looked too rigid and posed. I kept saying "Smile at the camera!" So instead, I started telling her jokes to make her relax and giggle. At one moment during the jokes, she threw a snow-ball at me and put her hands to her face giggling about it. Because I never took the camera from my eye, I was able to catch that moment."

PHOTO © GIANNA STADELMYER. CANON EOS 300D, 1/500 SEC AT ƒ/5, ISO 400, 70–300MM LENS AT 218MM

PLAYING DRESS-UP

Kids love to dress up. Make a photo shoot really fun by letting them play and pretend. Keep a bin dedicated to old clothing and accessories that you think your kids may enjoy. Hats, sunglasses, cheap jewelry, and other items all make great additions to the collection. and be sure to collect Halloween costumes ranging from pirate outfits to princess gowns. All of these costume parts—from angel wings to eye patches—are loved by boys and girls alike.

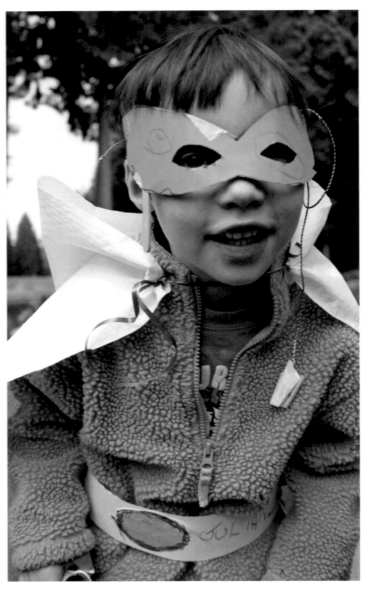

Don't want to spend the money on expensive costumes and props? No problem! Make your own! This will give you even more quality time with your kids, and you can come up with some fun photos of great memories. After all, the photo is going to trigger a memory, so why not be sure it's a happy memory.

ABOVE: PHOTO © JIM MIOTKE. CANON 5D, 1/320 SEC AT ƒ/5.0 ISO 100, 28–135MM LENS AT 50MM.
RIGHT: PHOTO © JIM MIOTKE. CANON 5D, 1/250 SEC AT ƒ/5.0 ISO 100, 28–135MM LENS AT 28MM

One of the benefits of having a home studio is that I can photograph my children any-time they get a cute new outfit. A quick session in the studio allows me to record those clothes before they get tarnished, as kid clothes always do.

LEFT: PHOTO © JIM MIOTKE. CANON 5D, 1/125 SEC AT ƒ/8.0 ISO 100, 28–135MM LENS AT 70MM. RIGHT: PHOTO © JIM MIOTKE. CANON 5D, 1/160 SEC AT ƒ/11 ISO 100, 28–135MM LENS AT 56MM

ASSIGNMENT Play Date

Set up a play date with your child. Get out the old costumes and play dress-up. Blow bubbles. Play peek-a-boo. Go to the playground and photograph your kids playing on the swings or merry-go-round or see-saw. It doesn't matter what you do, as long as you set up the play date and get prepared for a fun photo shoot.

Pretending Is Honest Playfulness

IT GOES WITHOUT SAYING that it pays to be truthful with people of all ages. If you want an expression, don't promise a reward with no intention of delivering on your promises. Don't try to be "cool" or pretend to be somebody you are not in the hopes of winning favor. People can usually tell when truth is being spoken, and kids are better than most people at spotting lies.

However, kids do know the difference between dishonesty and the world of pretend. If you say you're a giraffe and you can't find any leaves to eat, they'll eagerly play along with a glint in their eyes. Most boys love to be pirates, spies, cowboys, garbage men, firefighters, sol-diers, and a variety of animals. Girls love to become princesses, horse riders, angels, fairies, and often all the same things boys would like to become. Use your imagination to kick something off and be prepared to witness a superior imagination take over. Go along for the ride, occasionally responding to play your part.

Don't worry about what any other adults around you think. If you cannot let your hair down with others about, ask them to leave or stand a ways away, so you can play and pretend without inhibition. Do whatever it takes to have a fun playtime with the little one, while remaining in control of your immediate environment.

KID QUOTE

I ask Julian to let me be a bit because "I just need to concentrate to get my work done." He replies, "I don't need you to get your work done, Dad."

Rewarding Your Child

Some call it bribing. I call it "positive reinforcement." Whatever you call it, promising the child a reward can be a double-edged sword. It will often give you just a bit more time and cooperation from the child. It can also be a distraction or obsession, where the child can talk about nothing but the reward. I have never been able to get a particular expression by promising a reward ("Smile for just a few more photos and you can then have some ice cream"). For anything other than funny faces, requesting of an expression rarely works. Rather, prompt the expressions you are aiming for with your own or an assistant's behavior. Use the reward for nothing more than an extension of their time in front of the camera.

Note: Be sure to ask parents beforehand if you would like the option of rewarding the young one with candy, soda, or another food treat. This goes for extended family, too. If you're photographing your grandchildren, take it from this parent: Please don't give your kids sweets without asking the parent first. Yes, I know that this is the Grandparents' Prerogative, established at the Beginning of Time and passed down throughout the generations. All the same, check with parents first before rewarding others' children with any kind of food or drink. Great alternatives to sweet treats include stars, stickers, and temporary tattoos. These go a long way with kids of all ages.

Toys and Props

IT SOMETIMES HELPS to allow the child to hold or play with a favorite toy until she is warmed up. Familiar, well-loved toys and things help make kids feel at home. Sometimes they will even forget they are having their picture taken, just a few moments after you introduce a favorite stuffed animal. In addition to being a useful icebreaker, these additions will be welcomed by your chil-dren. As they grow older, they will enjoy being reminded of a particular toy or fuzzy friend.

You can use almost anything to add to the moment when photographing kids. The best props are simple, colorful, and timeless. Simplicity and color can add beauty to a composition. Timelessness is important if you are interested in classic child photos that don't become too dated

This boy enjoyed tooting this toy horn for several minutes, more than enough time for me to make several exposures.
PHOTO © JIM MIOTKE. CANON 5D, 1/125 SEC AT ƒ/7.1 ISO 100, 28–135MM LENS AT 112MM

over time. Avoid anything with a logo. Such branding can overpower the subject and distract the viewer's attention.

Just remember that props are secondary. The best, most timeless photos are going to be those images with just the child—of a natural, beautiful expression. Your number-one goal is to capture the spirit of the child. Use props if they help you get images of that spirit, but also take images that don't include the prop.

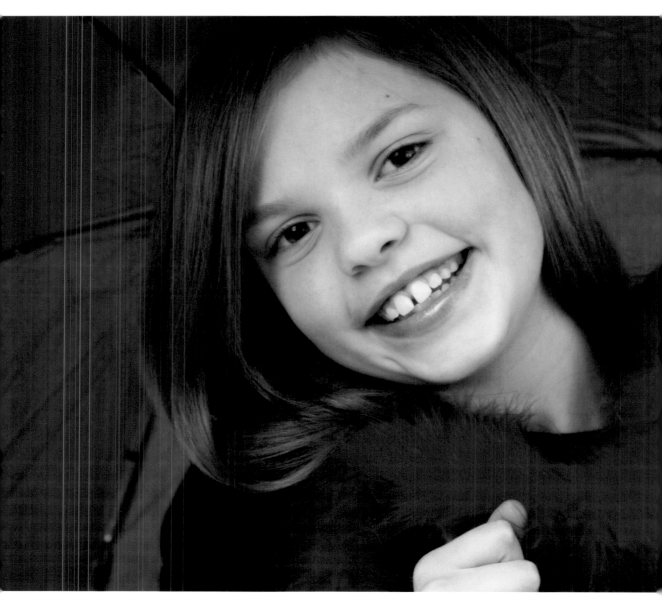

This girl had great fun and looked super-photogenic as she played with a number of props in my studio—including this red umbrella and feather boa.

PHOTO © JIM MIOTKE. CANON 5D, 1/125 SEC AT *f*/7.1 ISO 100, 28–135MM LENS AT 120MM

Distract Before Removal

After capturing some images with a prop, remove the prop so you can capture more images without it in the picture. A word of caution: Unless you want images of a crying child, be sure to distract the child before removing the prop. If you're employing the services of a kid wrangler, ask your helper to clown around more than usual for a minute. Alternatively, you can talk about another interest. If the child appears attached to a toy such as a stuffed animal, you can pretend to employ it—for example, "Let's see if doggie will take the picture!"

TIP

Well-loved blankets and stuffed animal friends can look tattered and dirty. For some parents, this is perfectly fine. I don't mind pictures with my son's well-worn little stuffed dog, Muffy; it delights me to see him with something he so loves. However, I also make sure I get plenty of pictures without Muffy. Variety in images is the key.

Expand Your Horizons

You can expand your portfolio of great kid photos by photographing children wherever you find them—at friends' homes, around town, in the playground. However, always be respectful of people's privacy. Photographer Jessica Sandberg explains how she approached strangers in a restaurant to capture this wonderful portrait: "I saw this beautiful little boy. His eyes just captivated me and I couldn't resist taking his picture. I approached his parents and explained that I was a photographer and that I couldn't pass up the opportunity to photograph their son. They kindly accepted."

Keep in mind that to use images of people in any commercial way, including entering them into contests that award prizes, you need to get model releases. Carry with you at all times simple releases for both adults and minors. When you ask people to sign them, explain their purpose and what you intend to use the pictures for. If you're organized and diligent enough to follow though, you can offer them a 4 x 6, 5 x 7, or 8 x 10 print as a thank-you for their time and modeling services.

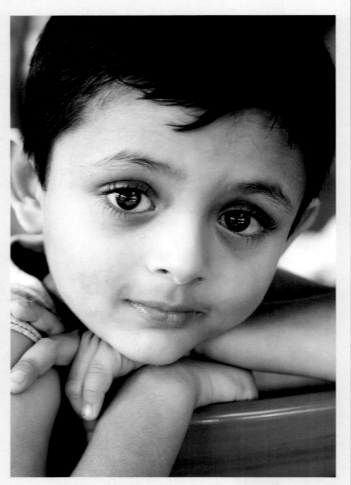

After asking permission from this boy's parents to photograph him, Jessica Sandberg seated him close to a window where she could get the best possible light. She took about six quick pictures. She says, "This one is my favorite since it shows the depth of his eyes."
PHOTO © JESSICA SANDBERG. CANON 20D, 1/40 SEC AT *f*/4.5, ISO 400, 28–77MM LENS AT 63MM

Pets

BY PHOTOGRAPHING YOUR SUBJECT with a favorite pet, you can make a more meaningful portrait. It also gives the child something to hold that's important to them. This addition to the portrait often makes the entire process more of a fun, special occasion. The child will get to interact with the animal, and hopefully forget that you're taking a picture. You have to be quick and careful, though, when using a pet or special object. You can easily lose control of the session.

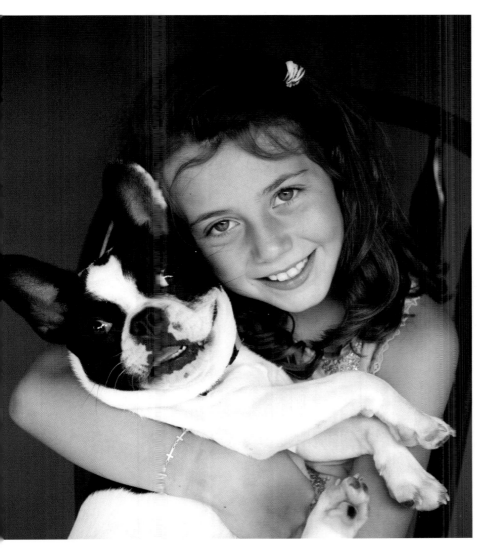

This photo shows great use of the light just inside the photographer's garage. Megan Peck explains how she got this shot of her daughter with their family dog: "I was setting up some paper in the garage to try and get some photos of my daughter for her birthday. Our puppy came out and got all excited about what we were doing, so my daughter grabbed her for a hug and I grabbed the opportunity for a photo. These two adore one another, so I was thrilled to capture them as they really are."

PHOTO © MEGAN PECK. CANON 5D, 1/250 SEC AT ƒ/4, ISO 400, 50MM LENS

Shoot Fast, Shoot a Lot!

CREATING TRULY WONDERFUL child photos is less about painstaking precision and more about flexibility and speed. As mentioned previously, the key is to get your act generally together beforehand and then start shooting like crazy. You want to shoot both frequently and quickly, responding in a heartbeat every time you see a pose or an expression shaping up to be something potentially interesting. With kid photography, you cannot wait for the perfect situation to materialize before you take the shot. You need to have your camera in hand and ready to go so you can react almost without thinking.

In addition to shooting quickly, you need to make a lot of images to get one great keeper. In a group portrait, one person is bound to blink during exposure. Or one child will be looking directly into the camera with the most delightful, charming expression while the other two kids are looking up or off to the side. At yet other times, one child will be using this as an opportunity to assert his dominance over his sibling. There is only one solution to this array of potential problems: Shoot a ton of photos! Don't settle for just one or two. The key is simply to shoot, shoot, shoot. Aren't digital cameras wonderful?!

Go with the Flow

It's essential that you have a plan—that you have creative ideas such as poses to try or props to use. In the end, though, when it comes time to actually start shooting, you will often need to simply let go of your preconceived ideas and go with the flow.

When you feel as though you've got the shot, stop and let your models go play. Don't push it. If you do, they may start associating time in front of the camera with boredom or, worse, frustration. And you don't want that to happen. Once the novelty of the photography event wears off, you will no longer be the center of attention. Or perhaps your subject simply crashes—having a hunger-induced fit. Either way, when the moment is gone, when the energy turns sour, it's time to call it quits. If you do not feel like you got several good photos, either break for a while, allowing the kids and parents some much-needed downtime, or reschedule. The window of opportunity can be very small, but, all the same, you must respect the needs of your subjects and their guardians. If their needs are not being met at the moment, set up another time to finish the shoot. Make it short—and be willing to come back another day.

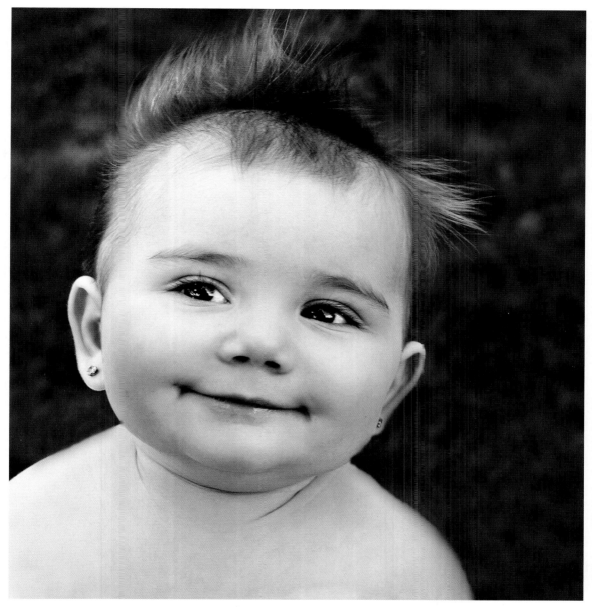

This funny and cute baby photo was taken outdoors on a shady lawn. The day was breezy (hence the wind blown hair). Even though the baby was completely cooperative and seemed to enjoy her photo session, photographer Denise Synder had to work quickly. This moment would have come and gone if she had not been fully prepared to shoot it.

PHOTO © DENISE SNYDER. NIKON D200, 1/160 SEC AT ƒ/5.6, ISO 100, 50MM LENS

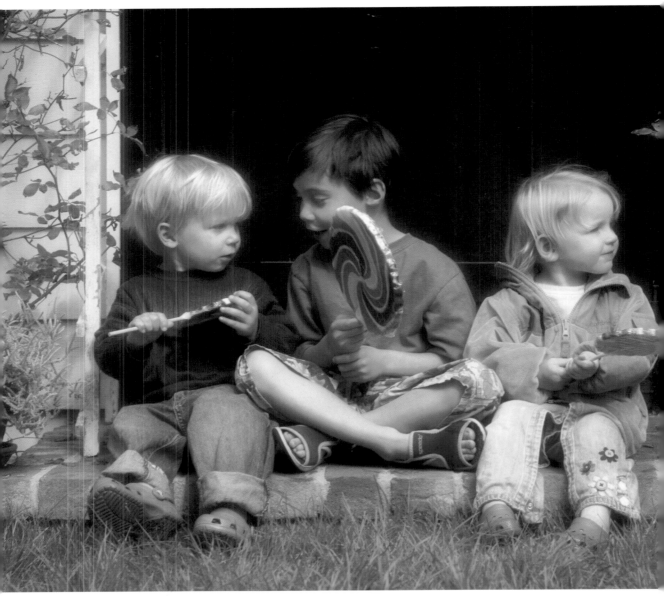

Even the most seasoned professionals know that they have to take many photos to get one good winner. I made over forty attempts to get this one photo that successfully captures the moment.
PHOTO © JIM MIOTKE. CANON 5D, 1/80 SEC AT ƒ/9.0 ISO 200, 28–135MM LENS AT 100MM

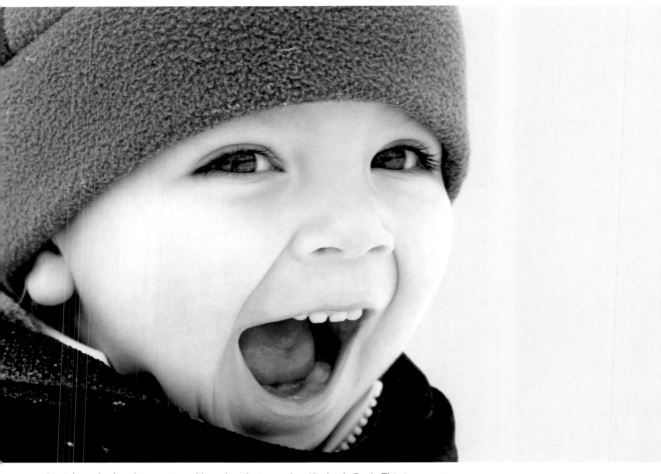

I just love the laughter captured here by photographer Kimberly Peck. This is a great example of both shooting quickly and using a fast shutter speed to capture the moment.
PHOTO © KIMBERLY PECK. CANON 20D, 1/400 SEC AT ƒ/7.1, ISO 400, 60MM LENS

KID QUOTE

Julian picks out a bulldozer to play with and says to it,
"You're my favorite . . . aren't ya, little cutie!"

CONTINUOUS SHOOTING MODE

When photographing kids and pets, I often work in a continuous shooting mode. When the subject is moving fast, catching the decisive moment becomes much more difficult. Firing off three shots right around the time you see an expression beginning to occur greatly increases your chance of getting the shot.

There are two exceptions: when I am using my flash and when my camera is tethered to a studio lighting system. In these situations, my light sources usually need a moment to recharge. Because of the additional recycling time required by the lights, I find the single shot or one-shot mode best in these circumstances.

At all other times, I can either take shots one at a time, slowly but surely, or I can take shots really fast in a continuous or burst mode, which is comparable to a motor drive on a high-end film camera, making several exposures every time I press down the shutter button. I usually prefer to shoot in a continuous mode and just get as many shots as I can, because when the subject is moving as fast as Julian is, and the bubbles are moving so fast, I can't predict exactly what's going to be in the photo. So whenever I see a photo op coming, I take three or four photos at the same time. This greatly increases the chance that one will be acceptable in terms of both focus and composition.

ASSIGNMENT Quick Kid Portraits

When you are about to photograph a child or pet, it's crucial that you be prepared to work quickly. Here are the things you should do to get ready:

1 Attach the remote shutter release to your camera.

2 Attach camera to tripod and attach anything else you might use, such as a studio strobe setup or external flash unit.

3 Make sure your ISO and other settings are as you see most fit. I start most sessions at ISO 100 with the AF setting and matrix metering turned on. I also prefer white balance, one-shot focus, and aperture priority.

4 Place your tripod and compose quickly. Don't worry about things being perfect.

When, and only when, you're all set to go, call in your models and shoot, shoot, shoot!

After you've captured a few images, upload your favorites to BetterPhoto.com. Enter the contest or simply upload them and request discussion. If you want to get maximum feedback, spend time giving feedback to others; they will often respond with reciprocal generosity. Alternatively, sign up for one of our courses on photographing children or another topic. This way, you will get a constructive critique from one of our professional, published instructors. Okay, thus ends the shameless plug for my company!

Expressions Other Than the Smile

IT'S OKAY IF YOUR CHILD is feeling an emotion other than delight. When you notice your child in any pure emotion—whether it is serenity or frustration or boredom, to name a few—capture that moment. All expressions are okay to capture, even sad ones. When you're presented with the perfect pout from a toddler or a bit of a "tude" from a teenager, capture it quickly before it goes away.

Even though they may not be joyful and happy, these are the moments of unique expression that make a photo all the more interesting to an objective viewer.

Let's face it, one's own kids can sometimes be uncooperative. You may occasionally feel that you can photograph any child except your own—that your close relationship makes it easy for them to

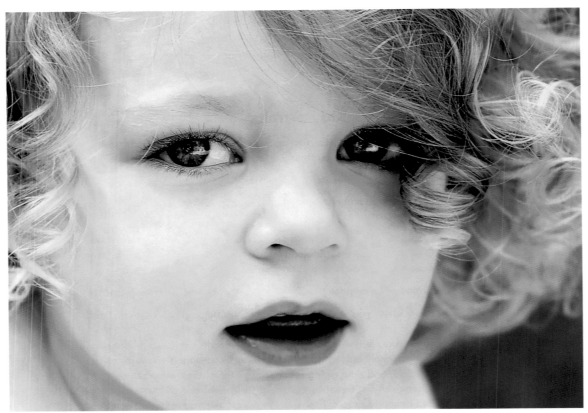

When photographer Karen Kessinger photographed this gregarious three-year-old, she admired her many expressions and interesting features. Karen said that the child was "quite a sprite! Between her bouts of laughter, I managed to capture a more pensive expression. The sparkle in her eyes, however, gives her true personality away. Even the recent addition of a new baby brother didn't dampen her spirit. Was it perhaps because I was following her around with my camera and not him? To capture this image I simply gave her time to be comfortable around me. She spent time playing in her yard with me by her side. After the novelty of my presence had worn off and she became more engrossed in her play world, I started snapping away."
PHOTO © KAREN R. KESSINGER. NIKON D50, 1/60 SEC AT f/3.2, ISO 100, 85MM LENS

refuse to give you their attention. You might be tempted at times to throw up your hands. But if, as a photographer, you can get other kids to cooperate, you can get your own to do so too. It might take extra patience, extra planning, and a little creativity. But you can find a way, and it will be well worth the effort, both in terms of your having a special time with your kids and in terms of the results you'll see framed on the mantel or hanging on the wall.

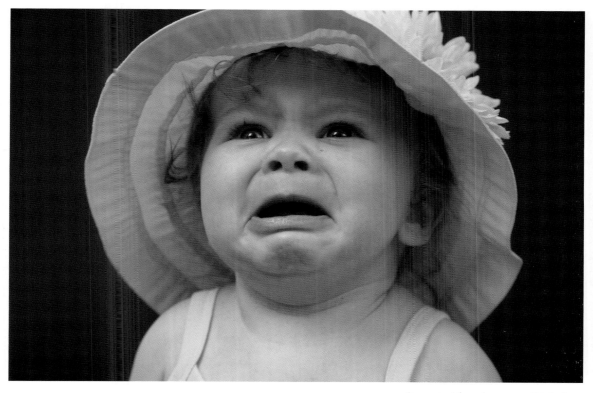

Separated from her mom, this baby was not a happy camper.

PHOTO © JIM MIOTKE. CANON 5D, 1/125 SEC AT *f/7.1* ISO 100, 28–135MM LENS AT 135MM

A Note about Overstimulation

What is overstimulation? Simply, it is too many conflicting sources of stimulation directed at the child, usually caused by too many people espousing opinions or directions in the shooting area. The solution is to remove extra parents, spouses, and other grown-ups or children. They are often just trying to be helpful, but, in the process, they are actually hurting your chances of getting a great shot. Kindly ask them to either leave or move away and remain quiet.

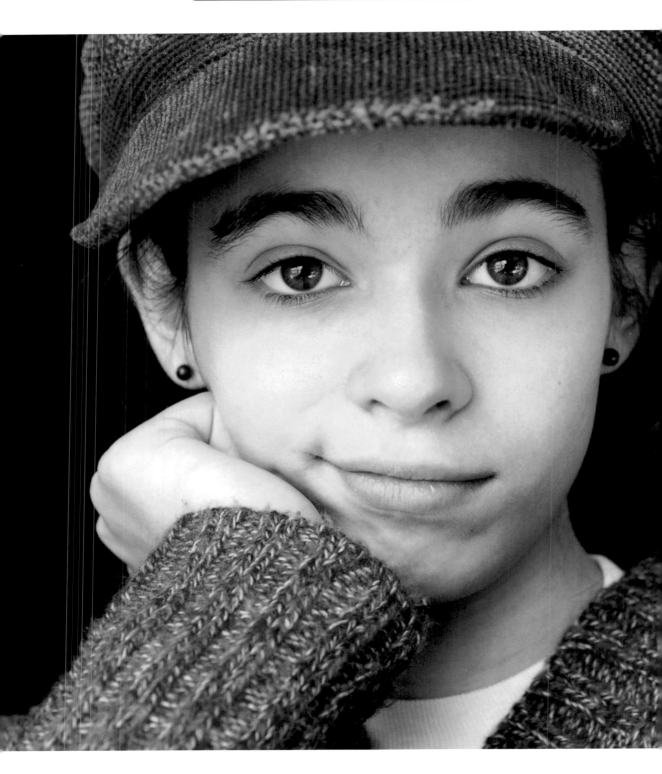

This expression was captured using natural light indoors. The photographer's daughter gave her a few poses and then produced this "whatever" look. Thankfully, the photographer was able to capture it. Sherry says she was thrilled with the result: "It says so much more about her personality—as a just-turned teenager—than any image I've ever captured!"

PHOTO © SHERRY S. BOLES. CANON 5D, 1/90 SEC AT ƒ/4.8, ISO 100, 50MM LENS

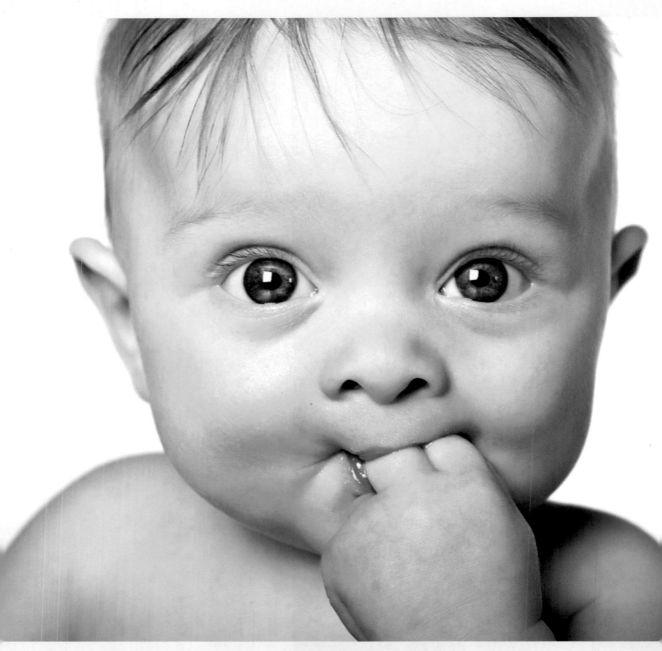

Photographer Julie Monacella used studio lights to illuminate this subject. When she got the eye contact of this baby—along with the delightful fingers-in-the-mouth pose—she responded quickly and got the shot!

PHOTO © JULIE MONACELLA. CANON 5D, 1/160 SEC AT ƒ/8, ISO 100, 24–70MM LENS AT 70MM

Eye Contact: Getting and Keeping Attention

THEY SAY THE EYES are the windows to the soul. In the same vein, photographs are windows to the subject. Think of your audience as looking through the photo at your subject. As they peer through, they want to see the subject looking right back at them— not off to the side or toward something up above the photographer. Candid photos can be wonderful—as we discussed in the introduction—but your viewers will occasionally want to see your child's face and eyes. The best of all worlds is to collect a mixture of photographic styles of your children—some portraits and some candid photos. For the portrait-style images, your goal is to capture the subject when he is most animated and interested, looking at the camera with an engaged and natural expression. Often, you want to see that sparkle in the eyes.

In this chapter, we will continue our examination of cooperation and set out to learn the following:

❑ How to get and keep a child's attention

❑ How to get the child to look into the camera so you get pleasing eye contact

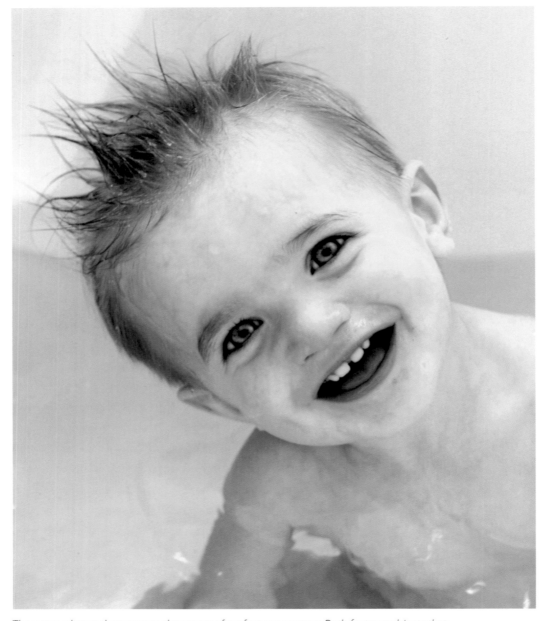

These two photos demonstrate the power of perfect eye contact. Both feature subjects that appear to be gazing through the camera, right into our eyes. For the final image of the baby in the yellow hat, the photographer set the infant on the bed with the light coming from the left from a big window. The child was super-cooperative, which certainly helped the photographer capture this charming portrait. What great eye contact!

ABOVE: PHOTO © JESSICA HUGHES. CANON 5D, 1/160 SEC AT ƒ/1.4, ISO 100, 50MM LENS. RIGHT: PHOTO © MEGAN PECK. CANON 5D, 1/250 SEC AT ƒ/4, ISO 320, 50MM LENS.

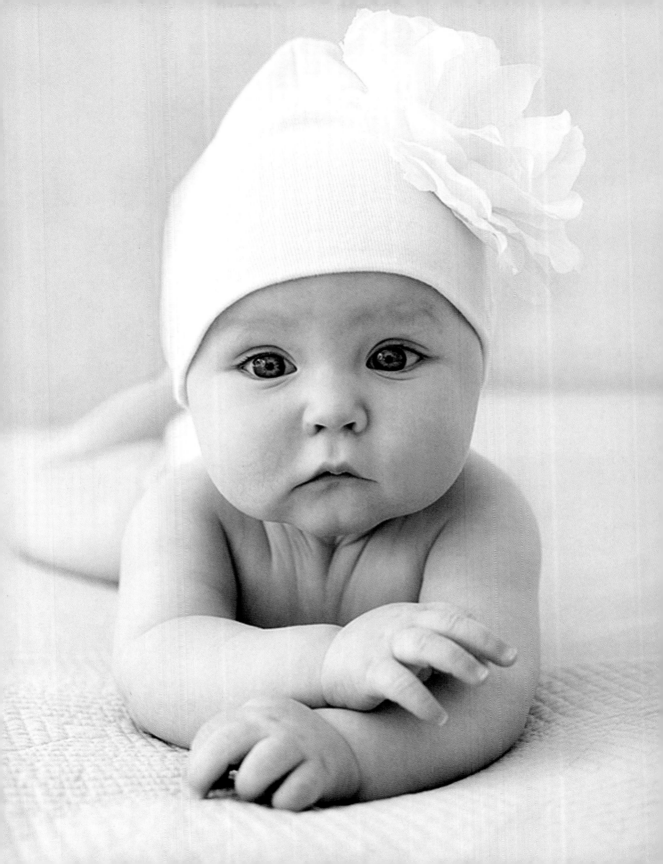

Getting Kids' Attention

THE KEY CHALLENGE goes beyond mere cooperation and requires that you grab and hold attention. Children do not yet have the patience and attention span of an adult. And toddlers have a shorter attention span than preteens. You have to be ready to make a quick photo and move on.

Making Eye Contact with Infants

Flexibility with your schedule will make the biggest difference when it comes to getting outstanding baby photos. If it just does not seem to be working during one shoot, set up a time to try again. Often it takes several attempts before you, your subjects, and their parents are all operating on full burners. The results can be so charming and delightful, though, that a great session is worth the time it takes.

To get a flattering photo of a baby, remember the essentials: shoot from his eye level and capture that fleeting instant when he is looking directly into the lens. A huge part of your success when photographing babies is dependent on food, rest, and their schedule. While you cannot always control their mood, you can try to catch them during those few moments when they are in the right mood.

When your two schedules do sync up, there are many things you can do to get babies' attention. Making infants smile or laugh is all about bold colors and noise makers. A xylophone or bells with different tones can be employed to get babies' momentary attention. Infants require that you get very close to them. Allow them to see you and connect with you for a moment.

Above all, be patient with both yourself and the infant.

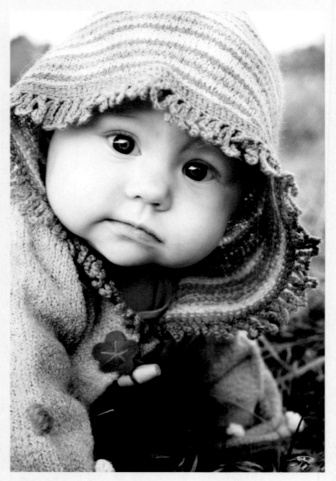

Getting down on the baby's level, photographer Kimberly Peck was able to record this delightful expression.

PHOTO © KIMBERLY PECK. CANON 20D, 1/100 SEC AT ƒ/7.1, ISO 400, 35MM LENS

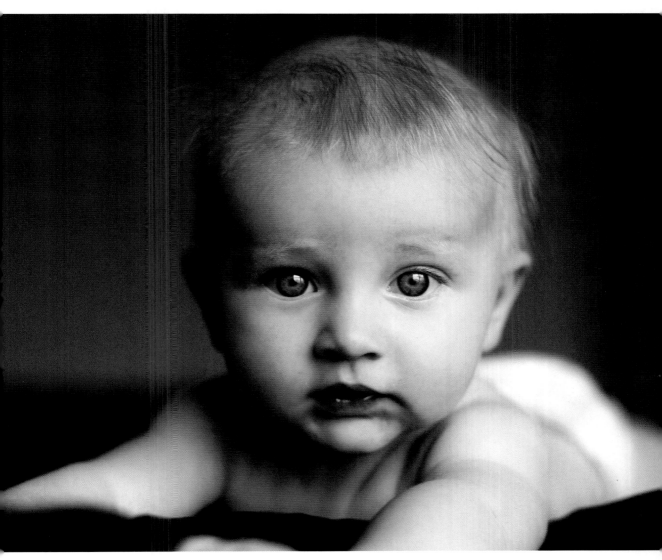

Look at the beautiful blue eyes in this baby portrait. To get this charming portrait, the photographer placed the baby on a bed near a window, which provided an abundance of natural light. After making sure everything was set and ready to go, she got the child's attention, fired away, and got this super-sweet baby photo.
PHOTO © ERIN TYLER. CANON 5D, 1/1600 SEC AT ƒ/2.3, ISO 800, 50MM LENS

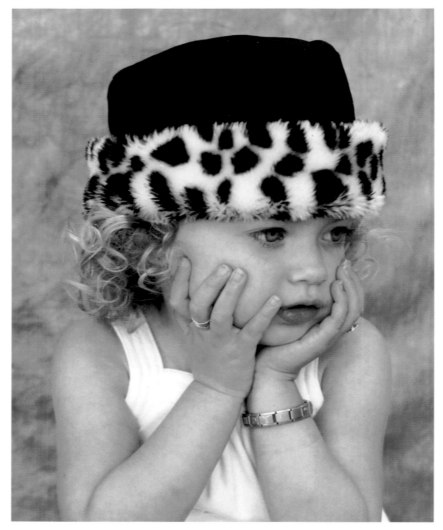

Kimberly Whipps created this sweet portrait using the light from a large window behind the camera and a small window camera left. She also bounced light off a low ceiling, using her 580EX Speedlight external flash with a Sto-fen Omni-bounce modifier. Prepared to make the most of this light, Kimberly was equipped to deal with this highly spirited child. She says, "This little gal is actually faster than greased lightning, and a moment of calm is rare. This was one of those rare moments." When the subject seemed to be losing interest (as you can see in the "before" photo above), Kimberly grabbed her attention with a funny noise and face and got the smile and sparkly eyes she was looking for. The first photo is cute but lacks the sparkling eye contact and sweet smile that makes the "after" photo (right) so good. Also notice how, although this was lit in the same way, there are no catchlights in the eyes, since there was no window to the right of the camera.

ABOVE: PHOTO © KIMBERLY J. WHIPPS. CANON 20D, 1/80 SEC AT ƒ/5.6, ISO 400, 28–135MM LENS at 90MM.
RIGHT: PHOTO © KIMBERLY J. WHIPPS. CANON 20D, 1/80 SEC AT ƒ/5.6, ISO 400, 28–135MM LENS at 90MM

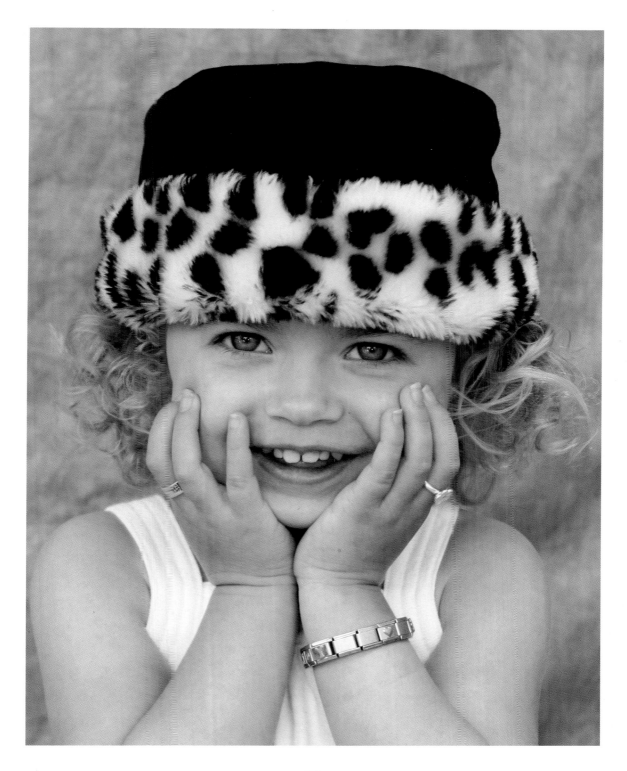

GOOD ATTENTION-GETTERS

When your goal is to capture a child's true personality, it's important to note what works to get natural eye contact as opposed to things that influence the expression too much and make it unnatural.

What works:

❏ Noisemakers

❏ Games

❏ Teasing

❏ And above all, the threat of tickling!

BAD ATTENTION-GETTERS

Eyes avoiding the camera—as when the child has "gone on strike"—are not ideal but can sometimes be used to your advantage; you can occasionally pull out a pensive or thoughtful look when the child is refusing to look at you. Even though good eye contact is required for so many photos, you can easily go too far in your efforts to gain attention. The result will be an unnatural expression or a session that backfires and ends up causing exactly the opposite of what you intended. And the last thing you want when photographing children are fake smiles.

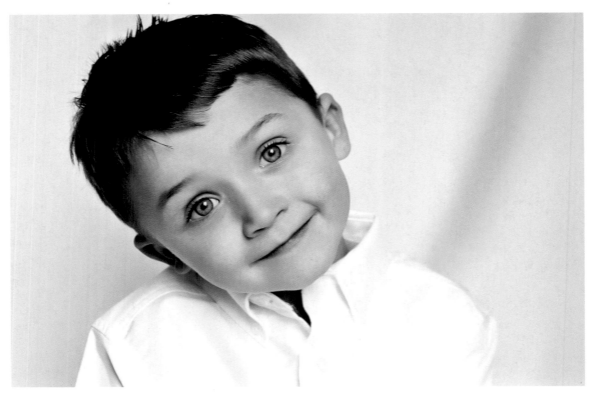

Photographer Allison Gaulin used the natural light just in front of a glass door for this portrait. When the eye contact and fun expression appeared, Allison was ready to make a few exposures.

PHOTO © ALLISON GAULIN. CANON DIGITAL REBEL XT/350D, 1/100 SEC AT ƒ/5, ISO 800, 28–135MM LENS AT 47MM

What doesn't work:

❏ Saying "Smile!" (at best, this will only elicit a fake smile or rigid, pained "camera face")

❏ Telling the child to "act natural" (What does that mean to him?)

❏ Asking the child to try to "relax"

❏ Directing the child to try to put on a certain expression.

If you do more to make children feel comfortable, asking them about a favorite toy, for example,

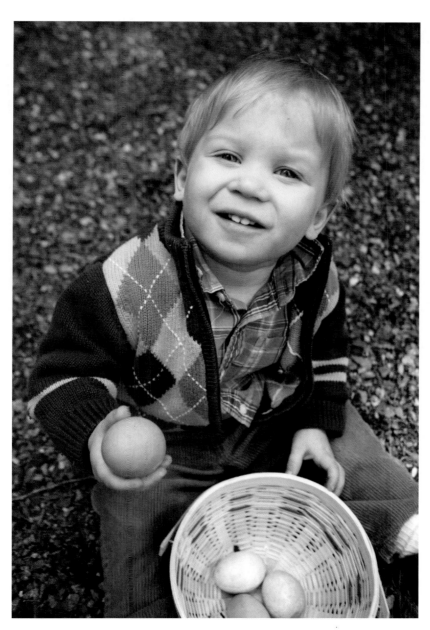

Often I will walk close to one of my kids so that I am looking almost straight down at him. Then I will say, "Hey, whatcha got there?" If he looks up for an instant, I grab the shot. This only works once or at most twice when you approach a child in each setting, and it goes without saying that I have to be fully prepared—with my camera settings perfect.

PHOTO © JIM MIOTKE. CANON 5D, 1/50 SEC AT ƒ/5.0 ISO 160, 28–135MM LENS AT 41MM

your models will forget your job and fall back into the present moment, unaware of you as the photographer. If you tell them to smile, you will pull them out of the moment and cause them to put on their "camera face." Instead, talk normally and naturally, tease them, or even say the opposite of what you want. For example, saying "Don't smile . . . whatever you do . . . don't smile!" in the right tone, with a wink in your eye, can be very effective in getting a fun, natural smile.

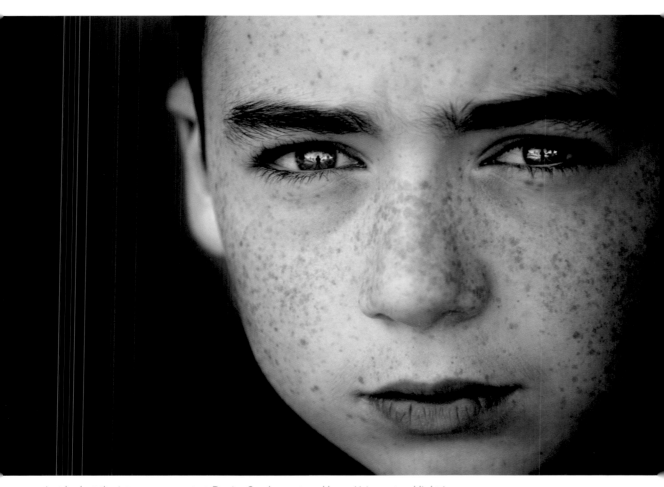

Just look at the intense eye contact Denise Synder captured here. Using natural light in open shade, she made this photo the day her son cut off his hair, which was previously curly and past his shoulders. She writes, "He was turning fourteen and decided it was time to cut his hair short. I was taken aback by just how mature he suddenly looked without all those curls. I think that this image captured the maturity that I suddenly saw in him. It was as if my little boy disappeared in the pile of hair . . . and was replaced by a young man."
PHOTO © DENISE M. SNYDER. NIKON D200, 1/160 SEC AT ƒ/4, ISO 100, 50mm 1.8 LENS

Keeping Kids' Attention

YOUR CHALLENGE IS not only to get your models' attention but to hold it long enough for you to snap that perfect picture. At the very least, you need to keep them entertained long enough to make a few good exposures. Keeping children engaged during the photo shoot requires the same skills as does getting their attention, balanced with sensitivity to energy levels and limits. Pay attention to signs of overstimulation or exhaustion. Also, work in a cyclical pattern. Let go from time to time. Loosen up and relax. When you let the activity level cycle up and down, you will get many more great photos than when you demand that they stay attentive for a long time. The latter will just exhaust your subjects' powers of concentration. Give children a break every ten or twenty minutes, if you sense it would be welcome. You want to keep them amused long enough for you to get a good photo, but you must respect their needs and work within their limitations.

ASSIGNMENT Look at the Birdie

Your assignment is simple this time. Within the next ten days, select the child of your choice and arrange a shoot. Start with one child (you will find it much easier than attempted to get attention for a duo or group portrait). Your objective is simply to capture a selection of images with the subject smiling and looking into the camera. In particular, you want "smiling eyes"—that engaged look where your audience can see the sparkle of the child's joy in their eyes. Ask a friend to act as a kid wrangler, playing the clown and making funny faces and noises to get your child's attention and hold it long enough for you to take several photos. Make a fun day of it. You'll love the results!

KID QUOTE

One night when I was reading Julian a story, he needed to excuse himself for a moment but didn't want me to leave. He said, "Don't lose your focused, Daddy. Stay like a statue on that page."

You Don't Always Need Eye Contact

THERE ARE TIMES when eye contact is not necessary. Candid photos and even some portraits can work well when the eyes of the subject are not looking right at the camera. A profile, for example, can provide a pure shape, unlike your typical pose. Likewise, kids looking down can create a pensive, thoughtful image.

Photographer Josh McKenney attributes the success of this photo to shooting babies of the perfect age and at the perfect time, as well as to some pure luck. He advises that, when trying to get a good picture of multiple babies (triplets in this case), photographers need to be aware of the short windows of opportunity in their lives when positioning is possible. "In this case," he writes, "our cuties were just able to sit up and not old enough to do much crawling. This phase only lasted about two short weeks for us." Josh has two other tips for baby photographers: (1) Older siblings are often the best people to keep babies' attention or to make them laugh. In this picture, the older brothers were playing in the yard in front of the three babies, which helped keep them focused. (2) Always be ready for anything. In this case, Josh was delighted when the oldest of the three put her arm up on her sister's shoulder. Because Josh was ready, he was able to capture the brief and charming moment.

PHOTO © JOSH W. McKENNEY. NIKON D70, 1/1250 SEC AT ƒ/2.2, ISO 400, 50MM LENS

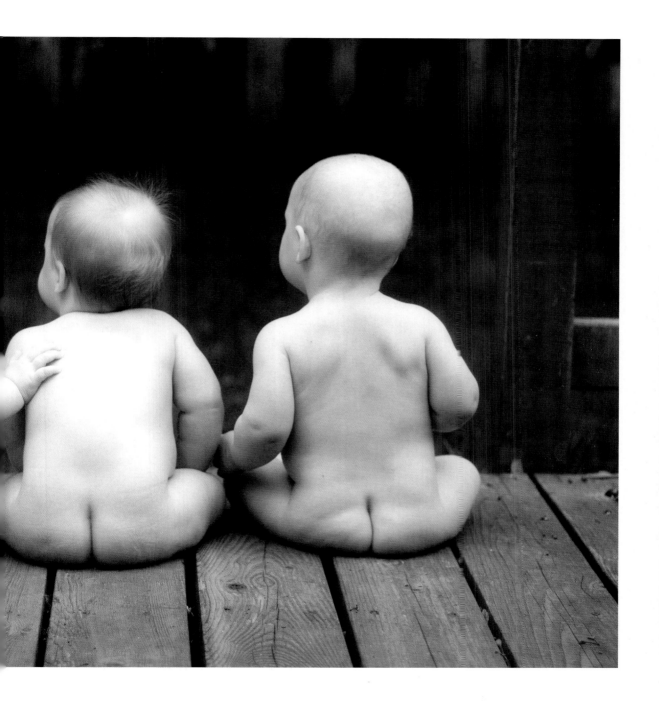

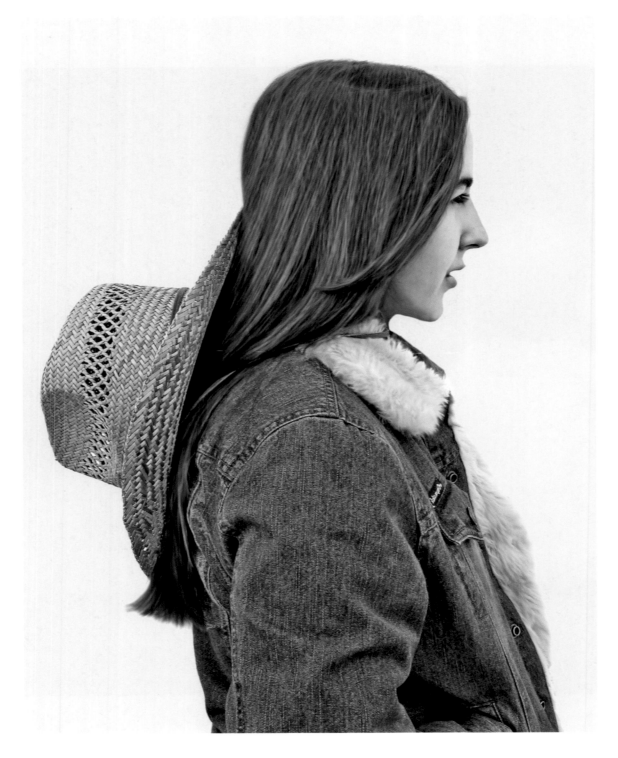

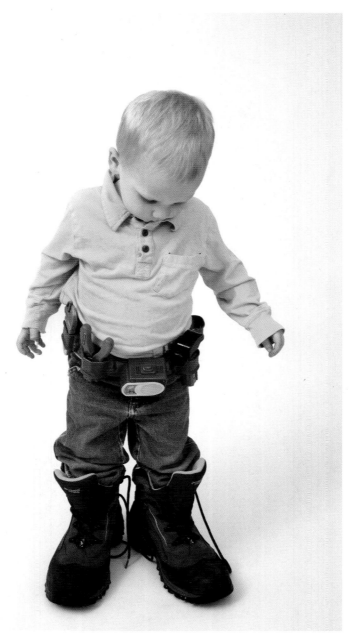

You don't always need eye contact. Look how much fun this photo is with the child looking at the true focal point—Daddy's big boots.
PHOTO © JIM MIOTKE. CANON 5D, 1/125 SEC AT ƒ/9.0, ISO 100, 28–135MM LENS AT 38MM

Photographer Susi Lawson captured a textbook profile in this image (opposite), created with natural light in front of a white shed.
PHOTO © SUSI LAWSON. CANON POWERSHOT G3, 1/160 SEC AT ƒ/4, ISO 100, 35–140MM LENS AT 35MM

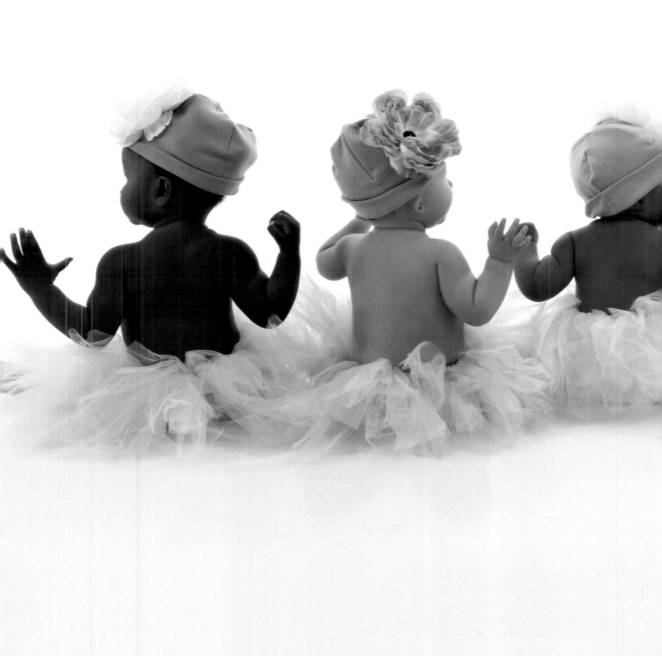

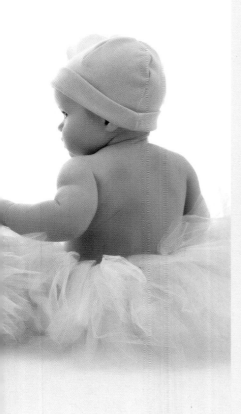

A Quick Guide to Posing

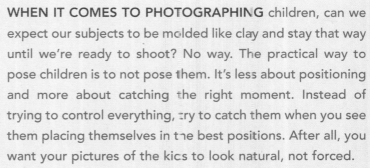

WHEN IT COMES TO PHOTOGRAPHING children, can we expect our subjects to be molded like clay and stay that way until we're ready to shoot? No way. The practical way to pose children is to not pose them. It's less about positioning and more about catching the right moment. Instead of trying to control everything, try to catch them when you see them placing themselves in the best positions. After all, you want your pictures of the kids to look natural, not forced.

Having said that, there are a few posing guidelines you can keep in mind. Here are some posing dos and don'ts that apply to photographing children.

To create this image, photographer Linda Krehbiel used five lights—one main, one fill, two lights pointing at the backdrop, and an overhead light used to light their faces. Knowing that they would be at their happiest, she planned this shot at the very beginning of the session. Linda had two assistants on either side of the drop who faced the babies to keep them entertained and looking away from both the camera and their mothers in the studio. Linda was grateful that she started off with this shot because, about twenty-five minutes into the session, the baby in the lavender tutu had had enough and the session was over.
PHOTO © LINDA KREHBIEL. NIKON D200, 1/160 SEC AT *f*/9 ISO 100, 17–55MM LENS AT 38MM

Posing Basics

❑ Only older kids can actually be posed. With younger children, the best you can do is to try to catch them when they naturally work themselves into a pleasing pose.

❑ When you can, turn the body so it is at an angle to the camera. Unless you want a mug shot or a strong athletic pose, don't have your models squarely face the camera.

❑ When possible, direct the model to tilt the head. Again, this works best with older children. If you ask a five-year-old to tilt his head, you will likely get an exaggerated pose with him touching his ear to his shoulder.

❑ One hand can rest on a chair. This pose can work well for kids of all ages.

❑ Boys can put their hands in their pockets.

❑ When doing full-body portraits, try not to cut off limbs at all and refrain in particular from cutting off limbs at a joint.

❑ When photographing a group, vary the head height among your subjects. Direct your subjects to sit on various steps on stairs, have some people in chairs or kneeling while others stand, or a combination.

❑ Don't allow people to be distant from each other in a group portrait. Keep them close!

SHOW, DON'T TELL

If you want your subject to do something, have your assistant do it or do it yourself. Showing the child and encouraging her to mimic you will work much more effectively than telling her what to do. Often children simply don't know what you mean. Try asking a toddler to turn to the left or hold a particular prop in a particular way. It often leads only to confusion. Mimicking is easier for a child, or for anyone, than is following a verbal instruction.

AT AN ANGLE

One of the most basic principles of posing involves turning your subject a bit to one side, when you can. This practice will keep your portrait from looking like a mug shot. Direct the subject to move her feet (or move them yourself) until her body is at an angle to your camera. Your goal in this quick pose is to have your subject still looking at you but turning her body so that it is positioned at an angle. If the child seems to have difficulty staying in this position, try an angled sitting chair or angled footprint-like marks on the floor.

KEEP THEM LOOKING NATURAL

Sometimes kids will actually be too responsive to posing instructions. In an effort to give you what you want, they will exaggerate the pose so much that it looks unnatural. The solution is to simply start over and try to distract them again. Help them forget once again that you are trying to take their picture. Hopefully, they will fall back into a natural position once you get silly or goofy with them again. Your goal is to effectively erase the previous pose so they can fall into a new pose.

Posing Babies

YOUNG INFANTS in particular can be a challenge when it comes to posing. If they are too young to sit up on their own, here are some solutions:

❏ Have a parent hold the baby in his or her arms or hands.

❏ Lay the baby gently on the floor surrounded with appropriate decorations such as flowers.

❏ Prop up the baby next to its mother as she sits or lies on the floor.

❏ Place the baby between older kids for a group portrait.

❏ Lay the baby in the middle of a big bed with an even-toned, light-colored comforter.

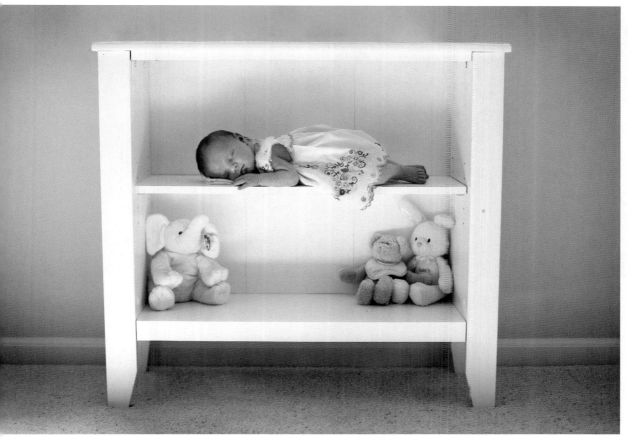

This shot was created using natural light coming in from a nearby window during early afternoon. Before this photo was taken, this baby was quite fussy. After some time, the photographer tried rocking her in her nursery to calm her down. She fell fast asleep and then the photographer gently placed her on a little bookshelf nearby. She snapped a few shots and came away with this sweet and subtle baby photo.

PHOTO © JILL LENKOWSKI. CANON 5D, 1/800 SEC AT ƒ/3.2, ISO 400, 50MM LENS

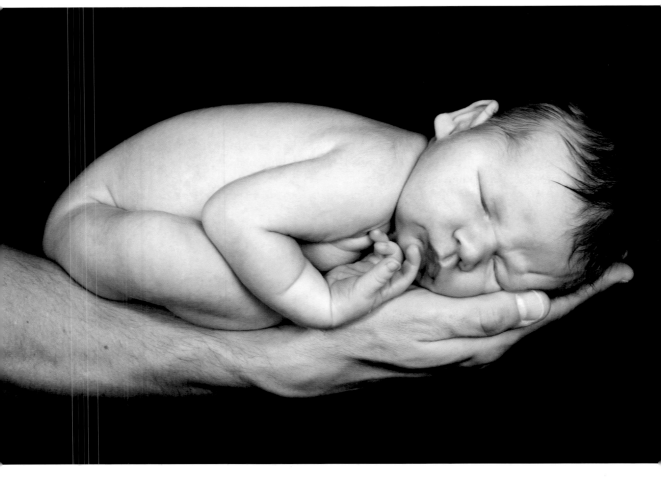

These photos show creative and effective ways to pose a baby.
ABOVE: PHOTO © JENNIFER JONES. CANON 5D, 1/125 SEC AT ƒ/8, ISO 100, 35MM LENS. RIGHT: PHOTO © JESSICA HUGHES. CANON 5D, 1/160 SEC AT ƒ/2.8, ISO 100, 40MM LENS

TIP

One trick when photographing babies in the buff is to let them run naked for a while before the shoot. Alternatively, dress them in full-body pajamas without a diaper before the shoot. This will reduce the indentations caused by pinching clothing or diapers.

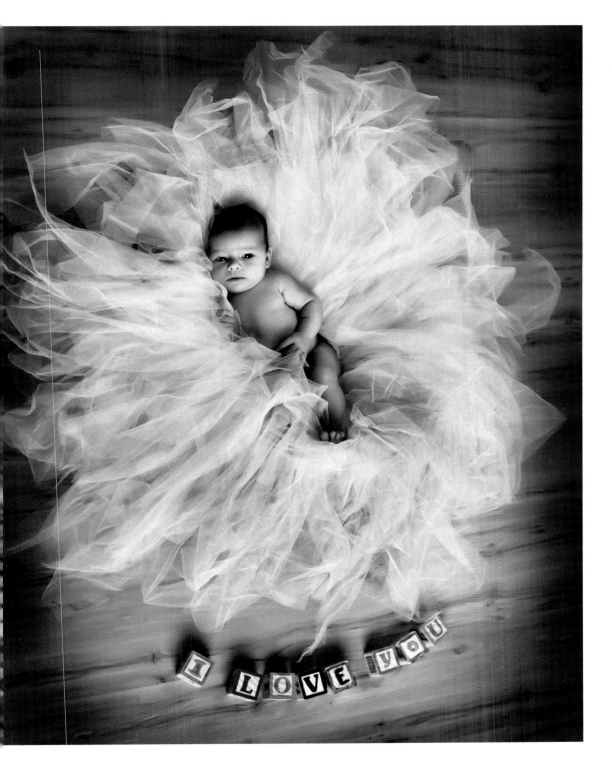

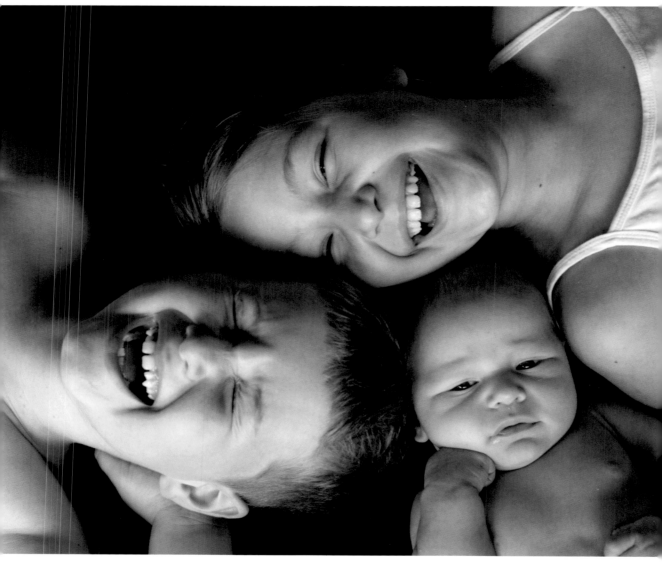

*What a great way to pose a baby: on the floor surrounded by family! This portrait was
illuminated with natural light just inside the photographer's garage. The mother had
expressed that she most wanted a photo of all three children. Megan was having a hard
time with the older children holding the baby, so she set them up on the ground lying on
a pile of blankets. She then stood over them on a table and shot away. The older siblings
got a case of the giggles, which obviously worked for the photo. I love how the baby
appears disgruntled while the older siblings are obviously having such a great time. The
expressions of the older children as well as the baby are priceless.*
PHOTO © MEGAN PECK. CANON 5D, 1/60 SEC AT ƒ/5.4, ISO 250, 50MM LENS

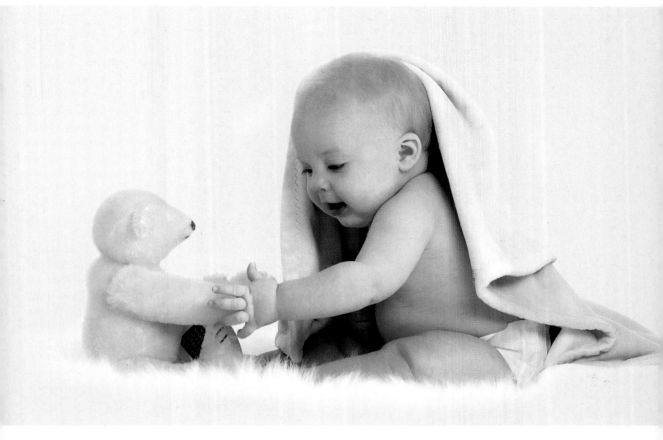

Placing a blanket over a baby can provide a wonderful framing device and add a sense of charm to the photo. The only trick is that you have to work very quickly. Datha Thompson agrees, saying, "This baby was pretty mobile, and I had to be fast. I barely caught the blanket on his head for longer than a second! He was definitely the boss during our session!"

PHOTO © DATHA Y. THOMPSON. CANON 10D, 1/125 SEC AT ƒ/8, ISO 100, 100MM LENS

TIP

Don't let great photo opportunities slip by you. As babies get older, you will have a brief window of opportunity in their lives when they are just old enough to sit up but still too young to crawl and walk. This is a time when positioning the baby is easier than usual. This phase may last only a few weeks, but it can be a great time to get cute photos.

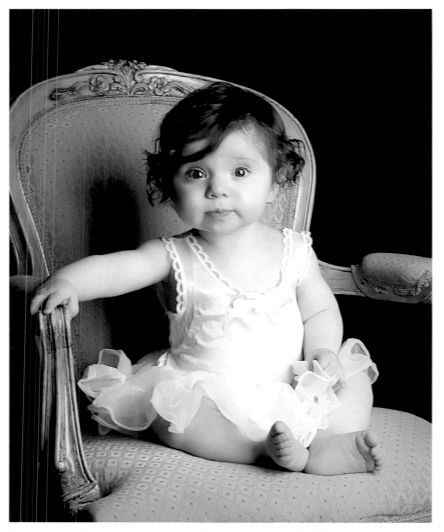
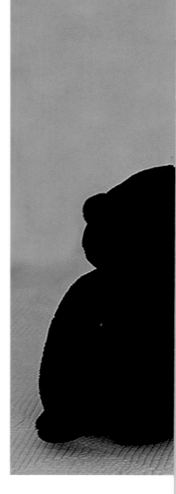

Photographer Teresa Lee explains that "this little girl just looked like she'd make a per-
fect little princess, so I pulled this little dress from my costume closet and we set her in
this chair (her 'throne'). With Mom and Dad just out of the frame, she fit the part and put
her hand on the arm of the chair and gave us a little face that produced a priceless and
timeless photo." The portrait was created with studio lighting consisting of one large 3 x
4–foot softbox with a white reflector providing fill light.
PHOTO © TERESA LEE. NIKON D 100, 1/125 SEC AT $f/9$, ISO 200, 50MM LENS

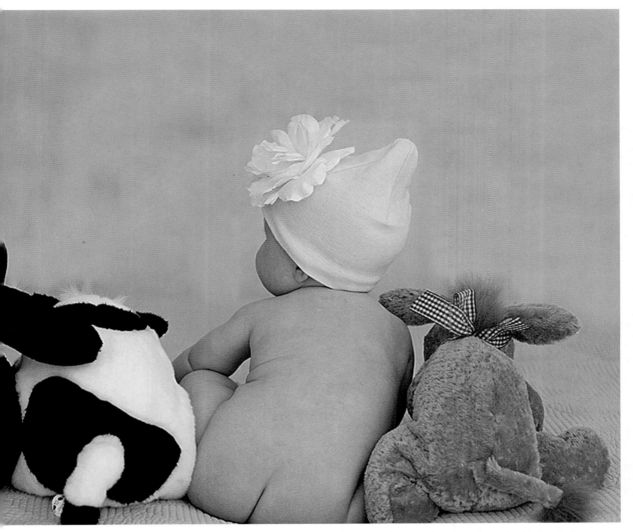

This is a wonderful example of the good way to photograph a naked baby. Facing the baby away from the camera and framing her with some favorite stuffed animals, photographer Megan Peck captures a bare-bottom photo that elicits a smile or laugh every time. "It was a challenge," recalls the photographer. "If the baby was not flopping over, the animals were. At the end, the mother and I were hysterical with laughter." This shows that fun photos come from fun photo shoots.
PHOTO © MEGAN PECK. CANON 5D, 1/250 SEC AT ƒ/2.8, ISO 400, 50MM LENS

Babies with a Parent

PARENTS CHERISH PORTRAITS of themselves with their baby. There are a variety of interesting poses of parent and baby you can try, such as baby in the parent's arms or over the parent's shoulder. It's a good thing parents cherish these portraits; it sure amplifies the challenge of posing newborns.

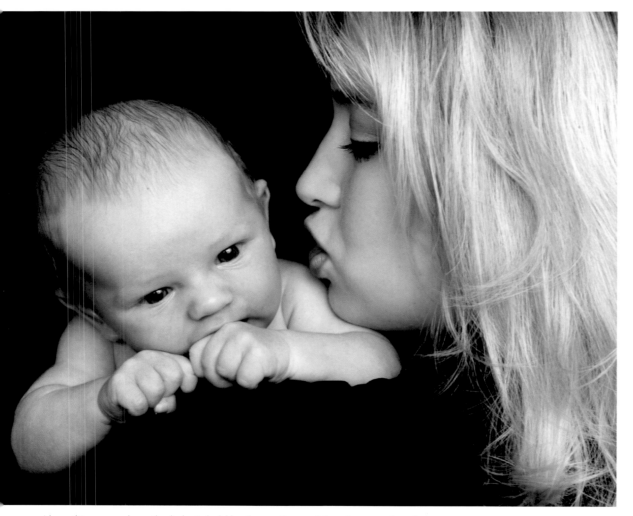

I love this pose, where the baby is held by the mother and the photographer shoots over the mother's shoulder. Whenever you photograph babies, it's a good idea to try to photograph their tiny hands either by themselves or as a supporting element in a portrait. If you see their hands showing, be sure to include them in the composition.

PHOTO © JENNIFER JONES. CANON 5D, 1/125 SEC AT ƒ/8, ISO 100, 35MM LENS

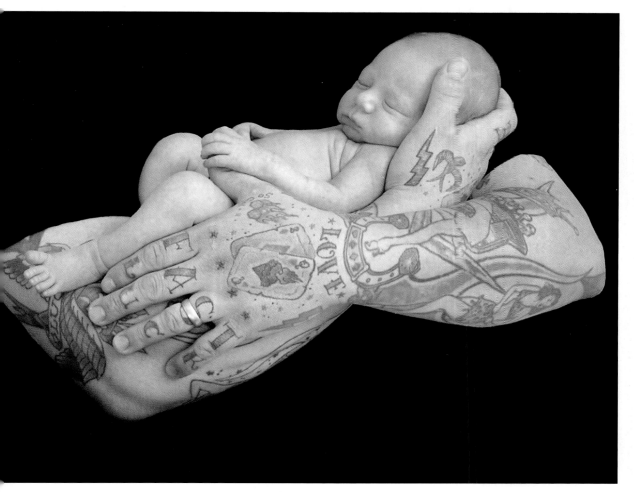

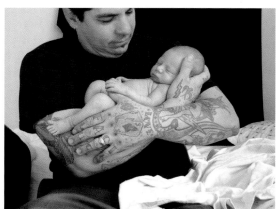

Placing the baby in one parent's arms is an excellent way to pose a newborn. Norma Warden used Photoshop to remove some distractions in the background and created this image that allows the viewer to concentrate on the interesting combination of baby and tattooed arms.
PHOTO © NORMA WARDEN. OLYMPUS C740UZ, 1/25 SEC AT f/2.8, ISO 100, 35MM LENS

Toddlers and Preteens

AS THE LANGUAGE SKILLS of your subjects develop, you have more opportunity to pose. All the same, you will likely get more great photos of toddlers and preteens by following and documenting than by trying to control and pose these kids.

When I pressed the shutter button for this image, my daughter Alina was enthusiastically stomping on the fake "buggie" (really just an X) that I had drawn on the white seamless paper backdrop.
PHOTO © JIM MIOTKE. CANON 5D, 1/125 SEC AT ƒ/11 ISO 100, 28-135MM LENS AT 50MM

On Your Marks

Photographers should take a lesson from the film industry. To remain sharply in focus, actors need to be in exactly the right spot when they are being filmed. To achieve this perfect positioning, a star or mark is often placed on the spot where they need to stand. In the same way, you might find it useful to draw an X or position a fallen leaf or twig in a particular spot. Make a game out of the child standing on the X or even stomping on a pretend bug. Playing make-believe can go a long way when you're trying to get your subject into the perfect spot, or at least into the general area you'd like them to occupy.

I often draw a quick X on the base of the white seamless paper that I use as a backdrop in my studio. I draw this where I want them to stand and then make a game out of them trying to stand on it or hide it from my view. Once they are there, though, the next challenge is to get them to temporarily forget about the X. To do this, you or your wrangler needs to very energetically call their attention to the camera. Whether these two hats are being worn by one or two people, the wrangler's job is to call the attention up toward the camera and the photographer's job is to keep shooting whenever the gaze appears to be coming toward the camera. You'll only have fleeting moments; the name of the game is to watch for the right moment, start shooting when you see it about to occur, and keep shooting until it's long gone.

This photo by Denise Snyder demonstrates a number of principles found in great photography. First, it shows the power of eye contact. As you view the photo, notice how engaged and connected you feel with this boy. The portrait also shows excellent composition, making good use of the rule of thirds. The eyes are placed in the upper right area and give the photo a balanced and interesting composition. The boy is posed in a natural, pleasing way, with the V shape of his hands adding a sense of dynamic diagonal line and framing his face. Lastly, the light is gorgeous. She used a large softbox to the left of the camera and a reflector to the right. This setup brings out the curves and form of his face without creating overly bright highlights or overly dark shadows.

PHOTO © DENISE SNYDER. NIKON D200, 1/250 SEC AT f/7.1, ISO 100, 28–70MM LENS AT 38MM

This image demonstrates how much a tilted head can add to a portrait. In this case, it helps create a diagonal line and pleasing off-center composition.

PHOTO © ANNAMARIE FERGUSON. NIKON D100, 1/60 SEC AT ƒ/4, ISO 200, 85MM LENS

The photographer made great use of natural window light to photograph her daughter. She says that usually "she is such a tomboy, I was surprised she agreed to pose in a tutu." Together they captured a great pose, with the girl looking back over her shoulder into the camera.

PHOTO © JENNIFER B. SHORT. CANON DIGITAL REBEL XT, 1/50 SEC AT ƒ/5.6, ISO 100, 46MM LENS

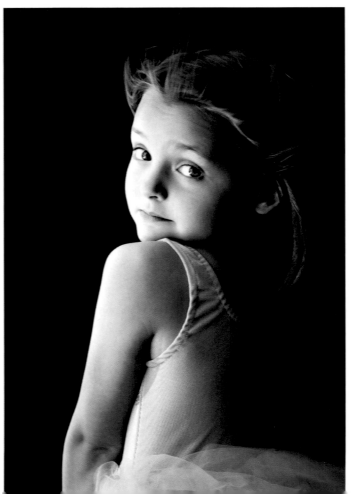

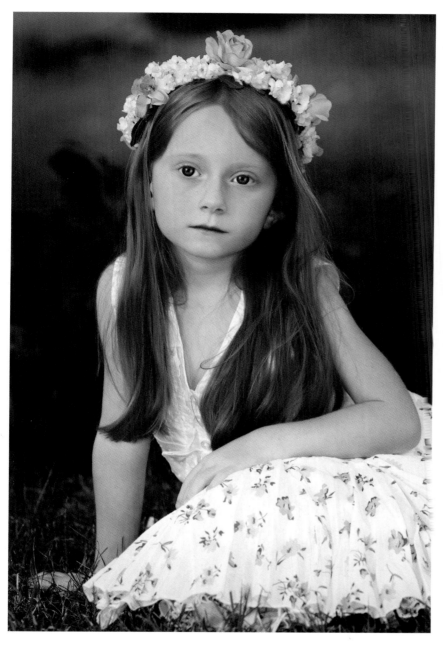

This portrait was created in the early evening using a 580 EX external flash unit. The photographer bought the skirt and blouse and—with silk flowers and a glue gun—made the laurel wreath for the girl's hair. She asked her to sit in the grass on her front lawn and got this lovely pose. The camera was hand-held. The photographer explains: "As usual with children, I had to be fast on my feet with my eye glued to my camera and my finger ready on the shutter button." The subject's serious expression adds to the emotional reaction this creates in the viewer.

PHOTO © DENISE KAPPA. CANON DIGITAL REBEL XT, 1/60 SEC AT f/4, ISO 200, 70–200MM LENS AT 126MM

"You're the bestest dad I've ever had in my entire childhood."

Older Kids

ONE OF THE JOYS of photographing older children is that they are easier to pose than younger ones. Try asking them to do any or all of the following poses:

❏ Body at an angle to the camera

❏ Head tilt

❏ Head resting on either one or both hands

Using a studio lighting setup, Datha Thompson photographed her daughter who, she says, "is always willing to pose and show me some attitude!" She shares her secret to capturing these great portraits: "We just have a mother/daughter talk during our photo sessions, and I get some really great expressions while we're talking."

PHOTO © DATHA Y. THOMPSON. CANON 10D, 1/125 SEC AT *f*/8, ISO 100, 100MM LENS

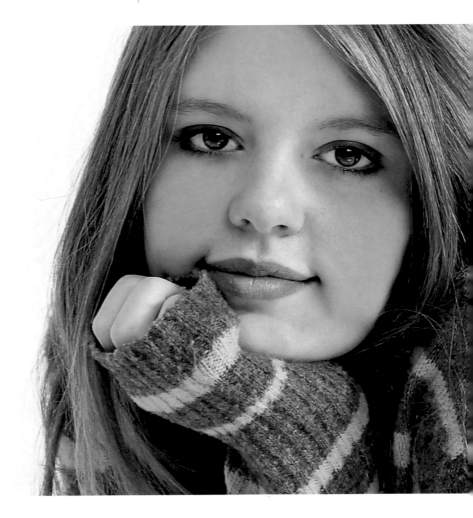

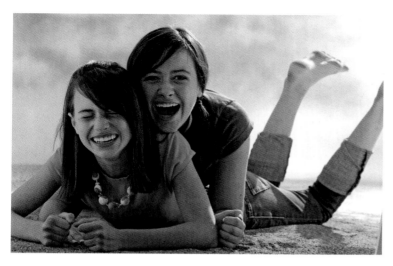

You can direct older children to find a pose that works well in the photo. Before I captured this fun portrait of two sisters, the girls were asked to get into this pose. The image works well because of this direction. The girls found posing for the photo to be hilarious, and the resulting image conveys the high energy of the moment.

PHOTO © JIM MIOTKE. NIKON 2DX, 1/125 SEC AT f/6.7, ISO 100, 30–200MM LENS 100MM

ASSIGNMENT Take Turns in Front of the Camera

It's good if parents can trade off taking the pictures. Otherwise, a family ends up with photo albums filled with pictures of one parent only. For the next week or two, strive to produce a variety of shots—some with you in the photo and some with your spouse in the photo. Extra credit: You can also involve your child, asking him or her to take some portraits of you. If you go this route, a tripod will come in handy—both to stabilize the camera and keep the composition constant. Little kids in particular have a tendency to move the camera down just as they take the picture. It's fun to have them shoot both with and without a tripod; you can get some fun photos from their point of view when they handhold the camera. Whether you, your spouse, or your child is behind the camera, experiment with a variety of poses to see which of the posing principles we've discussed make the biggest difference to you.

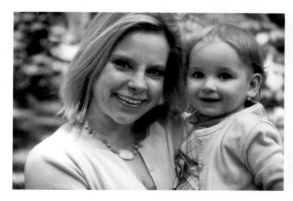 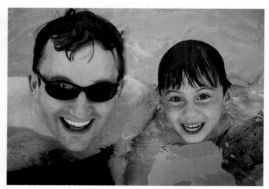

It is a great idea to hand off the camera from time to time, so both parents end up in the family photo album.

LEFT: PHOTO © JIM MIOTKE. CANON 5D, 1/125 SEC AT f/5.6 ISO 400, 28–135MM LENS AT 135MM.
RIGHT: PHOTO © DENISE MIOTKE. CANON 5D, 1/200 SEC AT f/5.6, ISO 400, 28–135MM LENS AT 132MM

The Group Portrait

AS IF POSING AN INDIVIDUAL child was not challenging enough, what happens when you are tasked to photograph a group of children or children with parents? The following section will guide you in your endeavors to take great group portraits. Keep these recommendations in mind and you'll get fantastic group portraits every time:

❏ Make sure everyone is positioned very close together.

❏ Place heads at different levels.

❏ Make use of the powerful triangle, as we discussed in chapter 2 on composition.

❏ Get everyone to look at the camera at the same time.

❏ Take a lot of pictures!

TIGHTENING UP THE GROUP

Placing members of the group in the photo close together makes for a much more cohesive composition. People will naturally stand together with a little bit of personal space between them. You will probably have to ask all of your models to move closer together, saying "Don't be shy." Asking your subjects to lean their heads together

> **TIP**
>
> Take a lot of photos, as many pictures as there are people in the portrait—at least nine or ten exposures. This will give you coverage for those occasional images in which one person is looking screwy or blinking. Take as many as the group will allow before they turn on you like an angry mob!

The primary challenge when doing group portraits with adults and a child is to get good eye contact. When shooting this portrait, my wife asked the adults to continue to look at the camera while she worked to get the attention of our child.

PHOTO © DENISE MIOTKE. CANON 10D, 1/30 SEC AT ƒ/5.0, ISO 200, 28–135MM LENS AT 75MM

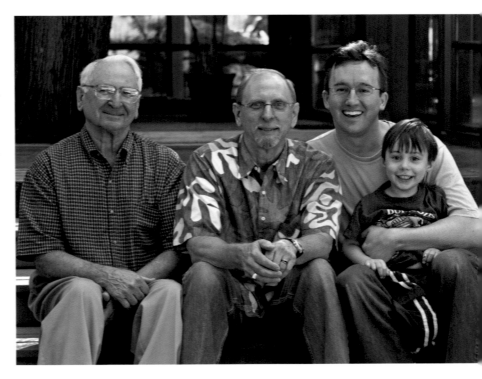

also helps create intimate, engaging group photos.

Place heads, when possible, according to your sense of balance. Aim to keep the subjects more or less the same distance apart. If one child appears farther from the other two, this will cause the viewer to surmise that the far child is distant, detached, or at odds with the other two children. Positioning everyone close together will give you an intimate portrait with little background peeking through and everyone looking "tight" and super-friendly.

EYE-CONTACT: "EVERYONE LOOK AT THE CAMERA"

The greatest challenge when photographing groups is getting everyone to look at you when you take the picture. Typically, if there is an infant in the mix whose attention you are trying to catch, the group members will naturally turn their eyes and their attention to the baby. Then you end up with a picture of an infant looking at you while everyone else is looking at the infant.

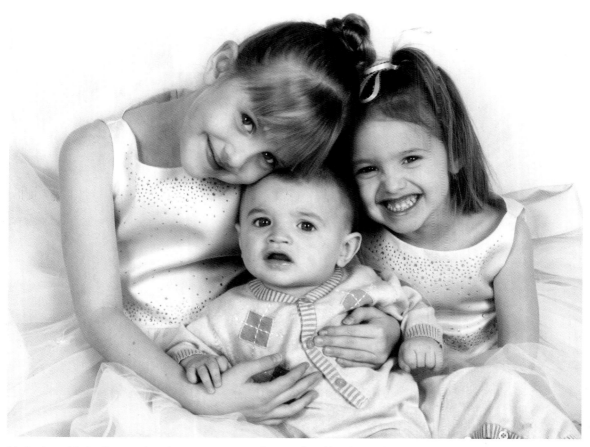

Notice how this family portrait makes great use out of varying head heights and the triangle. When posing three or more, it works well to arrange the subjects so that the heads are on different levels. It's even better when you are able to form a strong triangular shape out of the various faces in the portrait.

PHOTO © JESSICA HUGHES. CANON DIGITAL REBEL, 1/60 SEC AT ƒ/5.6, ISO 400, 45MM LENS

The solution to this problem is to forcefully direct the adults to look at the camera at all times. Explain the difficulty in getting everyone looking into the camera. Ask them to forget about the little one and keep their gaze directed right into the lens. Then, for as long as they can do this, you and/or your kid wrangler should try to get the baby's attention. The wrangling antics will likely make the others relax and smile, too. If they look down or join you in trying to get the baby's attention (which most moms and grandmas almost can't resist doing), gently remind them to keep looking at the camera. With this method, you'll likely get great group photos in which everyone is making perfect eye contact and engaging the audience.

Using an Assistant

For a great family portrait, you need everyone to be looking at the camera. Ideally, they will have that special something in their eyes—that spark of interest and engagement. To get such a portrait, you need a human being by the camera—ideally, a clown or a comedian! My recommendation is that you avoid the self-timer and ask a friend or neighbor to help. Try to find someone who can get and hold a crowd's attention. Ideally, you'll be able to find someone who is a bit of a clown and can draw all eyes to the camera.

When capturing this portrait of her three children, photographer Allison Gaulin kept her subjects close together and arranged them so that their head heights varied in a pleasing, dynamic way. She also did a fantastic job of getting the attention of all three subjects. This image is an example of good eye contact and great posing.

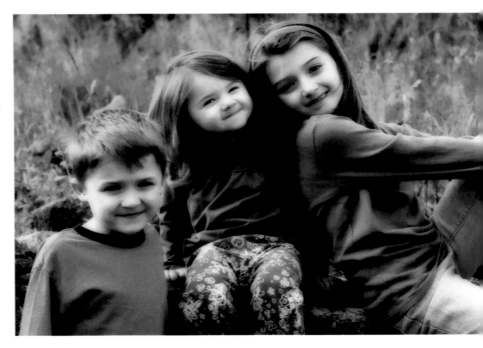

TIP

Pose on steps, or have one person in a chair to vary the head height among your subjects.

Natural Expressions = Great Portraits

LIGHT, COOPERATION, TIMING—all of the ingredients we have discussed in this book—lead to our one main goal of getting natural expressions. You first need to learn the craft of working with light and preparing the scene. You then work to make the child forget she is having her picture taken. Once you have natural activity happening in front of you, it's all about shooting often and fast to catch the right moment.

To get real smiles, replace the need for personal control and the knee-jerk urge to say "smile" with humility, flexibility genuine connection, engagement, and interaction. Only in this way can one enjoy a lifetime of making great photos of children.

There is no doubt that one needs to have a deep commitment and passion to photograph children. I know you do. You would not have set aside your valuable time to read this book if you didn't. You clearly have the dedication and driving desire to be creative in the world of kid photography. Now you have all the tools you need to get the results you want . . . consistently.

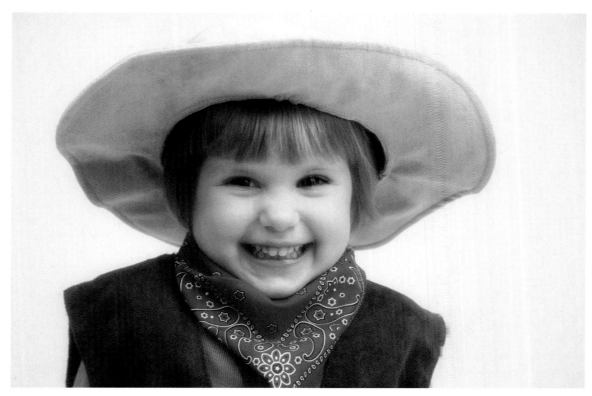

This little girl took just a minute to warm up to me. Once she felt that it was safe to play, she thoroughly enjoyed dressing up in a variety of costumes and giving me the most delightful expressions of joy!

PHOTO © JIM MIOTKE. CANON 5D, 1/125 SEC AT ƒ/8.0 ISO 100, 28–135MM LENS AT 90MM

For this image, photographer Teresa Lee wanted to produce a very soft, porcelain-doll-like portrait. Using a studio lighting setup, she had her model lie on flowing white material. Key elements in making images such as this one work are choosing very simple clothing and giving attention to the model's hair and face.
PHOTO © TERESA LEE. NIKON D 200, 1/125 SEC AT *f*/11, ISO 100, 50MM LENS

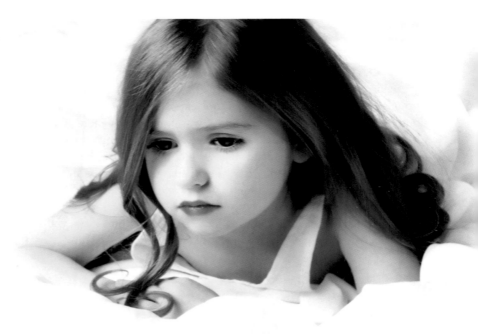

Dress and Makeup

One common mistake that many parents make when photographing their children is that they don't pay attention to details such as clothing. When you're doing a portrait, go for simple, evenly colored clothes and avoid loud colors and busy patterns. This will allow all the attention to be focused on your subject without competing for attention with the other elements. If you use simple colors, bold colors, or pastels, it'll work better than busy colors. By keeping it simple when it comes to wardrobe, you'll get a portrait that focuses attention on your subject's face and eyes.

Also remember to check details like belts and the shoes. You may not notice a missing belt or ugly shoes in the excitement of the moment, but they will be seen as glaring oversights when viewing the final results. Of course, the subject's hair should be combed. Personally, I avoid using any makeup on children. It looks unnatural and is almost always unnecessary. The goal is a natural look. If the lips are dry and need shine, try a lip balm. If the skin is super-shiny, try diffusing your light more before applying a power or foundation. Ensuring that these details are covered, you will make an image that shows off the eyes with the least possible distraction.

Direction regarding clothing can easily be taken to extremes. Some photographers love color harmony and try to get everyone dressed in the same way. Sometimes this works well. In other portraits, in which all members of a family are dressed in matching sweaters, for instance, the resulting portrait can have an unnatural quality. You need to balance a desire for color harmony with an eye to what is natural for the members of the family.

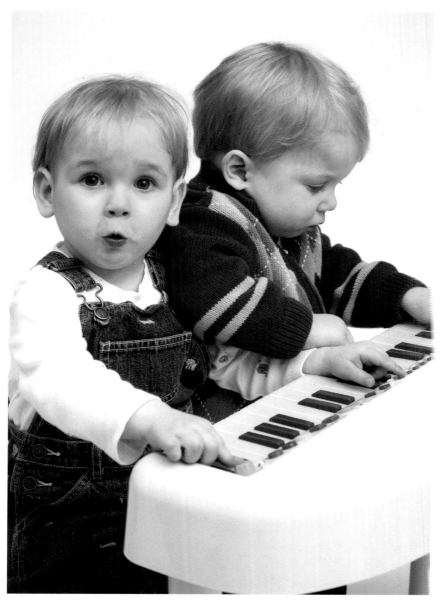

I have always enjoyed the interaction captured in this moment. My daughter Alina's surprised expression is classic, and so is the behavior that her brother Alex is demonstrating as he tries to elbow her away from the toy piano.

PHOTO © JIM MIOTKE. CANON 5D, 1/125 SEC AT ƒ/8.0 ISO 100, 28–135MM LENS AT 80MM

TIP

To get an excited expression, ask the mom to go outside for a while and then knock before coming back in. Often the child will be naturally delighted to see Mom returning.

It's been my pleasure to guide you as you learn the joyful art of photographing kids. Together, we've explored the main principles of light, composition, and digital exposure. Keep these in mind as you prepare for each child photography session. Print out the preceding top tips and use it as your cheat sheet. Especially when photographing children, there are many moving parts and a great deal to keep in mind. With these tools and techniques you have learned in this book, you can do it! You can create charming, beautiful, and insightful photographs of children every time you draw the camera up to your eye.

Go forth, make many exposures, and share your favorites with all of us at BetterPhoto. I look forward to seeing your many successes!

Top 10 Tips for Photographing Children

The following ten tips represent the tactics that have most helped me to get successful photos of kids over the years. Focus on these ten techniques, and you'll be making masterpieces in no time at all.

1 Talk to your kids about whatever interests them. Don't say "smile." Instead, give them a reason to smile. Ask them to tell you about their favorite toy, subject in school, or rock band. Make them laugh and give them affirmation, saying things like "great job!" often. (For review, see chapter 5.)

2 Get help—in the form of a "kid wrangler." (See chapter 5.)

3 Carry your camera with you at all times. Once you're set up to shoot, come out from behind the camera to interact with your child. This will help the child forget the camera and feel more relaxed. (See chapter 5.)

4 Get down on their level. Try unusual points of view—high or low. (See chapter 2.)

5 Use fast shutter speeds to freeze the action and get sharper photos. (See chapter 3.)

6 Shoot in the soft, natural light near a large window or open door. (See chapter 1.)

7 Use a telephoto lens and zoom in close for more impact while retaining natural perspective. (See chapter 2.)

8 Use the rule of thirds to create balanced and beautiful compositions. (See chapter 2.)

9 If you don't already use one, upgrade to a digital SLR camera. (See chapter 4.)

10 Set up an entry-level home studio in your garage or a spare room. (See chapter 1.)

Resources

The BetterPhoto Guide to Digital Photography

My first book in this series, *The BetterPhoto Guide to Digital Photography*, gives readers a practical, lesson-based guidebook with all the tools they need to create eye-catching digital pictures. You get a step-by-step tutorial in getting bright, crisp, beautiful pictures from your digital camera every time. Everything a beginner or intermediate digital photographer needs to know is here, including full information on file formats, low-light photography, filters, and white balance. Learn about the basics of exposure, light, composition, and much more, all in a handy, bring-along format.

The BetterPhoto Guide to Digital Nature Photography

If you enjoy photographing flowers, landscapes, and animals as much as you enjoy photographing children, you will find a complete nature photography course in *The BetterPhoto Guide to Digital Nature Photography*. Hands-on lessons cover every aspect of digital nature photography, and the book includes special sections on photographing close-ups, landscapes, and wildlife.

Online Courses at BetterPhoto.com

BetterPhoto offers over a hundred online photography classes.

Vik Orenstein's "Photographing Children" Course

One of our most popular classes, *Photographing Children*, taught by Vik Orenstein, attracts students from all over the world. Each week, students are provided with a lesson and assignment. After shooting the assignment, they upload the results and Vik personally critiques their efforts. It's a thrilling and effective way to completely master the art of photographing kids.

Kathleen Carr's and Lewis Kemper's Photoshop Courses

When it comes to child photography, or any kind of photography for that matter, learning Photoshop is essential. Kathleen Carr's Beginning Photoshop for Photographers course will help any beginner overcome the first learning hurdles of Photoshop. Lewis Kemper's Photographer's Toolbox for Photoshop courses include lessons to master important tools in Photoshop such as Actions, conversions, composites, and more.

Scott Stulberg's "Eye to Eye" Course

Scott's course on capturing the face of your subjects is a fun and fast paced four-week course. Each weekly lesson includes valuable tips, fresh ideas, and an inspiring assignment. With Scott's lessons and feedback, your child images will improve dramatically.

Ibarionex Perello's "Available Light" and "Posing" Courses

In Ibarionex's Available Light (I) and Posing and Portraiture (Part II) series, you will learn how to capture memorable portraits without sophisticated lighting equipment. These four-week online courses will show you how to make your subject—and not the camera—the focus of successful portraiture. To learn more about these great classes, visit www.betterphoto.com/online-photography-courses.asp

Hunt's Photo and Video

Whether you are a student, hobbyist, or photo or video professional, Hunt's Photo and Video will help you choose the right equipment for all of your imaging needs. You'll be ready to start shooting as soon as you leave the store when you purchase your camera at Hunt's Photo and Video. The team at Hunt's makes sure every client feels

comfortable with his or her purchase and confident in its use. Hunt's Photo, Video and *definitely* Digital is a trusted partner of BetterPhoto.com. www.huntsphotoandvideo.com

Photographing Children Club

The BetterPhoto Photographing Children Club is an online photography club intended for anyone who loves photographing kids and gets endless joy out of the fun things kids say and do. Our mission is to capture those moments and expressions that make life with children so amazing and delightful. www.betterphoto.com/Clubs/Default.asp?id=5376

Photographer's Edge

Photographer's Edge features a complete line of do-it-yourself photo frame greeting cards that are perfect for child photographers. Whether you consider yourself an amateur or professional, these matted cards were developed to give you a way to showcase your talents, resell your work, and share your special moments with family and friends. Their photo-frame greeting cards are guaranteed to hold your photo exactly in position without shifting. The result is a professional-appearing distinctive greeting card showcasing your child photographs. www.photographersedge.com

Nature's Best Photography for Kids

NBPK is a great magazine for kids interested in nature photography. Through a comprehensive blend of creativity, natural history education, and new technology, *Nature's Best Photography for Kids* seeks to connect and inspire children worldwide to explore, embrace, and experience the natural world. In this beautiful magazine, young photographers around the globe can share their extraordinary views of nature and all photographers twenty-one years old and younger can compete in the NBPK Photo Contest. If your kids enjoy photography, writing, and the outdoors, *Nature's Best Photography for Kids* is a great resource.

Blurb

Blurb is a company and a community that believes passionately in the joy of books—reading them, making them, sharing them, and selling them. Blurb offers a creative publishing service that is simple and smart enough to make anyone an author—every photographer, parent, traveler, pet owner . . . everyone. Holding a finished book with your name on the cover is a truly amazing feeling; it's one of those experiences everyone should have. www.blurb.com

Index